POSTCARD HISTORY SERIES

Saginaw

IN VINTAGE POSTCARDS

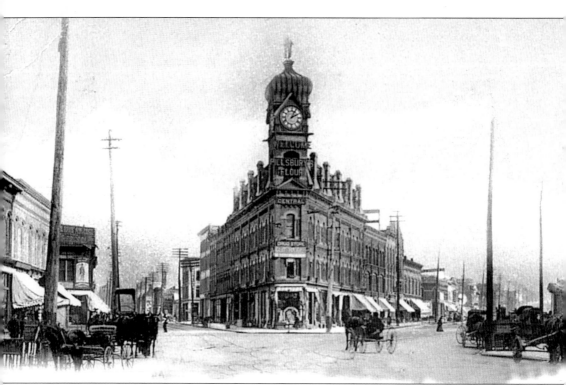

"LITTLE JAKE" SELIGMAN. Adding to the city's history, this card, postmarked in 1906 and showing the Tower Block, was written by Jacob "Little Jake" Seligman. "Letter rec'd. Am having the best time of my life—great welcome reception. This is the clock I donated to the city with my bronze statue on top. J Seligman." In 1843, Jacob came from Germany to Pontiac, Michigan, where he was a tailor's apprentice. After opening his own clothing store, he took the name "Little Jake." He heard of the booming lumber business in Saginaw and settled here to become "King Clothier." He sold to the shanty boys while promoting his business with parades and newspaper ads. The Tower Building, with his statue on top, featured the clock known as "Little Jake's Time." When the lumber business waned, Jacob moved to Colorado where in 1911, because of poor health, he took his own life. In 1940 a windstorm toppled the statue, and city officials had to decide its fate. The Saginaw Valley Historical Society first took custody of it, and later State Sen. John P. Schuch recommended that it be scrapped to help the war effort. Closer inspection revealed that the likeness was not bronze but copper over an iron frame and in 1942 it brought only $6.25 for the war effort.

POSTCARD HISTORY SERIES

Saginaw

IN VINTAGE POSTCARDS

Roberta Morey

ARCADIA

Published by Arcadia Publishing
Charleston SC, Chicago IL, Portsmouth NH, San Francisco CA

Printed in Great Britain

Library of Congress Catalog Card Number: 2004105278

For all general information contact Arcadia Publishing at:
Telephone 843-853-2070
Fax 843-853-0044
E-mail sales@arcadiapublishing.com
For customer service and orders:
Toll-Free 1-888-313-2665

Visit us on the internet at http://www.arcadiapublishing.com

This book is dedicated to my husband, Don, who has chauffeured me to many postcard shows over the past few years. He was always willing to wait while I pored over boxes of cards looking for that one additional card that I desired to add to my collection. It is also dedicated to all of my family and friends who provided encouragement for this project.

CONTENTS

ACKNOWLEDGMENTS

I wish to thank the people who were so willing to help me in my research for this project. I owe thanks to Sandy Schwan, curator at the Saginaw Historical Museum; Mary Ellen Fike, First Baptist Church historian; the secretaries from Holy Cross, Bethlehem, and St. Paul's Lutheran Churches; Sally Ippel Haines; and especially to Lorri Lea, Saginaw News Library/Information Specialist, who was always happy to return my many phone calls and to share historical information relating to the people and places pictured on my cards. Also, I am indebted to Patricia Stoppelworth, who shared the collection of her late father, William Culver, and to George Barrett and Herman Rindhage, who graciously shared cards from their own collections for use in this book.

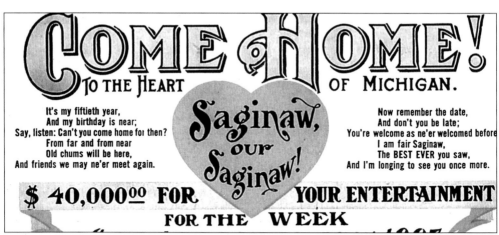

SEMI-CENTENNIAL. Many cards were sent to friends inviting them to Saginaw for the 50th year celebration in August of 1907. A young woman sent the card on August 9, 1907, inviting her friend to come to the city "as we have excursion rates." The card indicated "Railroad Excursions from Everywhere." Another part of the celebration was a Floral Day Parade which moved from the Tower Block on Genesee west to Washington Avenue where it turned past the Bancroft House.

A complete Semi-Centennial souvenir booklet was printed under the auspices of the Board of Trade showcasing Saginaw's 50 years from 1857–1907. It contained a history of the city, articles on the current government, pictures of important buildings, pages showing residences of prominent citizens, and descriptions of the churches, schools, parks, and hospitals of the time.

INTRODUCTION

There are at least two theories concerning the origin of the name Saginaw. One is that the Ottawa Indian term "sag" means to flow out, or go out, referring to a river that flowed into another river or lake. At Green Point, where the Woodland Indians built their villages, the Tittabawassee River flows into the Saginaw River and forms a low flood plain.

The more accepted theory is that Saginaw, or the Algonquin term "Saug-e-nah," means "place of the Sauk." During the 1600s, the Ottawa Indians were the first tribe to build a large village at the mouth of the Saginaw River. When the Sauk Indians came to the area, the hunting and fishing grounds made the land a much sought-after location. Later the Chippewa, or Ojibwa, Indians, who often fought with other tribes, gradually moved from Canada into the area. According to legend, a fierce and bloody battle between the Chippewa and the Sauks occurred on a nearby island. Afterwards the island was known as Skull Island because of the many Sauks who were slain there.

Archeologists, on the other hand, have found no evidence that the Sauk Indians ever inhabited this area. It is believed that they lived nearer to Lake Michigan on the western side of the state, and the skulls on Skull Island were the result of a smallpox epidemic.

Whichever theory one accepts, know that the name Saginaw was so important to Jarvis J. Green that in 1882 he named a city in Texas after his home town.

With the arrival of the white man, the fur trade began to flourish. The Ottawa Indians traded beaver and mink furs for cooking pots, iron knives, axes, guns, and traps.

After the fur traders, the next visitor to the area was the Frenchman, Alexis de Tocqueville. In 1831 he traveled on horseback from Detroit to Saginaw to study the Indians of the area. He later wrote about his travels in his *Democracy in America*. In it he wrote, "In a few years these impenetrable forests will have fallen; the sons of civilization and industry will break the silence of the Saginaw. . . ."

Louis Campau, a French-Canadian fur trader, was the first permanent white settler in Saginaw. His first log house became a center for traders and trappers. His trading post was built on the river bank at the foot of present day Throop Street. It was the task of Louis Campau to build a council house and make the necessary arrangements for Governor Lewis Cass and his staff to negotiate the Treaty of Saginaw with the Chippewa.

The Treaty of 1819 ceded six million acres of land and part of Lake Huron for $3,000 plus $1,000 to be paid annually "forever" to the Indians. The treaty gave the Indians several reservations and the government the authority to sell most of the land to speculators—which it did.

The signing of the treaty brought changes to the area. One was the establishment of a fort to maintain the peace and to serve as a payment headquarters for the Indians' allotment. Fort Saginaw

was built in 1822 on the west bank of the river and was later abandoned after many of the men became sick with malaria because of the hordes of mosquitoes that hatched in the bayous.

With the arrival of more settlers and ambitious entrepreneurs, many from New York, the Saginaw area developed into two cities, one on either side of the Saginaw River. Many men came to Saginaw and saw the potential for a valuable lumbering industry.

Norman Little, a New York native, came to the area and purchased land west of the Saginaw River. His investments helped open a church, bank, hotel, school, and newspaper. He left in 1841 and later returned after encouraging James and Jesse Hoyt, New York businessmen, to invest in East Saginaw.

With a flourishing lumber industry, sawmills lined the Saginaw River and the waters were filled with the logs of white pine and hemlock trees. The "green gold" of the forests yielded 161 billion board feet of timber worth over $2 billion—greater than all of the gold mined in California during the same time—making Saginaw the lumber capital of the world. The lumber barons grew wealthy and they built beautiful mansions, many of which have unfortunately been torn down. The lumber era was a raucous time in Saginaw, with shanty boys arriving at the Potter Street Station ready to spend their money at the local brothels, bars, and at Little Jake's clothing store. Many shanty boys lost all of the money it took an entire winter to earn in the northern forests.

The shanty boys were not alone in their fabled barroom antics. One lumber baron, Curtis Emerson, was one of the most colorful characters of the day. When he was not invited to the opening of the Bancroft House, he crashed the party and destroyed the banquet table (the next day he paid for the damages). His home, "The Halls of Montezuma," was a meeting place for the other hard-drinking barons. Emerson drank more, cursed more, and did more to give Saginaw an unequaled reputation in a developing nation.

In spite of the fact that civic improvements were occurring in the Saginaws, an east-west rivalry developed that hindered much progress. There were many efforts to consolidate the two cities, and finally in 1889 the cities were combined. There were some conditions of consolidation. One was that the County Courthouse remain on the site it occupied on the west side and the City Hall be built in East Saginaw. Saginaw had bridges at Mackinaw, Bristol, Genesee, and Johnson before 1887. Another consolidation condition prompted construction of three more spans at Court, Sixth, and Center. By 1906, there were seven locations to accommodate traffic flowing back and forth across the river.

Saginaw had its setbacks, too. In 1883 a fire destroyed a large portion of the city. Major floods in the early 1900s caused problems for merchants and farmers, and the waning lumber industry took its toll on the economy.

Unlike other boomtowns, Saginaw found other ways to prosper. There was the salt industry which used sawdust to supply the fuel to process salt brine. Coal was discovered and coal mining became the area's main industry for a time. Next came the growing of sugar beets on the cut-over land left by the lumberjacks.

When the salt and coal industries were no longer profitable, a group of merchants joined together with the purpose of encouraging industry to come to Saginaw. The group consisted of such notable Saginaw names as Wickes, Huss, Jackson, Melze, Hanchett, Heavenrich, Eddy, Prall, Smart, Tanner, and Morley.

Many manufacturing plants were built in Saginaw, among them the plants of Jackson, Church, and Wilcox, which developed the revolutionary "Jacox" steering gear, the Erd Motor Company, and Eaton Manufacturing Company. General Motors located plants in Saginaw and brought many jobs to the area. During World War II the auto plants played a major role in the productions of weapons.

Today the lumber barons are gone, as are the once-thriving automobile and mining industries. But there is a new growth in the Valley. The downtown area is seeing a rebirth; old buildings are being restored and new ones are being built. The high-tech medicine, tourism, retail shopping, agriculture, and industrial jobs boast a renewed economy.

One
WASHINGTON AVENUE

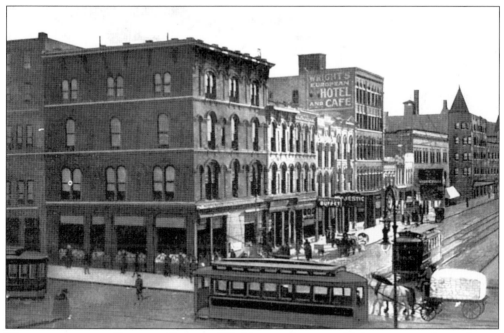

WASHINGTON AND GENESEE CORNER. Washington Avenue, with its streetcars, horse-drawn carts and busy shoppers, appears in this early post card. Seen here are a Buffet, the Majestic Theater, and Wright's European Hotel and Cafe. Located at 114–116 S. Washington, the Wright Hotel was one of the city's 38 hotels in this area. In the distance, the peak of the Vincent Hotel is also seen.

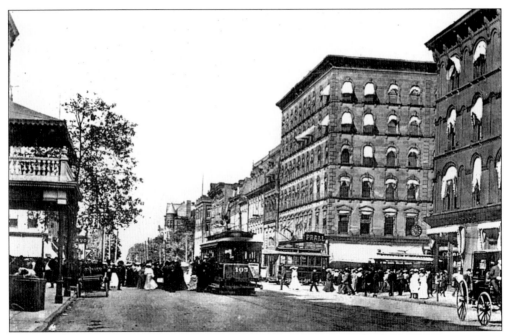

BUSY WASHINGTON AND GENESEE INTERSECTION. This was the busiest corner in East Saginaw. The streets were crowded with citizens, some strolling or shopping while others were boarding or alighting the many trolleys. The Bancroft House is on the left of the card, while Prall's Drug Store can be seen in the Eddy Building. Also in the scene are a horse and buggy and an early automobile.

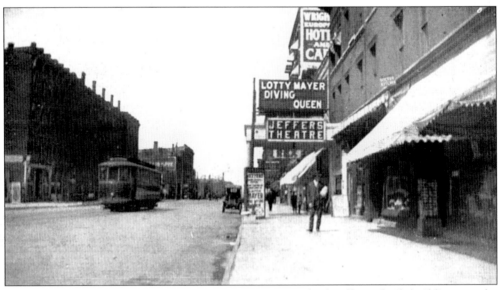

WASHINGTON AVENUE, JEFFERS THEATER. In 1902 Michael Jeffers rebuilt buildings on the north next to the Gas Building. The new theater completed here was named the Jeffers Theater after its owner. Entertainment here began with vaudeville, then stock plays, and in 1915, moving pictures. In 1917 the Jeffers returned to vaudeville entertainment. This card advertises the Jeffers Theater performance of Lotty Mayer, Diving Queen.

WASHINGTON AND CENTER STREETS. The busy corner shown on this card depicts early businesses, trolley service, pedestrians, and bicyclists. The large grocery is the business of Stanley J. Thompson. Located across the street were the American News Co., Fire Station No. 6, and Valley Metal Spraying Co. In the distance is the steeple of the Washington Avenue Presbyterian Church.

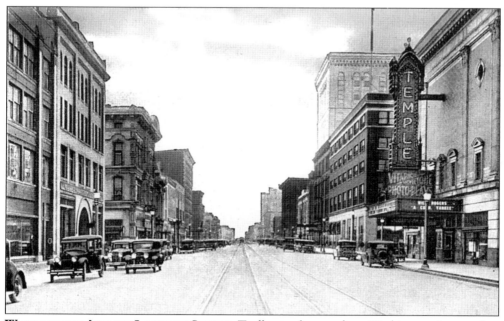

WASHINGTON AVENUE LOOKING SOUTH. Trolley tracks run along Washington Avenue, but the horses and buggies have been replaced with autos. The beautiful Temple Theater marquee is visible along with the ads for Vita Pictures, Movie Tone, and Photo-Plays. Currently playing is *A Connecticut Yankee* starring Will Rogers. Across the street is the Garber Cadillac Co.

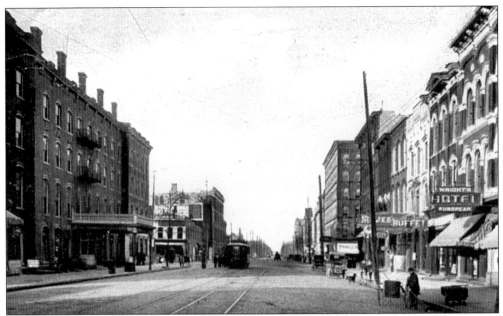

WASHINGTON AVENUE, WRIGHT'S EUROPEAN HOTEL. A devastating fire in the winter of 1918 destroyed the Wright Hotel. Guests at the Franklin Hotel in the block behind the Wright were routed from their beds as a precaution. Some of the Wright guests took cover across the street at the Bancroft Hotel, where Mueller Bros. opened their store to supply clothing to those wearing night clothes. Many of the firemen suffered from exposure to the extreme cold.

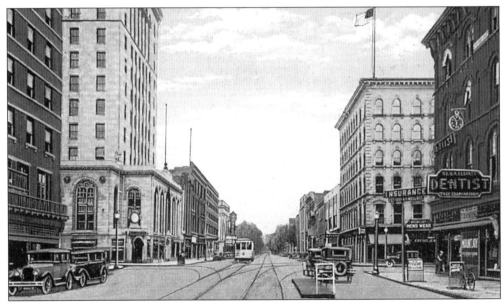

WASHINGTON AVENUE IN THE 1920s. The corner of Washington and Genesee shows the changes in the city. The Bancroft has been enlarged and the building across the street now houses an insurance office and a dentist's office. On the northwest corner is the tall Second National Bank Building. The trolleys are still being used, but automobiles have replaced the horse-drawn vehicles. To the north, the Temple Theater marquee can be seen.

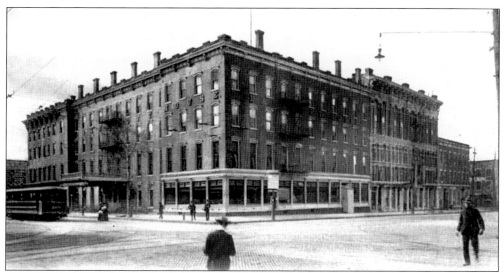

BANCROFT HOUSE. In 1858 Jesse Hoyt saw the need for a first-class hotel and thus began construction of a four-story brick building on the southwest corner of Washington and Genesee. The main entrance to the Bancroft House was on Genesee Street, with the ladies' entrance on Washington. The building held a dining room, a "shaving saloon," a billiard room, and suites heated with huge box stoves. There were gas lights in the rooms. Furniture and fittings were valued at $15,000.

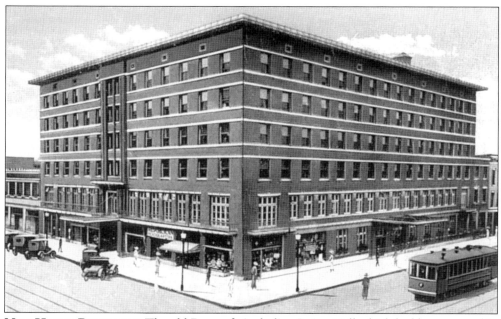

NEW HOTEL BANCROFT. The old Bancroft, including Irving Hall which had been erected in 1864, was demolished in September of 1915 and a new hotel building was constructed upon the foundation of the old. The new brick structure of six stories cost approximately $500,000. It contained 237 rooms, some with showers and some with only running water. The banquet hall was directly connected with the mezzanine balcony.

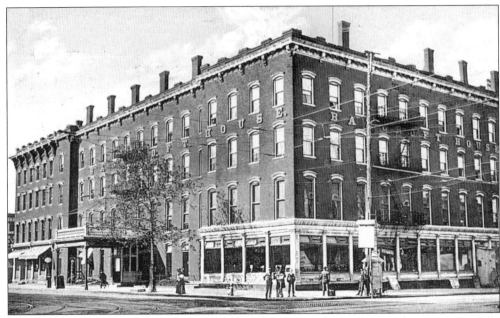

BANCROFT HOUSE HASH. Corned beef hash was one of the numerous items on the daily menu of the old Bancroft House. The hash became known far and wide and helped give the house its celebrity. In fact, Bancroft House hash could be obtained at several of the large hotels in New York City. Use 1c. chopped corned beef, 3c. chopped boiled potatoes, $^1/_4$c. butter, $^1/_2$c. milk. Stew in a saucepan over a slow fire. Brown in a frying pan.

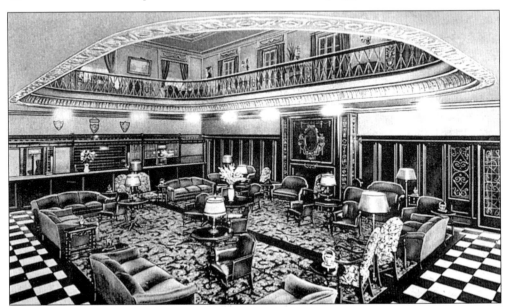

BANCROFT HOUSE LOBBY. The floor of the lobby featured a huge checkerboard of black and white marble along with a patterned carpet and plush furniture in the center. Entering from Washington Avenue, a short corridor led to the 35-by-70 foot lobby featuring huge panels of American walnut finished in edgings of gold. The fireplace was also elegant walnut trimmed in gold. The ceiling was made of frosted glass which admitted soft, diffused light to the floor.

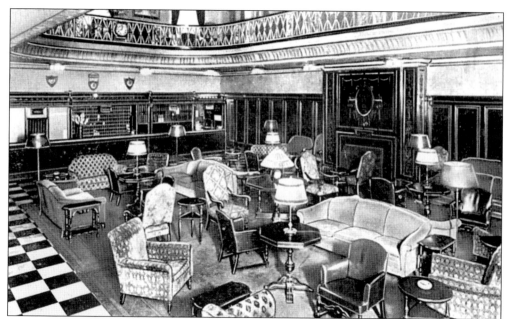

BANCROFT HOTEL LOBBY. When the Bancroft House was enlarged, the lobby was redecorated also. The patterned carpet was replaced with a tile-patterned floor and more furniture was added, making for an extremely crowded lobby. On the south side of the lobby were the desk, telephone booths, cigar and newspaper stands, entrances to the barber shop, coffee shop, telegraph office, billiard parlors, and roof garden.

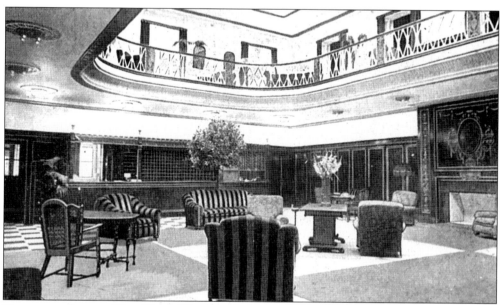

BANCROFT LOBBY, NEW VIEW. The crowded lobby was changed again. This view depicts a more spacious area, with fewer chairs, a writing table, and a bouquet of gladiolas on the center table. Visitors could enjoy the lovely fireplace in this setting. The heavy draperies on the mezzanine had also been replaced with lighter fabric.

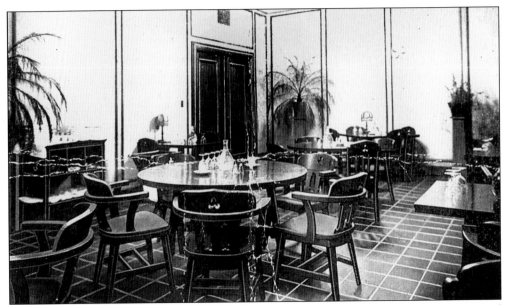

BANCROFT HOTEL, MEN'S CAFÉ. On the Genesee Avenue side was the elegantly appointed men's café, opening out onto the corridor which led from the ladies' entrance to the lobby. The cafe was richly decorated in white and gold, and the small-paned windows and large mirrors set in the opposite wall were exceedingly attractive features. At the west end of the cafe was a private dining room, stylishly decorated and furnished.

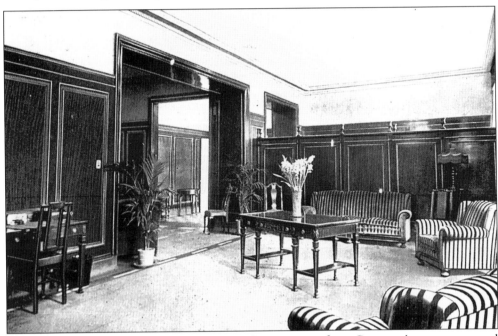

BANCROFT HOTEL, LADIES' LOUNGE. The ladies' entrance from Genesee Avenue connected with the ladies' rest room, elevators, and lobby. The lounge's comfortable plush furniture sat on a light carpet. The walls were paneled with American walnut trimmed in gold. There was a desk and table also of beautiful walnut. The ample room afforded the ladies a lovely place to relax.

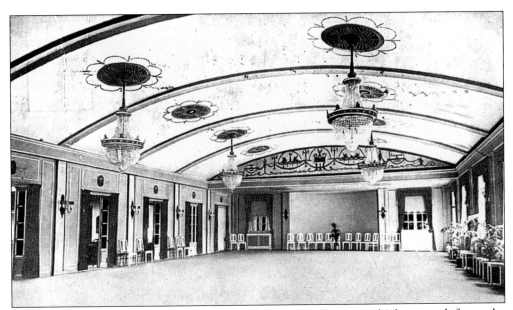

HOTEL BANCROFT BALLROOM. The banquet and ballroom, which opened from the balcony, were magnificent in finish and decoration. The walls were soft tones of white and gold with touches of pale blue and deep pink tints. At each entrance or doorway hung red plush curtains which added a pleasing effect to the walls. From the arched ceiling hung four exquisite electric chandeliers of Austrian glass suspended by crystal fixtures. (Courtesy of the Wm. J. Culver Collection.)

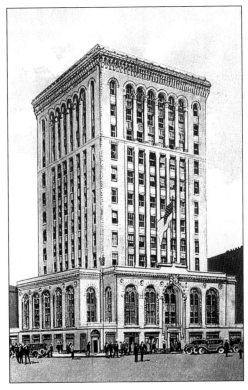

SECOND NATIONAL BANK. The bank, located at 101 N. Washington, was built in 1925 and displayed the opulence of the times. It had vast arched windows, stone griffins, romanesque columns, and terra cotta surfaces in the interior. Each year on Christmas Eve, the employees would gather in the lobby to sing Christmas carols. A former girl scout remembers singing with her group from the roof of the building.

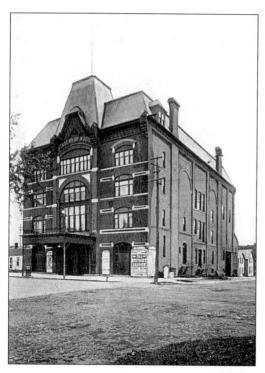

THE ACADEMY OF MUSIC. This fine brick building located on the northeast corner of Janes and S. Washington featured its first performance on Dec. 16, 1884. The auditorium had a seating capacity of 1,200 and was noted for its fine acoustics. It hosted numerous famous stage stars, including Sarah Bernhardt. In April of 1917 it was destroyed by fire, which started on the stage. Also destroyed was the drop curtain, which was painted by the Michigan artist Robert Hopkin.

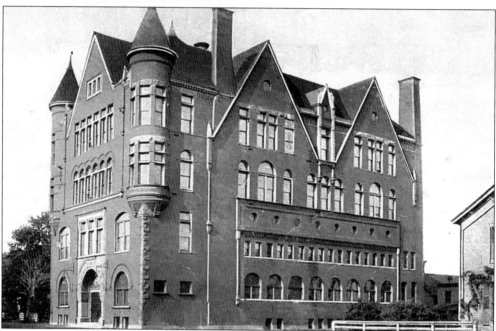

MASONIC TEMPLE. The red brick and stone building of the East Saginaw Masons Lodge was located on the corner of Washington and Johnson. The charter was granted in January of 1856 and the lodge was dedicated on February 27th. The four-story structure cost $175,000 and had an auditorium with seating for 1,200. It was well furnished and lighted with gas. Today it is the site of the County Events Center.

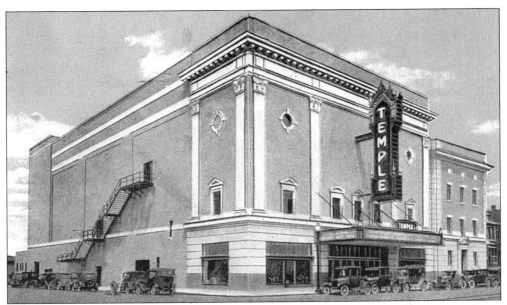

TEMPLE THEATER. The Temple Theater on Washington Avenue was built in 1927 and cost $1 million. It was the largest theater in Michigan outside of Detroit and was owned by the Elf Khurafeh Shrine who leased it to the Butterfield Theaters. Along with the equipment necessary to show movies, it housed a remarkable theater organ which cost $12,000. Today it is the oldest running theater organ in Michigan. The Temple, after extensive restoration, was again opened in November of 2003.

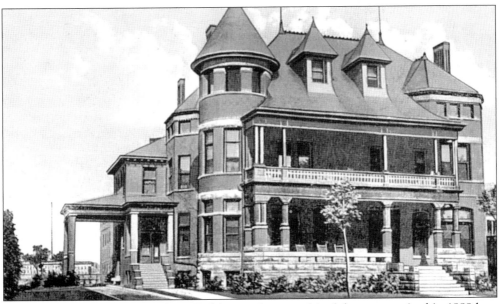

THE SAGINAW CLUB. Located on Washington Avenue, this club was organized in 1889 by a group of 47 business and civic leaders. The initial cost of the building including heating and lighting was $25,000. In 1905 it was enlarged to add a grill room and a roof garden. The building contains many art treasures and oil paintings. There is a large portrait of Shopenagons, the noted Indian chief, done by E. Irving Couse, a well-known Saginaw artist.

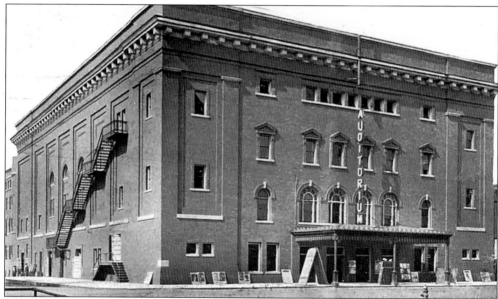

AUDITORIUM. W.R. Burt bought out the Simpson Grocery Store on the corner of Washington and Janes for an auditorium to be built across from the Academy of Music. In October of 1908 the 4,000-seat building was dedicated, and was the entertainment center for Saginaw until it was demolished in 1972. A multitude of stars performed there during its heyday, and children delighted in watching the Shrine Circus when it came to town.

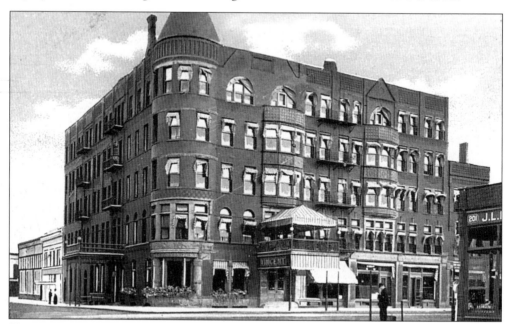

THE VINCENT HOTEL. This five-story brick and stone building, at Washington and Germania (later Federal), was one of the most attractive hotels in Michigan with the most inviting and spacious lobby in the city. Erected in 1890 by Arthur Hill and James Vincent, there was nothing in the hotel which was second-class or passe. The hotel provided private baths, beautiful parlors, smoking rooms, and efficient elevator service.

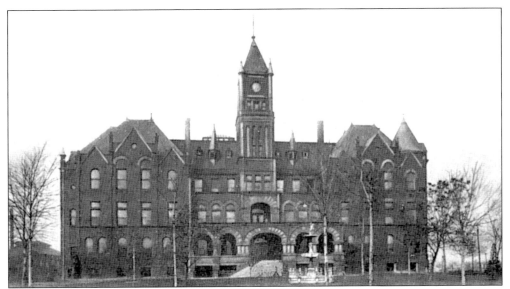

OLD CITY HALL. After the two Saginaws were consolidated, a City Hall was built on the corner of Washington Avenue and Bristol Street. It was a large structure made of brick and stone and was completed in 1893. In 1935 the building was completely destroyed by fire. People stood for hours watching the firemen battle the blaze. Some would leave for a time and return later to resume watching.

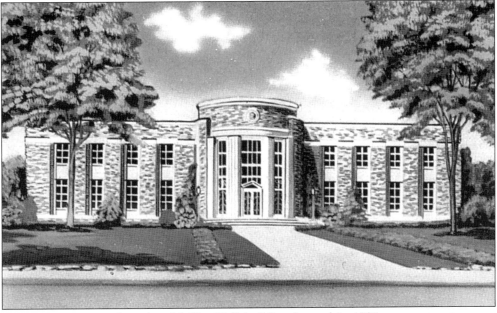

NEW CITY HALL. When the old City Hall building burned in 1935, a new structure was needed and a new form of government was introduced. Since this time, the business of the city has been performed by a city manager-council type of government. With a short, concise charter the government attends to Saginaw's growth through its business and industries.

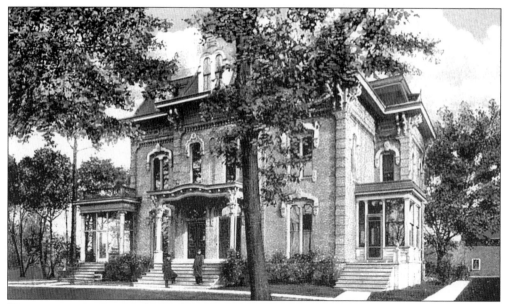

HOME FOR THE AGED. This buff-colored brick mansion located at 1446 S. Washington was built in 1872 by T.B. Corning at a cost of $25,000. It originally consisted of two houses, but was made into one with 43 rooms when it became the Home for the Aged. In its heyday it was furnished with beautiful works of art symbolic of the times. Many art treasures in the home were donated by former residents. The "home" is no longer used as a residence for the elderly.

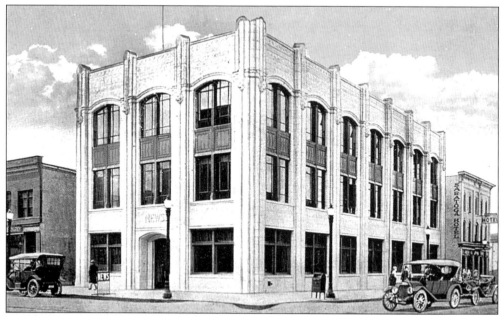

THE SAGINAW DAILY NEWS BUILDING. This impressive three-story building constructed of white terra cotta, brick, and concrete opened in September of 1916 on the corner of Washington and Germania Avenues. The spacious lobby featured a mosaic tile floor, oak counters with a marble base, and a ceiling finished in tints of old gold. The sprinkler system made the building nearly fireproof. Offices were on the second floor and an auditorium on the third.

FOREST LAWN CEMETERY. In 1881 the city saw a need for another cemetery, as the lots in the Brady Hill Cemetery were nearly gone. Forest Lawn was opened in 1882 at 3110 S. Washington, a year after the city acquired 98 acres of farmland from D.W.C. Eaton for $17,000. This cemetery contains some of the finest mausoleums in the state.

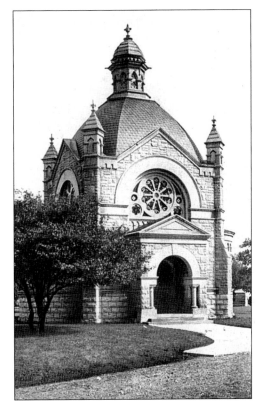

FOREST LAWN CEMETERY CHAPEL. At the entrance to the cemetery sits a large chapel constructed of limestone bricks and featuring a circular stained glass window. The chapel formerly contained records for all three city cemeteries: Forest Lawn, Oakwood, and Brady Hill.

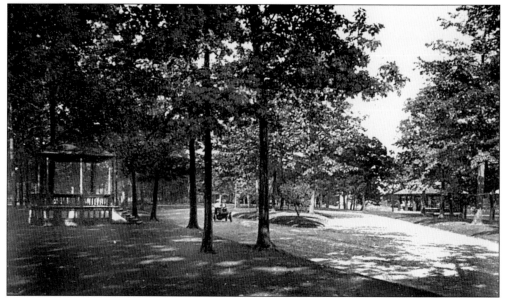

HOYT PARK. New York businessman Jesse Hoyt willed 27 acres to the city in 1883. Homeowners in the Grove area on S. Washington purchased the property across the street from their homes in 1919 for the city park system, increasing the size of Hoyt Park to a square mile. The park enjoyed great popularity among skaters from the turn of the century into the 1960s. In 1937 skaters could skate to music under the lights.

FIELD HOUSE AT HOYT PARK. The property on S. Washington was formally owned by the Darmstaetter Brewery. The brewery was destroyed by fire in 1913. For years children played games in the storage cave and the property was used for storing city parks equipment. A Works Progress Administration crew discovered the brewery's underground vault in 1938 and salvaged the stones to build a shelter house at Hoyt Park.

Two
GENESEE AVENUE

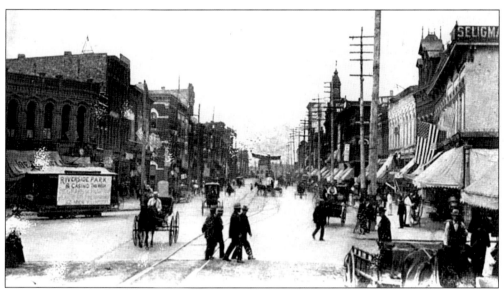

GENESEE AVENUE WEST FROM LAPEER STREET. This postcard of a busy day along Genesee Avenue in summer depicts crowds of pedestrians and the streets full of horse-drawn buggies. The trolley carries a sign advertising what is happening this week at the Riverside Park and Casino. Appearing along with others are "32 Michigan Volunteers." Notice the Seligman sign on the building on the right.

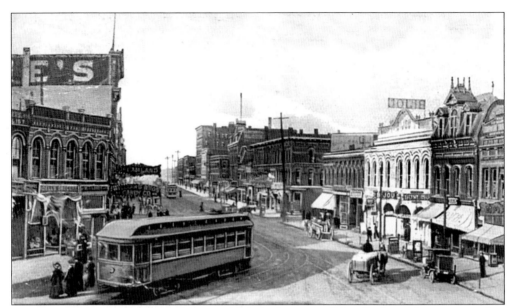

GENESEE WEST FROM TOWER BLOCK. This is the area of East Saginaw that was so often flooded. The trolley is turning onto Jefferson Avenue past Pendell's Grocery. This popular store sold fresh produce and fresh venison. A customer could purchase a whole deer which had been cleaned out and placed on the walk in front of the store. Across the way was the Bijou Theater where many vaudeville acts performed.

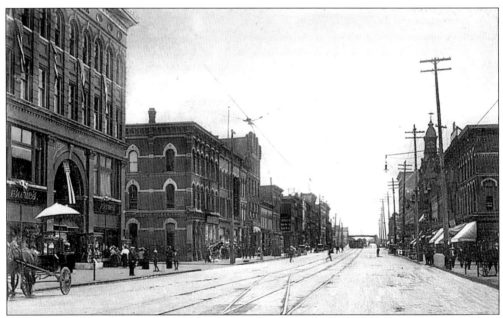

GENESEE AVENUE LOOKING WEST. Many businesses were located in this busy area of East Saginaw. The Barie Dry Goods Store on the corner of Baum Street is shown on the left. In later years the building housed the Montgomery Ward store. Across Baum Street was the Bank of Saginaw. In the same block was Seitner's Clothing Store. In the distance the trolleys appear. (Courtesy of the Wm. J. Culver Collection.)

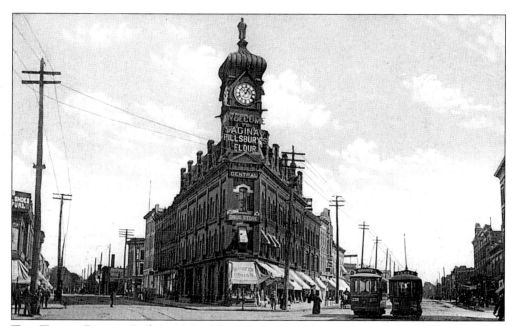

THE TOWER BLOCK. Built in 1859 at the intersection of Genesee, Jefferson, and Lapeer, the former Music Block was an impressive building with a large hall on the top floor that was used for lodge meetings, plays, and musicals. It was purchased by Jacob Seligman from Michael Jeffers in 1890 and the name was changed to the Tower Block. A clock with four faces was purchased for $9,000 by Seligman and known as "Little Jake's Time."

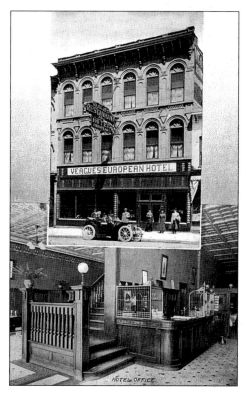

VEAGUE'S EUROPEAN HOTEL. On the north side of Genesee between Washington and Water Streets was Veague's Restaurant and Hotel. A three-story building, it featured an impressive lobby and office and was one of the popular places for travelers in the early 1900s. In 1903 W.C. McClure treated Saginaw firefighters to breakfast there after the men battled a blaze at his barn.

27

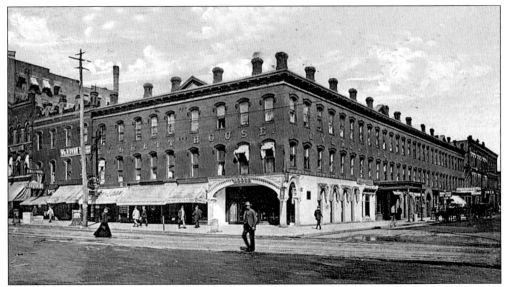

EVERETT HOUSE. There was no house in Michigan better known by the traveling public than the Everett House of Saginaw, at Genesee and Franklin. It was located in the heart of the city, furnished with steam heat, electric lights, private baths, sample rooms, spacious lobby and office, 65 comfortable bedrooms, and the best dining room in the country. The house was a home for the commercial traveler. The proprietor, Frank M. Totten, provided wholesome well-cooked food and plenty of it. There was no better hostelry in the U.S. for the price than this hotel.

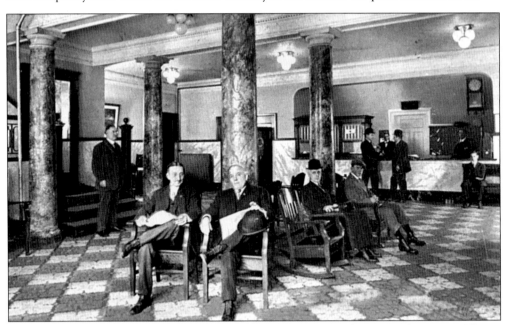

INTERIOR OF EVERETT HOUSE. One of 53 hotels in Saginaw in the 1880s, the Everett House was one of the "grand hotels." It displayed the extravagance of the moneyed lumber barons and was popular with lumberjacks as well. After it was remodeled in 1878, it had 30 hotel rooms and a livery stable. When the shanty boys came to town, they looked forward to their first baths in months at the Everett House.

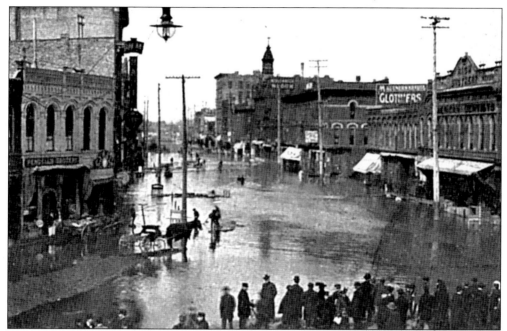

FLOOD OF 1904. The flood of 1904 was the worst in a long series of wet disasters. The river crested at six feet over flood stage. Following a very cold winter with no thaw, it began with an ice jam during the spring breakup and gained strength from an April blizzard. The flood raged for eight days, bringing downtown Saginaw to a standstill. Hundreds of spectators lined the banks of the river to watch the waters rise and ice chunks float by at six miles per hour.

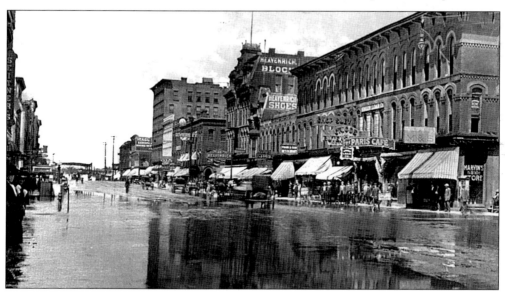

FLOOD SCENE, 1912. The floods of 1912 saw the river return with a vengeance as it crested to 24.1 feet. The May flood put the river at the third highest elevation recorded in the century. Work crews began dredging the Saginaw River to deepen and widen it as other workers raised street grades near the river banks. The hordes of mosquitoes that hatched in the standing waters were an additional nuisance to the residents.

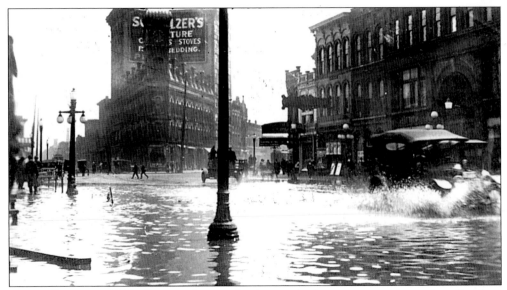

HIGH WATER IN 1916. Genesee Avenue businesses had to put up with another flood on March 30, 1916. Here the early cars and trucks drive through the flood waters past the Barie Dry Goods Store. The flood did not reach the Tower Block where crowds gathered to watch the water rise. Raised plank walks allowed pedestrians to walk above the water. (Courtesy of Pat Stoppleworth.)

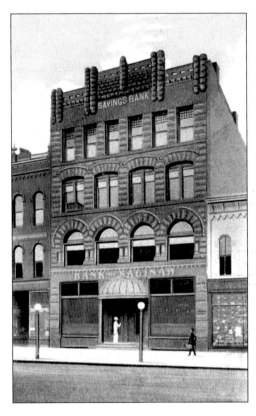

BANK OF SAGINAW, EAST SIDE. Located at 310–312 Genesee Street, this bank was organized in 1872 and was one of the features in the building up of the city. It was equipped for general banking business and received deposits from $1 and up, paying three percent interest. Its capital stock was $100,000, with deposits of $3,003,078. President of the bank was Dr. H.C. Potter, a prominent Saginaw physician.

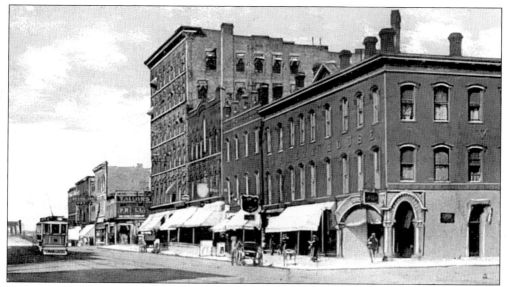

GENESEE AVENUE LOOKING WEST. A trolley is traveling east along Genesee past the shops on the north side of the street. The shops whose awnings shielded both storefronts and pedestrians included a liquor store, a clothier, and a drug store. The tallest building is the Crouse (later the Eddy) Building. On the east corner was the elegant Everett House. Little Jake, along with three partners, purchased the hotel from the Crouse estate for $45,000. They renovated and reopened it in May of 1878.

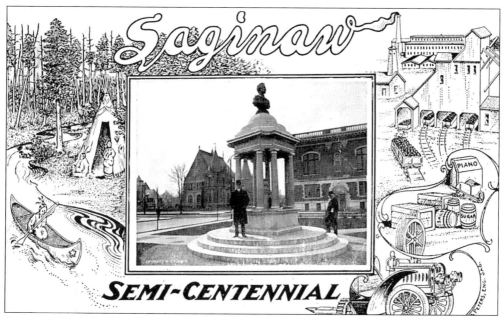

SAGINAW SEMI-CENTENNIAL. Many cards were produced to advertise the 1907 centennial. All cards had the same border format featuring sketches of the history of the area. This card shows the Indians who lived at the convergence of the rivers at Green Point. The teepee, however, was not true to their dwellings. Coal, sugar, salt, early automotive and the Germain piano industries were represented also. Many local scenes were inserted in the center of the cards.

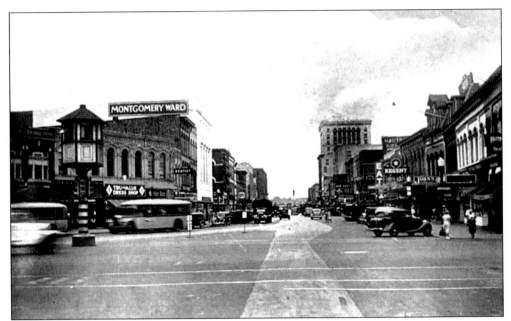

GENESEE AVENUE WEST FROM JEFFERSON. The trolley tracks are gone, as are the horse-drawn vehicles. This scene in the early 1940s shows the buses, trucks, and cars of the era. There is a traffic tower at this busy three-street intersection. The buildings remain, but the businesses have changed. Montgomery Ward has replaced Barie's; the "Eat" sign is for the Home Dairy, and in the distance is the tall Second National Bank.

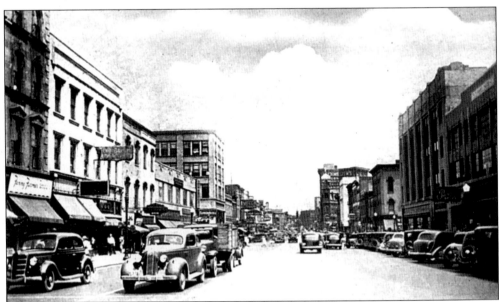

GENESEE AVENUE EAST FROM WASHINGTON. Shown here is another scene of Saginaw's busy downtown in the early 1940s. Many businesses thrived along these streets. On the left are Fanny Farmer Candies, Diebel's Department Store, Cunningham's Drugs, and the Mecca Theater. The buildings on the right housed Woolworth's 5 & 10 and Seitner's Dress Shop. Angle parking accommodates the many vehicles. In the distance the Tower Block can be seen.

Three
EAST SIDE SAGINAW

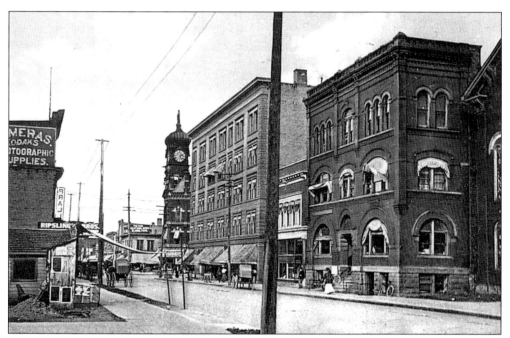

JEFFERSON AVENUE. The buildings pictured here are long since gone. On the right of the picture are the Avery Building (later the Wiechmann Building), the Courier Herald Building, and the People's Building & Loan Assoc. at 118 S. Jefferson. Across the street was Danforth's Kodak photo studio, located at 115 S. Jefferson. Prall Drugs was also here before it moved to the corner of Washington and Genesee.

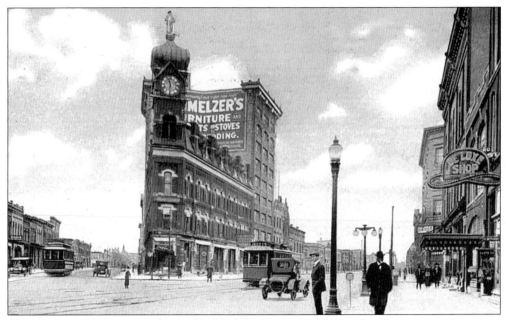

SCHMELZER'S FURNITURE. Located behind the Tower Block was the nine-story structure on Genesee built in 1912 by John Schmelzer. It was the site of the John Schmelzer Furniture Store. In addition to furniture, Schmelzer's sold stoves, talking machines, and records. In 1961 the firm of Henry Feige & Son moved from Baum Street into this building at 513 Genesee. By 1983 the cost of maintaining the nine stories became prohibitive, and Feige's moved to Saginaw Township.

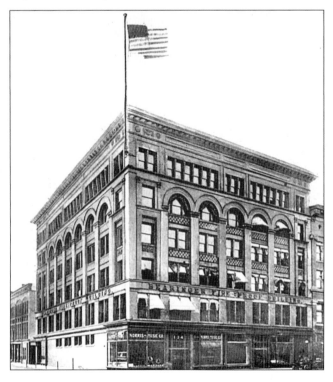

BEARINGER BUILDING. Isaac Bearinger, who made a fortune in lumber and real estate, built the "Bearinger Fireproof Building" in 1881–1882. Located on the corner of Franklin and Tuscola, it was a six-story ornate brick and steel structure. The first floor was occupied with retail stores and the upper floors with offices. Today the building features original marble and tile flooring, oak trim, and brass fixtures. A large skylight in the roof allows light into the center of several floors, an area that once was an atrium. The 123-year-old building has been purchased with hopes of renovating it. (Courtesy of the Wm. J. Culver Collection.)

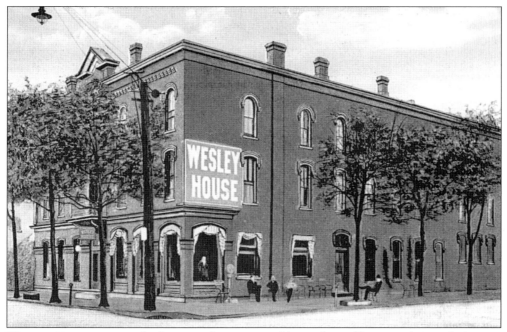

WESLEY HOUSE. Formerly the Naegely House and located at Jefferson and Tuscola Streets, this is another of the old-time hotels. It was a rendezvous for lumberjacks and river men, in the days when life in Saginaw was rendered indescribably lively and boisterous by the "red sash brigade."

ARBEITER HALL, EAST SAGINAW. This German workingmen's association was organized in August of 1869 at Janes and Fourth Streets. To increase membership, it was consolidated with the musical German Young Maenner Club. The object of the club was to assist members when sick, and to help with funeral expenses for members or spouses. The entrance fee was graduated according to age, from gratis to $7. Monthly dues were $1.

35

ELKS TEMPLE. The Elks Club bought the site on the corner of Germania (now Federal) and Warren in 1904 for $5,000. The location was formerly the home of William and Nancy Webber. The building's cornerstone was laid August 18, 1906. The two-story structure was built of paving brick and cut stone with a high basement. It was equipped with bowling alleys, billiards and pool rooms, a grill, a reading room, and a library.

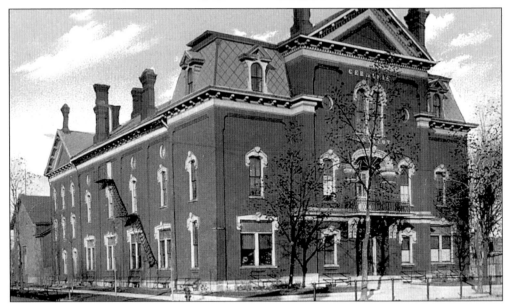

GERMANIA OF SAGINAW. The society founded by twelve German-Americans in 1856 purchased the block located between Tuscola, Lapeer, Third, and Fourth Streets. According to the first constitution, the object of the society was to improve the spiritual and physical welfare of its members, as well as to offer social entertainment. A large modern three-story building was built in 1877 at a cost of $11,000. The main floor consisted of an entry hall, library, reading room, committee room, tap room, and dining room. The new club is now located at the end of Wheeler Street at 1 Germania Platz.

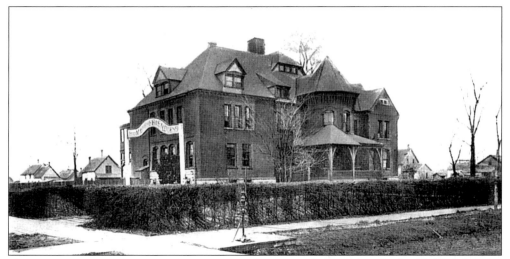

HOME OF THE FRIENDLESS. In 1870 a group of women who were involved with local charities met together and organized an association to establish and control a Home for the Friendless. It was formed to care for infants and children who were orphans or whose parents found it convenient or necessary to place them out of their homes while they were at work. Situated at the corner of Howard and McCoskry Streets, it was a brick structure surrounded with ample playgrounds for the children. On average there were 80 to 100 children cared for each year.

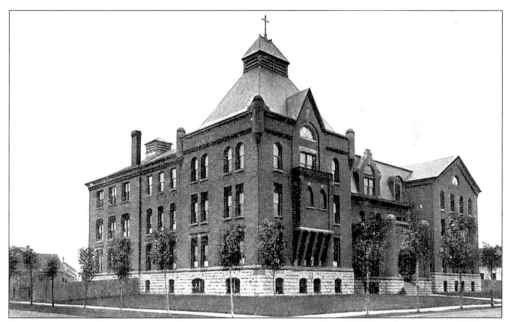

ST. VINCENT'S ORPHANAGE. This institution was founded in 1875 by the Sisters of Charity of St. Vincent de Paul. A wooden building on the corner of Howard and Emerson Streets, it had ample playground space for the children. On May 20, 1893, the great fire in Saginaw entirely destroyed both the home and its contents. A more substantial structure was built on the site of the old one and was opened in 1895. There were about 100 children cared for by nine Sisters. Most of the income needed for the support of the home was derived from the annual banquet on Washington's Birthday sponsored by Catholic women.

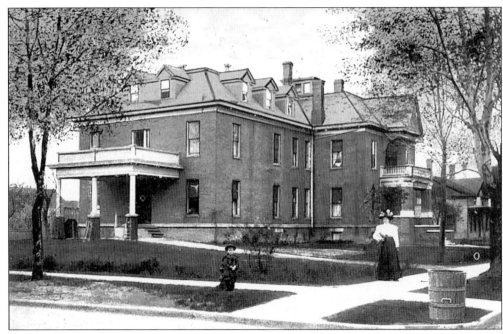

WOMEN'S HOSPITAL. This hospital was situated on the corner of Janes and Seventh. It was established in 1888 by prominent women of the city for the care of women and children. A training school for nurses also operated there. Lumberman W.R. Burt contributed much of the financial support for the hospital. In 1901, after extensive remodeling, an opening day and reception was held for guests. In addition to the wards, six new apartments had been furnished by the city's churches and societies.

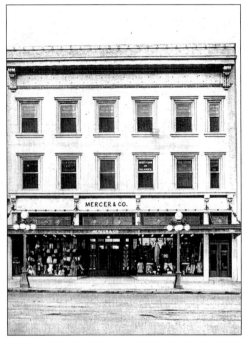

MERCER & COMPANY. In the 1920s this business was located at 209–211 Genesee Avenue. Located on the ground floor of the three story building, it was advertised as a leader in "Clothing, Hats and Gents' Furnishings." The upper floors of the building housed a ladies' tailor shop, a real estate business, and two loan companies, among others.

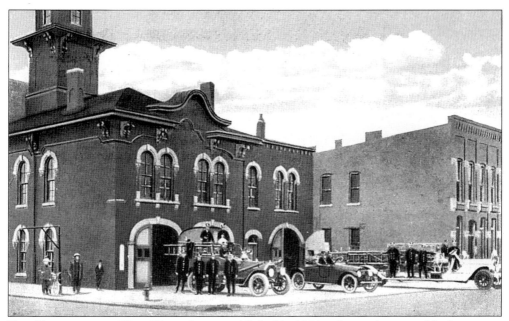

FIRE DEPARTMENT. Hose House 3 was established in 1866 and served as a notable downtown landmark for years. It was to be moved to the new Central Station in 1938. At one time, Hose House 3 had been considered a possible location for an American Legion Post which had been left homeless by a fire. In August of 1910 a checker tournament with Canadian players was held here, for the Hose House was the headquarters for local checker players.

SECOND NATIONAL BANK. Singing from the rooftop of the bank building in 1937 were 50 "sky carolers." These Girl Scouts made their way to the top and serenaded downtown shoppers on the Saturday before Christmas. In 1947 there were 300 singers, so the Bancroft Hotel's Crystal Room hosted the carolers. Amplifiers atop the hotel and bank carried the music through the shopping district.

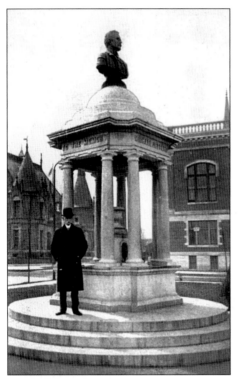

JEFFERS FOUNTAIN. John Jeffers created a park in the center of the downtown business district to honor the memory of his brother, Michael Jeffers, who had done so much to build up the city. John Jeffers soon erected a lasting monument, in the form of a large and ornate drinking fountain supplied with crystal water from a deep well close by. The park was heavily frequented by the public. This card pictures John Jeffers on the steps which surround the fountain. At the top of the fountain is the bust of Michael Jeffers.

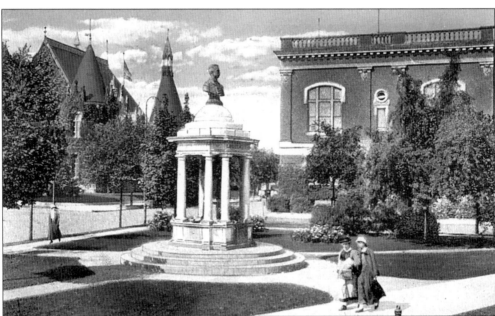

JEFFERS PARK. At the triangle intersection of Genesee, Germania (now Federal), and Warren Avenues there was a small park laid out with shrubs and flowers. In order to leave a fitting memorial to his brother, Michael Jeffers, John Jeffers and his niece, Elizabeth Champe, cleared the ground and converted it into an attractive little park. The park was situated almost in the center of the east side business district.

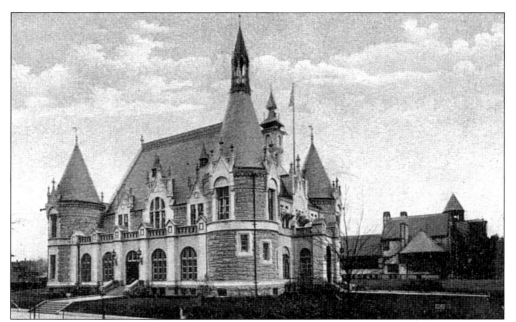

CASTLE BUILDING. Many scenes are available of this historic Saginaw building. It was constructed as a post office in 1897, and patterned after a French Chateau complete with gargoyle rain spouts on the roof. On July 4, 1898, it was opened to the public. It was completely rebuilt and enlarged in 1937 and named the "Federal Building." In 1976, for the price of $1, it became the property of Saginaw County. Today it houses Saginaw's Historical Museum.

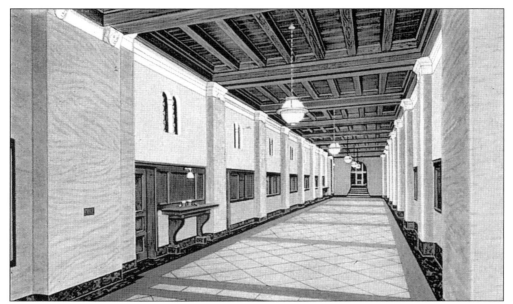

POST OFFICE INTERIOR VIEW. The original lobby was located on the north wall of the building. At the end of the lobby was a circular staircase, which was completely sealed off during the renovations of 1937. Today the beautiful staircase can be seen again. A staircase leading to an upper hallway allowed inspectors to look down through peepholes at the lobby and the post office workers. Today the building is on the National Register of Historic Places.

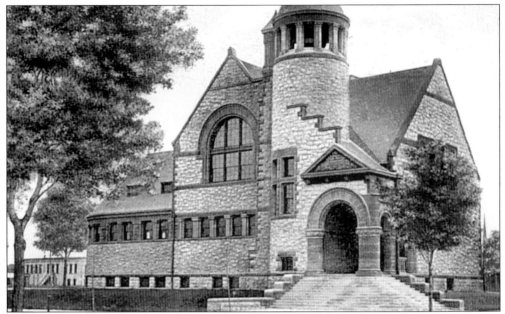

HOYT LIBRARY. Jesse Hoyt, one of the men responsible for the development of East Saginaw, provided for a circulating and reference library to be established in his name. The library, located at 505 Janes, opened for use in 1895. An addition was built in 1920. Clauses in Hoyt's will separated the reference library and the Eddy Genealogical and Historical Collection from the rest of Saginaw's libraries. The building, an example of Richardsonian Romanesque architecture, displays massive outer walls of limestone from the Bay Port quarries with carved trim of red sandstone from Lake Superior.

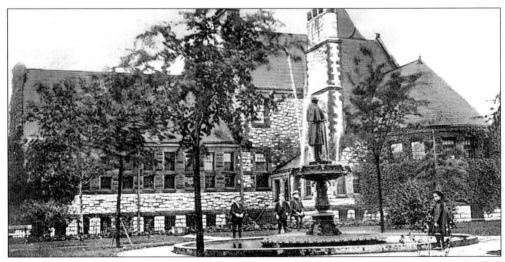

FEDERAL PARK. Between the Federal Building and Hoyt Library was a plot of ground called Federal Park. The park was owned and maintained by the U.S. government, which gave the use of the park to the city free of cost. In the center of the park was a soldiers' monument and fountain erected by Aaron T. Bliss as a memorial to his fallen Civil War comrades. The statue was later moved to Bliss Park and the park area is now a parking lot for the Castle Museum of Saginaw County History.

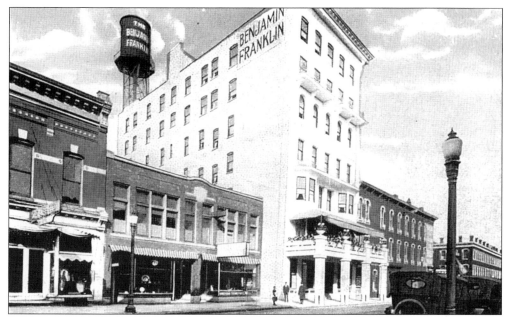

BENJAMIN FRANKLIN HOTEL. This hotel on Franklin Street was seven stories high and had 125 rooms. The facing of gray stucco with an ornamental pillared porch, iron railings, and latticework with hanging baskets of flowers and ferns gave an impression of distinction to this East Saginaw street. The tile lobby floor, the wainscoting of white marble, and the rich tapestry-upholstered furniture placed on oriental rugs offered comfort to the visitor.

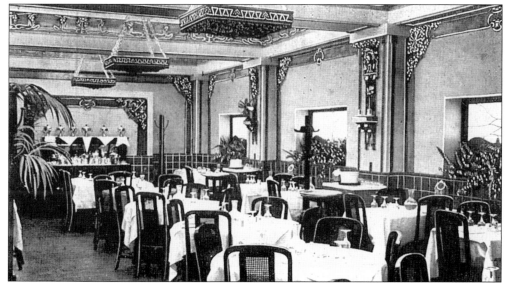

BENJAMIN FRANKLIN GRILL. The Franklin Hotel was completed and opened to the public on July 5, 1915. At 6:00 in the evening, the first dinner was served in the attractive grill room. The room was furnished with mahogany chairs placed at tables for four. The upper walls and ceiling were decorated in light bronze tone relieved with gold and the hanging light fixtures featured decorative grill work.

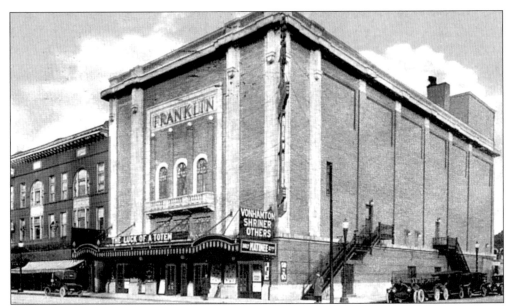

FRANKLIN THEATER. The businessmen of S. Franklin Street formed a company in 1914 and erected the fireproof Franklin Theater at a cost of $120,000. The theater was opened to the public on the night of February 22, 1915, with a vaudeville performance. The theater was leased to the Butterfield Syndicate, and after extensive alterations to improve the acoustics and make the house more comfortable, it was opened to vaudeville enthusiasts. The entertainment was later changed to moving pictures.

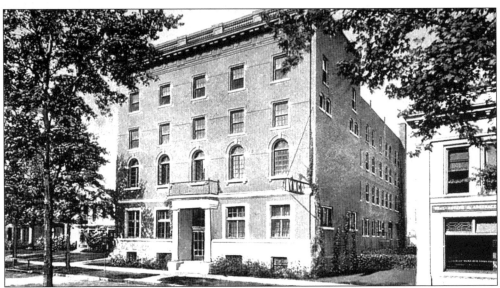

YWCA. The YWCA had many locations in Saginaw's early days. In 1905 land was purchased on S. Jefferson Avenue for the building of a YWCA. Saginaw residents donated money for this purpose, with Wellington R. Burt giving $25,000. The three-story building constructed of Saginaw brick featured pillars at the entrance. The cornerstone was laid in 1912, and the building served Saginaw until it was razed in 1965. In 1963 the YWCA moved into a new building at 600 S. Jefferson.

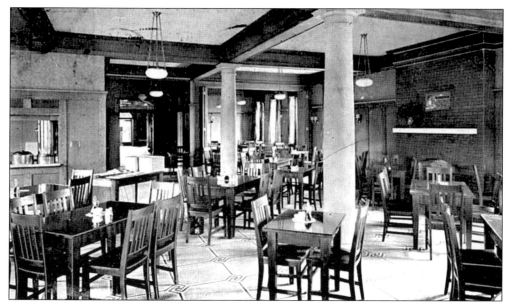

YWCA Cafeteria. The new YWCA was constructed on S. Jefferson Avenue, opposite Federal Park. The cornerstone was laid on June 6, 1912, with a gala ceremony. A cafeteria in this building was open to the public. Many East Saginaw working women were delighted with their new YWCA and enjoyed their lunch in this dining room, which featured sturdy wooden tables and chairs, a tile floor, and a brick fireplace. (Courtesy of George Barrett.)

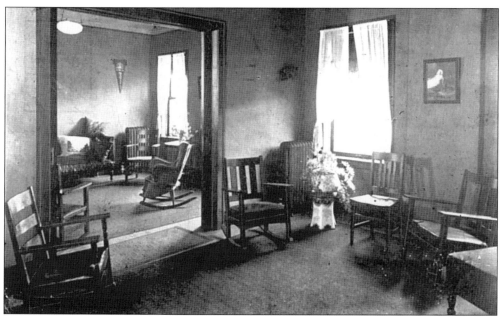

YWCA Bible Club Rooms. The first floor of the new YWCA had a broad hall leading to the stairway. To the right were the reception and reading rooms. Wellington R. Burt's donation ensured the building was well equipped for the needs and enjoyment of the women of Saginaw. The Bible room displayed comfortable furniture where girls could relax after a work day or after lunch in the cafeteria. (Courtesy of George Barrett.)

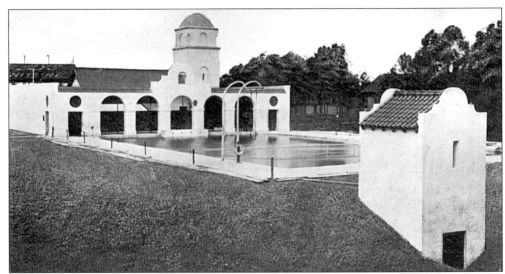

MERSHON-WHITTIER NATATORIUM. In August of 1910, a pool was built and presented to the city by Edward C. Mershon and Charles Merrill & Co. It was a memorial to Augustus H. Mershon and Joseph A. Whittier, both of whom were esteemed citizens of the city. The site for the pool was on the old Whittier Mill property at the west end of the Johnson Street Bridge. In 1914 the attendance was 28,877, of which 5,418 were women and girls who used the pool only on Tuesdays and Thursdays.

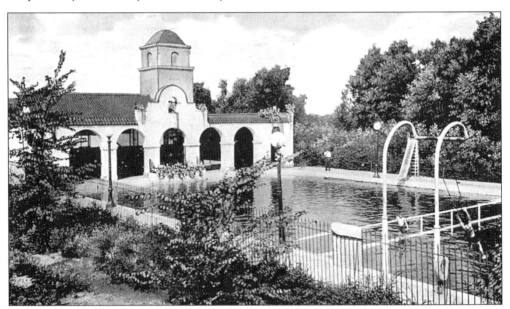

MUNICIPAL BATH HOUSE. The Mershon Pool was often referred to as the Municipal Bath House. The city furnished river water for the filters and maintained the operation of the pool. The concrete basin had two sections; the first had a depth of 18 inches to four feet, while the other was eight feet deep. The sections were divided by a concrete wall to keep non-swimmers out of deep water. The small charge for towels, bathing suits, and lockers provided revenue of about $500 each season. In 1914 the pool was in use for about six hours daily and used 47,500 gallons of filtered water each day.

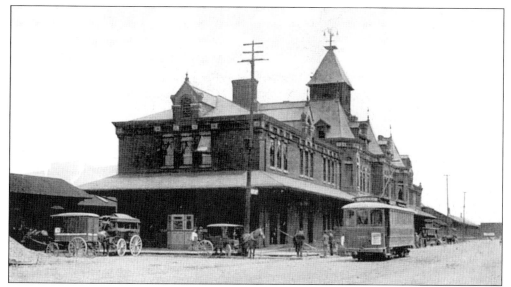

PERE MARQUETTE DEPOT. In the early 1900s this station on Potter Street was one of the busiest areas of the city. Here the shanty boys arrived on trains after spending a long season in the lumber woods. It was said that when the boisterous shanty boys arrived, most of the trains' windows had been broken. Along with the trolley, horse-drawn wagons and carts arrive to load and unload merchandise. Dr. H.C. Potter was one of the founders of the Flint and Pere Marquette Railroad. The Potter Street Station was named for him.

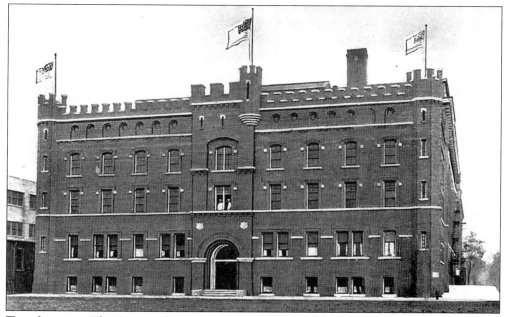

THE ARMORY. The Armory, located on Water Street at the foot of Janes and facing Battery Park, was erected in 1909. Still standing, it is a solid structure of paving brick and concrete. Originally there were spacious club rooms, a system of lockers, and a four-inch rapid firing rifle for practical instruction in the handling of big guns. On the waterfront was a boat landing, where small boats of the division were kept.

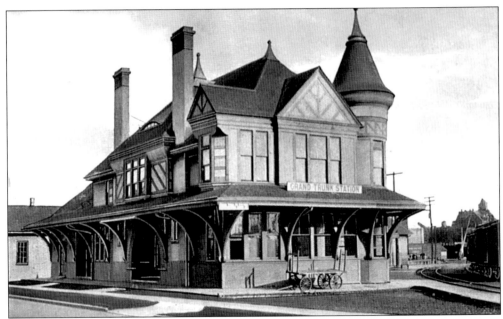

GRAND TRUNK DEPOT. From this location on Washington and Thompson Streets, passengers could take a ride on the Cincinnati, Saginaw and Mackinaw train to Port Huron. The trip east took about three hours. In 1900 a great crowd assembled at this station to welcome home Colonel Aaron Bliss who had been selected as the Republican candidate for governor of Michigan. In the 1940s, soldiers left from this station for duty in World War II.

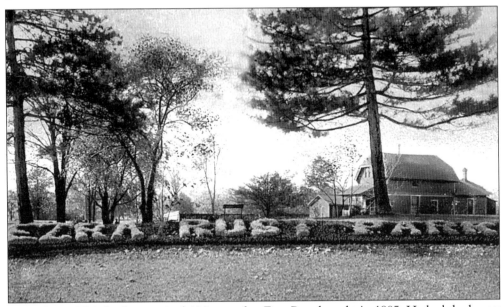

RUST PARK. This land comprised 136 acres that Ezra Rust bought in 1905. He had the bayou there drained and enlisted crews to clear the brush along S. Washington for a park. The park comprised land between the river and Washington, and included Ojibway Island. Rust recommended that the high ground at Washington and Court (now Ezra Rust Drive) be known as Mound Hill because of the Indian burial mound there.

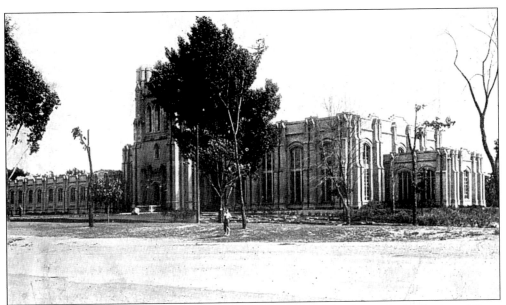

Saginaw Water Works. Looming large in the Rust Park landscape is the Saginaw Water Works building displaying beautiful Gothic architecture. Quarried limestone makes up the outer walls with carvings on the tower and sides relating to the history of the site. Inside cross vaulted ceilings, rust colored tile floors, and high arches can be seen. Oil paintings on the walls depict historic local events.

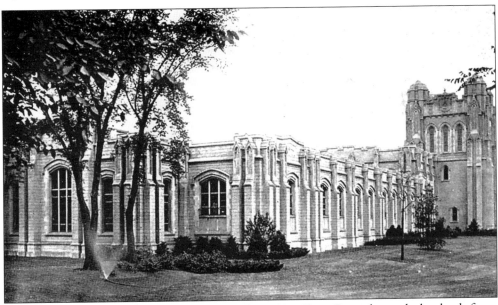

Saginaw Filtration Plant. In the early 1900s, Ezra Rust donated the land for a consolidated water plant to serve East Saginaw and Saginaw City. He offered a site south of the present facility, as he did not want the Indian burial grounds disturbed. His proposal was rejected and the filtration plant was only completed much later, in 1929. The water source was the Saginaw River. Corner pumps supplied household water until 1948 when Lake Huron water was delivered from Whitestone Point.

LAKE LINTON. The reservoir adjoining the Saginaw Water Works holds water waiting to be treated at the plant. The reservoir was named Lake Linton for the former mayor, William Linton. Before 1948, water was taken from the Saginaw River. Now water is drawn from Lake Huron at Whitestone Point and transported to the Saginaw Water Treatment (Filtration) Plant through large transmission mains. Each day millions of gallons of water are treated and pumped for distribution in the Saginaw area. Residents no longer have to rely on corner pumps for their drinking water.

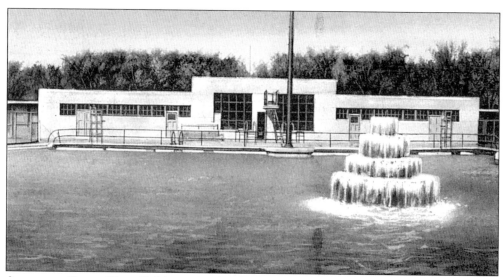

ANDERSEN POOL. The official opening for the $130,000 outdoor swimming pool, named for Frank N. Andersen, was held in June of 1942. Andersen, president of Andersen Sand and Gravel Co., contributed $15,000 worth of concrete for the structure. Located on beautiful Ezra Rust Drive adjoining the Saginaw River, it was built by the Works Progress Administration. On hot summer days as many as 2,000 children swam at the pool. By 1983 the pool had outlived its usefulness. The site is now the home of the Andersen Enrichment Center and the Lucille Andersen Memorial Gardens.

CHAUTAUQUA. The Chautauqua was a traveling group of entertainers who offered concerts, lectures, and recitals. It was held under a tent and was popular between 1903 and 1930. "Saginaw's Big Chautauqua" was held from August 9–15, 1914, in Thistle Field, which was later the site of Andersen Swimming Pool. Season tickets for the 1914 event could be purchased at the Anderson Stores for $2, but were advertised as $8 worth of high-class entertainment.

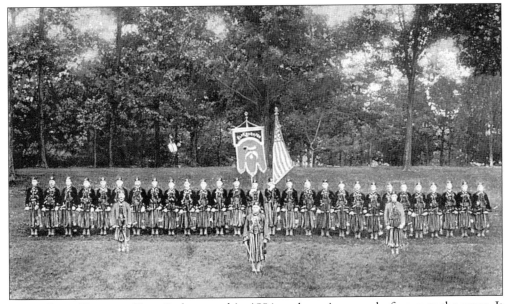

HOYT PARK PARADE. Hoyt Park opened in 1894, and was improved often over the years. It was used for summer baseball and winter skating, and was also the scene of many special activities, including parades. The group performing here is the Arab Patrol of the Elf Khurafeh Temple, Order of the Shriners. Spectators enjoyed many such events in the early 1900s. Today the front lawn of the park is the site of the Saginaw County Veterans Memorial Plaza.

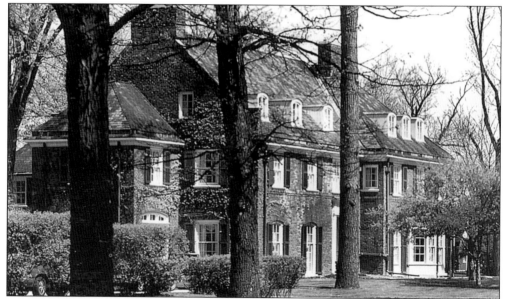

MONTAGUE INN. This is one of the beautifully restored mansions located in the Grove Area of S. Washington Avenue. It was formerly the home of Robert S. Montague who was president of the Sugar Beet Products Co. In the 1960s, the building was the home of the Saginaw Health Department. Now it is an elegant inn and restaurant.

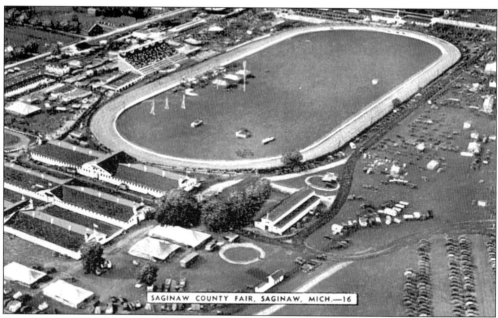

SAGINAW COUNTY FAIR, SAGINAW, MICH.—16

SAGINAW COUNTY FAIR. "The biggest county fair east of the Rockies" was held on the fairgrounds during the second week of September. On Monday of fair week during the 1940s, school children had the day off to attend the fair. The main entrance was on Genesee, at the corner of Webber, and was later moved to Ray Street. There were displays of agricultural products, farm machinery, and merchants' wares, along with lively midway and grandstand shows.

Four

WEST SIDE SAGINAW

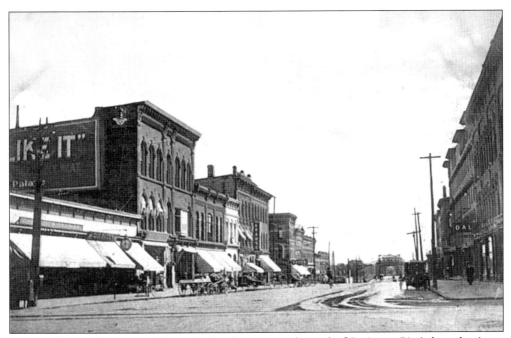

COURT STREET LOOKING EAST. In the distance, at the end of Saginaw City's busy business district, is the Court Street Bridge. The horse-drawn carts and buggies line the street in front of the awning-shaded stores. Among the early businesses here were Ippel's Department Store and the Dall Shoe Store. Across the street are the C.F. Bauer Jewelry Store (shown with the large pocket watch) and both the Krause and Bauer Clothing Stores.

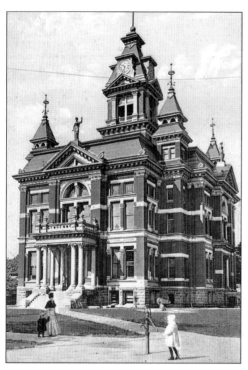

SAGINAW COUNTY COURTHOUSE. Two pairs of zinc statues, 10 feet tall and weighing several hundred pounds, stood on the four corners of the roof of the first courthouse. The statues of Law faced Court and Adams Streets and held scrolls in the left hand. The pair of Justices, holding a sword in the right hand and a pair of scales in the left, looked down on Michigan and Court. One of the justices lost her sword when high winds amputated her right arm in 1941. The courthouse was demolished in 1972.

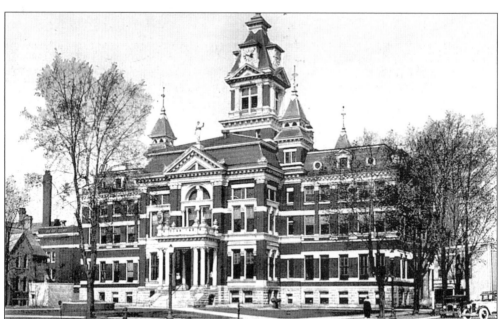

COURTHOUSE ADDITION. Located on Michigan at Court Street, this ornate, stately structure was built in 1883–1884. The red brick building, distinguished by the famous clock tower and statuary, served the city until 1927. When the population rose to 70,000, an addition of two wings, one on each side of the building, almost doubled the floor space. In 1965, with the population rising again, the courthouse was deemed too small and inefficient to serve the county. It was razed and a new County Courthouse was dedicated in 1972.

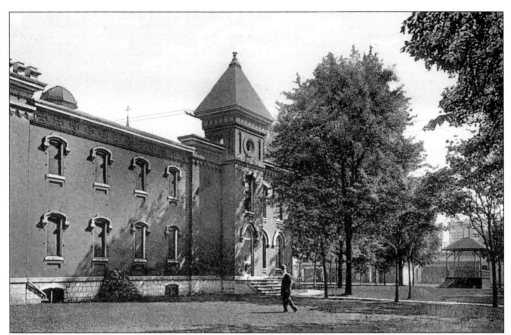

COUNTY JAIL. The two-story jail was located at Court and Michigan Streets. Across the street was the County Courthouse. This busy area called Jailhouse Square also featured a bandstand. The one pictured on this card was the first bandstand. It was moved to Gratiot Avenue when a new one was built. Public speeches, free concerts, and other gatherings were held here.

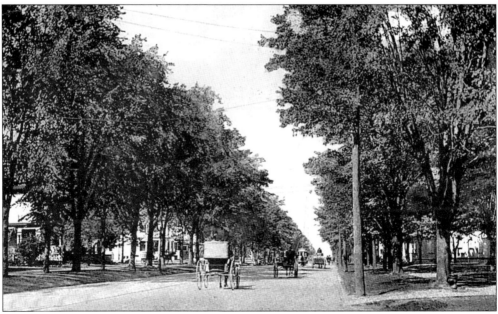

COURT STREET LOOKING WEST. This was an area of broad streets and tree-lined lawns running past stately two-story homes on Saginaw's West Side. The horse-drawn buggies share the road with the electric streetcar. The carriage houses were located in alleys behind the houses. In later years, the huge elm trees here were removed because of Dutch Elm disease.

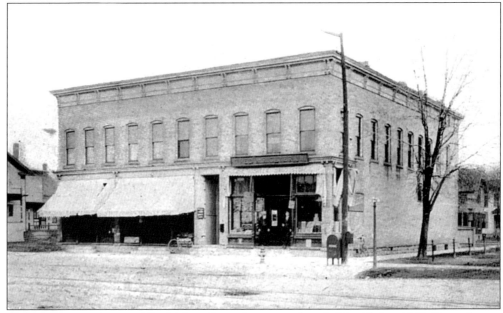

RICHTER DRUG STORE. The Richter Drug Store was founded in 1898 at 1200 Court Street, at the corner of Oakley. Pharmacist Louis J. Richter was known for being available to fill orders day or night and was said to have the confidence of physicians. In 1942, the Court Street store was purchased by Ern R. Chamberlin from Mrs. H.G. Johnston, formerly Evelyn Richter. The store was an agency for OKEH records, Parker fountain pens, Franc's flashlights, Johnston's chocolates, and Vulcan films.

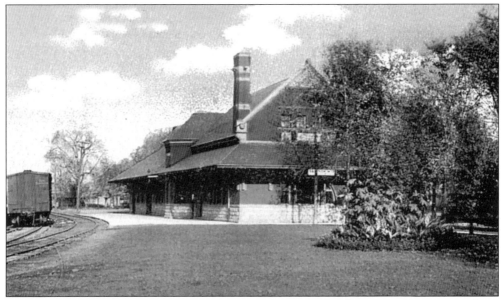

COURT STREET PM DEPOT. A busy depot was located on Court at Bates Street. Without telephones, family and friends would write messages on 1¢ postcards. The mail would be carried by the train and the receiver would get the card the following day. This depot no longer exists and the tracks have been removed also.

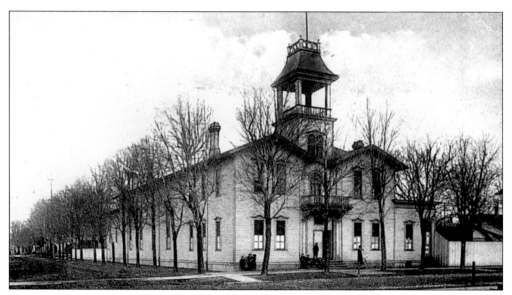

ARBEITER HALL, WEST SIDE. The dedication of this hall, located on the corner of Adams and Oakley, took place in December of 1875. The Arbeiter Vereins was a German workingmen's association. The purpose was to assist sick members for a period of 26 weeks at a rate of $5 per week. The society also donated $50 toward funeral expenses for a member or a spouse. A women's auxiliary was organized in 1898. (Courtesy of George Barrett.)

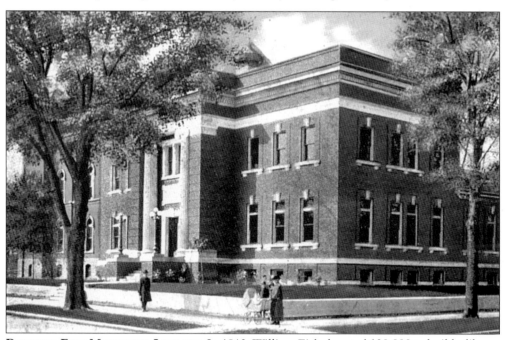

BUTMAN-FISH MEMORIAL LIBRARY. In 1913, William Fish donated $30,000 to build a library as a memorial to his wife, Mary, and her father, Myron Butman. Located on the corner of Harrison and Hancock, the library served the public from 1916 to 1978. A visitor to the library could view the Indian artifacts of Fred Dustin, a local archeologist. During World War I, the building was closed for several weeks because of a fuel shortage and the influenza epidemic.

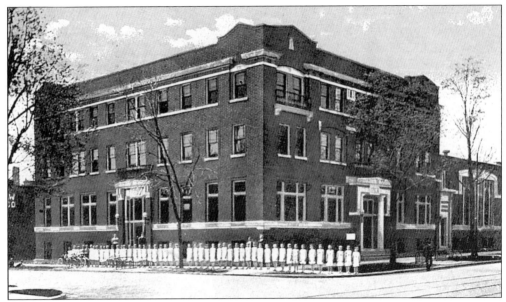

YMCA. The splendid YMCA building located on the corner of Michigan and Ames streets was opened on October 1, 1912. The construction was made possible by provisions in the wills of both Aaron Bliss and Arthur Hill. The building, with a separate entrance on Ames Street for boys, featured a modern gymnasium, a running track, a hand ball court, and a fine swimming pool. There were locker rooms for seniors and business men. The social department included billiard tables and two bowling alleys.

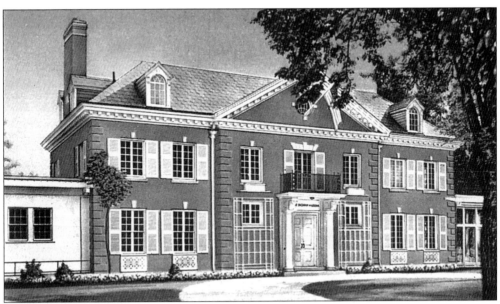

SAGINAW ART MUSEUM. Located at 1126 N. Michigan, this Georgian Revival mansion built in 1904 was the home of lumber baron, Clark Lombard, and his wife, Lizzie Merrill Ring. The mansion was presented to the Saginaw community in 1946 by the Rings' two daughters to encourage the appreciation of art and local history. After a $7 million campaign, a new exhibition and education wing were opened in 2003.

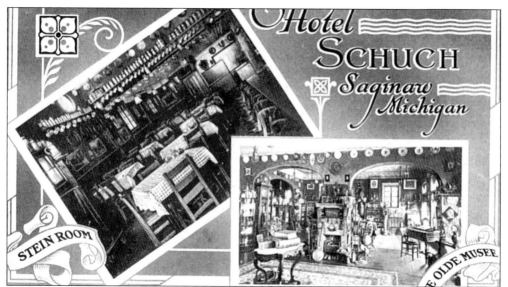

SCHUCH HOTEL. The Schuch Hotel, formerly the Brockway Hotel, was established in 1868 on Hamilton Street in Saginaw City. Under the proprietorship of John P. Schuch, it became a veritable museum of Saginaw's early lumbering and theater days. It showcased his vast historical collections of log marks and rafting pins, playbills, and souvenir programs from the Teutonia Opera House, plus a life-sized oil painting of Little Jake Seligman. The message on this card indicated "Don't fail seeing this hotel when in Michigan." (Courtesy of the Wm. J. Culver Collection.)

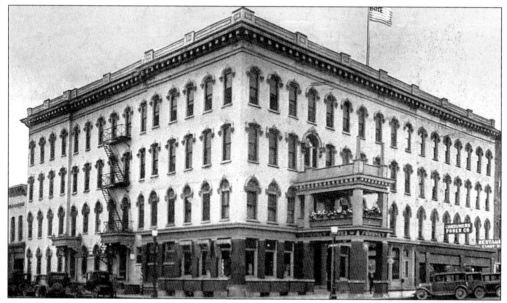

FORDNEY HOTEL. Originally built in 1866 on the site of Old Fort Saginaw, the Taylor House closed in 1879 and was vacant for a number of years. In 1909, the West Side Business Association saw the need for a modern hotel in their district. It was agreed that $50,000 could transform the eyesore into an up-to-date hotel. Joseph Fordney's enthusiastic support of the project led to the name change—the Fordney Hotel. In the spring of 1991 the hotel was consumed by fire.

SAGINAW GENERAL HOSPITAL. In 1886 a group of prominent Saginaw ladies saw the need for a hospital. They organized fundraisers at Teutonia Hall along with charity balls, baseball games and carnivals. In June 1889, the new 30-bed Saginaw Hospital opened at Houghton and Bond Streets. The three-story hospital held men's, women's and children's wards along with endowed rooms from the Rust and Bliss families.

DAVIS NURSES' HOME. Student living space on the third floor of the hospital became crowded as enrollment increased. Charles H. Davis, a wealthy lumberman, donated $13,000 for the construction of a spacious three-story home for the student nurses. The house was completed in 1907 and Mrs. Davis contributed $3,000 for completion of the interior. The home adjoined the hospital and overlooked Bliss Park. Provided were bedrooms, a library, two receptions rooms, and a kitchen.

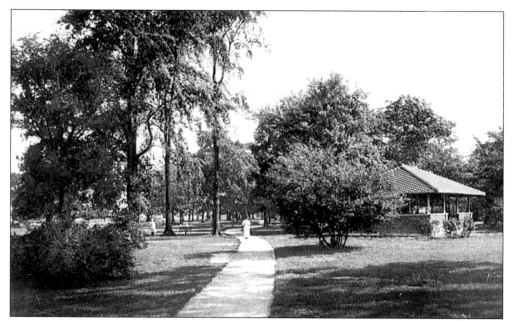

BLISS PARK. Located on N. Michigan and Houghton, the area was originally called "Butchers Woods," being owned by the Campau family. In 1905 ex-Governor Aaron T. Bliss bought the land for use as a park. Bliss donated liberally for the park's improvement and endowed the park for its future maintenance. Toward the close of the Civil War, the park was the scene of the organization of the 29th Regiment, Michigan Volunteer Infantry.

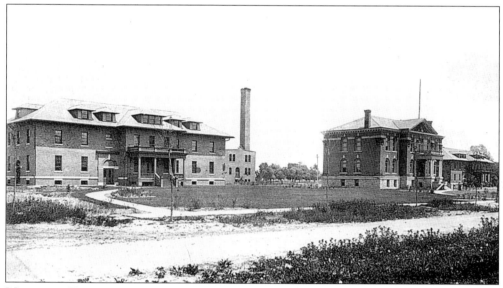

MICHIGAN EMPLOYMENT INSTITUTION FOR THE BLIND. The institution was established in 1903–1905 "to help the blind folk earn a living, renew their hope, regain their usefulness and self-respect, and brighten their lives" (according to James Cooke Mills' "History of Saginaw County Michigan"). The institute was located at 924 Houghton Avenue opposite Bliss Park. It was a trade shop for people between the ages of 18 and 60. They manufactured brooms, doormats, mops and rugs, wove rugs, re-seated chairs, and made cocoa fiber mats.

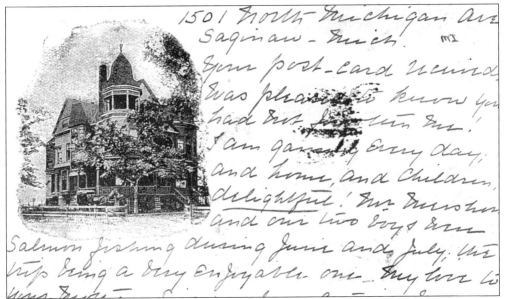

MERSHON HOUSE. This card with a small picture of the house on Michigan and Houghton was written by Catherine Mershon. Mayor William B. Mershon built the home in 1889 for his wife. The three-story home had 15 rooms and five fireplaces. It was built of the finest lumber from Saginaw County's woodlands. The main feature of the home was the refrigerator locker room, which held Mershon's wild game and fish.

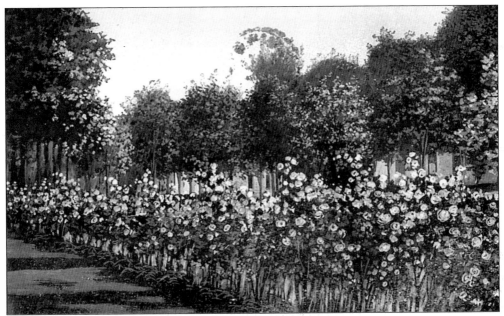

MERSHON'S ROSE HEDGE. The beautiful rose hedge was on the expanse of the Mershon property, which covered eight square blocks beginning on the northwest corner of Houghton and Michigan. The Mershon home at 1501 N. Michigan later housed the Saginaw County's Public Health services. The home was later razed to provide more parking for St. Luke's Hospital, which also occupies part of what used to be the Mershon grounds.

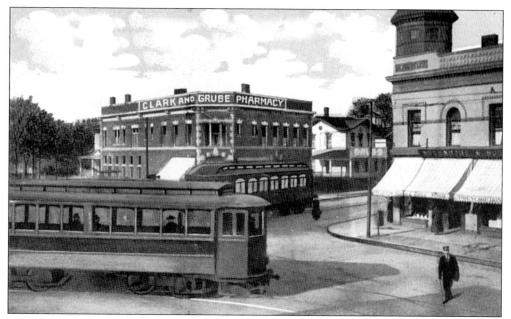

WEST GENESEE AND NORTH MICHIGAN AVENUES. North Saginaw's area of streetcar tracks made it a growing metropolitan site. Three drug stores also shared the area: Clark's, 518 W. Genesee; Schmeck's, 420–422 W. Genesee; and Grube's, on the corner of Genesee and Michigan. Here the streetcars could be turned around, helping the interurban service. When Schmeck's Drugs opened in 1911, the newspaper called it an important addition to Saginaw's North Side business district.

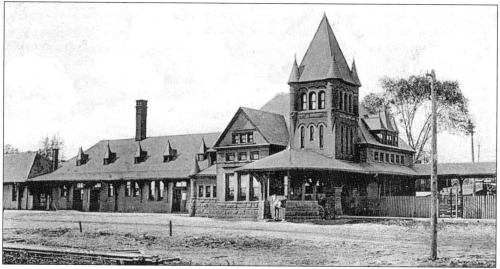

MICHIGAN CENTRAL STATION, GENESEE AVENUE. The depot located on Saginaw's West Side at Genesee and Michigan was formerly the New York Central Depot. On October 1, 1952, this station was the "whistle stop" for candidate Dwight David Eisenhower, the Republican candidate for President of the United States. The train stopped and Eisenhower was here for all of 15 minutes. The crowd was estimated at 12,000 to 15,000. Not everyone could hear the speech, but everyone cheered, some from nearby rooftops.

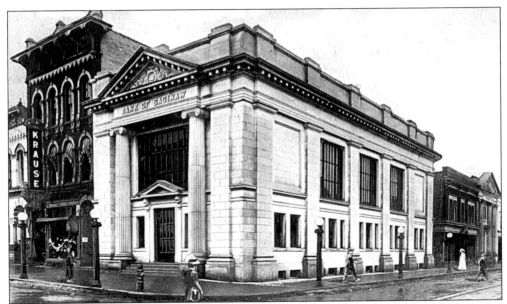

BANK OF SAGINAW, COURT STREET. An impressive white terra cotta structure featuring Ionic columns at the entrance, the Bank of Saginaw building is situated on the corner of Court and Hamilton Streets. The bank was organized in 1888. Along with its banking operations, it also accommodated Saginaw's huge lumbering interests. It increased the volume of its transactions by acquiring smaller banks by absorption and consolidation. The building was later a Second National Bank branch.

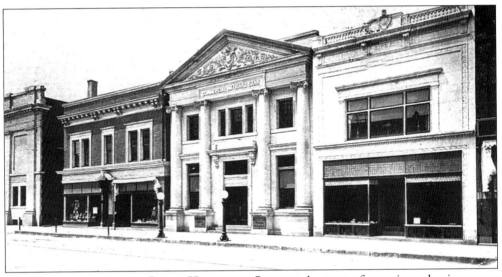

COMMERCIAL NATIONAL BANK, HAMILTON STREET. A group of prominent businessmen of Saginaw City thought the city required another National bank and organized the Commercial National Bank of Saginaw, with a capital stock of $100,000. Chartered on July 9, 1888, it began business in the Andre Block, 115 N. Hamilton Street. In 1902, the bank opened a savings department, adding to its deposits. Accounts could be opened by depositing $1 or more, and earned interest of four percent per annum. Safety deposit boxes could be rented from $2 to $10 per year.

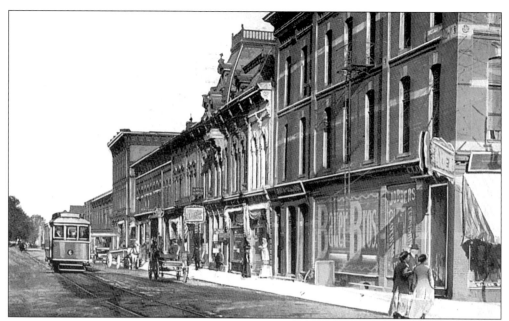

HAMILTON STREET, LOOKING NORTH. Located on the corner of Court and Hamilton Streets, Bauer Bros. was one of the pioneer business houses in Saginaw. In the records of 1855, the name of Bauer Clothiers was a commendable business. Through every business depression, this house stood firm. They handled everything in the clothing and furnishing line, supplied people with what they wanted at reasonable figures, and were rated among the high-class merchants of the town.

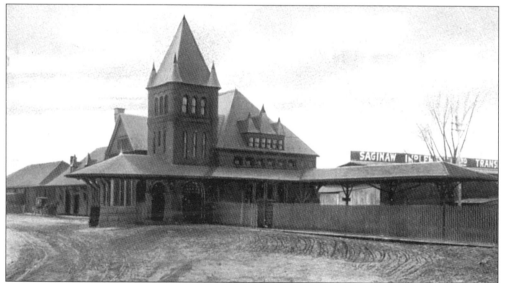

MICHIGAN CENTRAL DEPOT. This West Side depot is located on West Genesee Street. Behind the depot on the corner of N. Michigan and West Genesee is the Saginaw Implement and Transfer Co. This business was the headquarters for implements, wagons, buggies, harnesses, robes, blankets, coats, wire fencing, cedar posts, fertilizers, cutters, sleighs, gasoline engines, silo stock, and field and garden seeds.

FORDNEY PARK. Joseph W. Fordney donated this neighborhood park, situated in a lovely West Side location bounded by Gratiot, Braley, and Chestnut Streets. Mr. Fordney's home was adjacent to the park. With many beautiful trees, the ten-acre park was a popular place for family picnics. It afforded children a place to play on swings and slides, and also provided a wading pool to use on warm summer days.

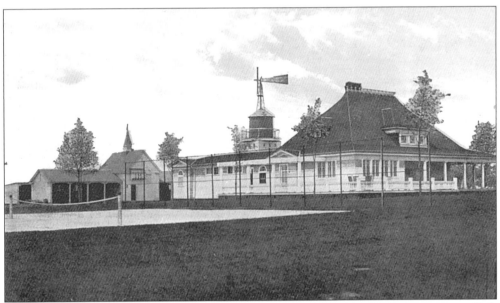

SAGINAW COUNTRY CLUB. Located on Gratiot Avenue, in 1907 the Saginaw Country Club was about one mile from the end of the streetcar line. The club owned a fine building with many conveniences. The original club house and furnishings cost about $10,000; it has since been remodeled. The club owns 60 acres of land with a top quality golf course. On June 1, 1970, Arnold Palmer put on a golf exhibition for nearly 5000 spectators.

Five

SCHOOLS

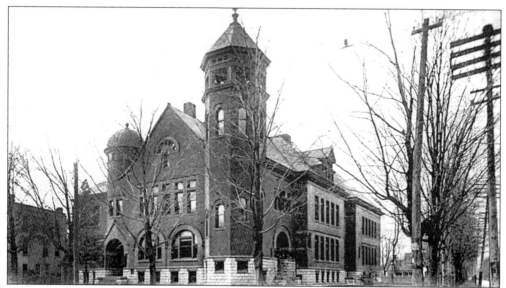

ARTHUR HILL HIGH SCHOOL. The west side high school on Court Street was named in honor of Arthur Hill, a generous lumber millionaire, and was located at the corner of Court and Harrison Streets. Students of the sciences had labs for chemical, physical, and biological studies. Courses were given in German, French, Latin, and English, along with commercial subjects. The building also housed the office of the superintendent of schools.

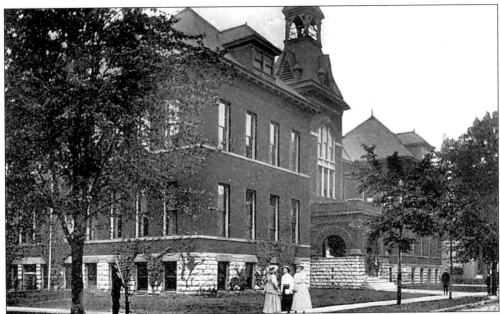

EAST SIDE HIGH SCHOOL. This school was opened in 1865 and was known as Central Union. The curriculum included Latin and Greek, even though the students still read from a fifth grade reader. Girls outnumbered the boys who were often working in lumber related industries. When the boys did attend, many of them were considered roughnecks. It took Miss Alice E. Freeman, who was sent from Ann Arbor, to take control of the school and solve the problem, which she did. She later married and as Alice Freeman Palmer, became president of Wellesley College. The east side high school later became Saginaw High School.

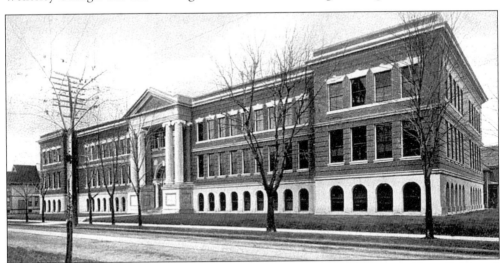

BURT MANUAL TRAINING SCHOOL. In September of 1905 the "magnificent" Manual Training High School was opened. Wellington R. Burt donated $200,000 with the $250,000 city's share toward the construction of the building. Connected to the school by a passageway was a bath house and swimming pool where swimming classes were given to seventh through twelfth graders, and elementary students during the summer. The school was built of paving brick and stone, and in 1908 the State Teacher's Association held their convention there.

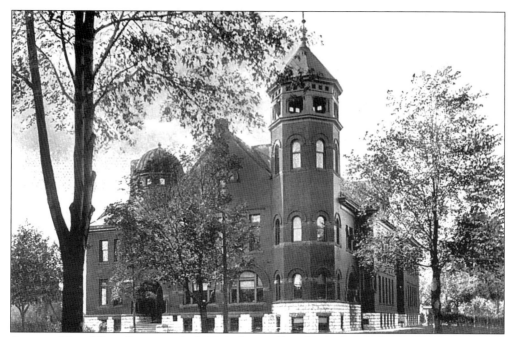

ARTHUR HILL HIGH SCHOOL. In 1893 Arthur Hill established a scholarship fund of $25,000. The interest was to be used for scholarships at the University of Michigan. One is awarded each year to the outstanding senior at the high school. The fund began by awarding $250, but later, because of successful investments, granted $3,000 to $5,000 to deserving seniors.

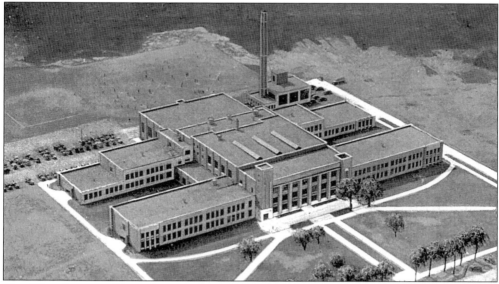

THE NEW ARTHUR HILL HIGH SCHOOL. Seeing the need for a new West Side high school, Superintendent Chester Miller received help from the Public Works Administration. With the latest in facilities and equipment, the new school was opened in 1940. Located on the corner of Mackinaw and Malzahn, it was quite a distance from the busy West Side area. Some students were less than pleased with their new building, which was "too far out in the country." In 1949 a memorial stadium beside the school was dedicated.

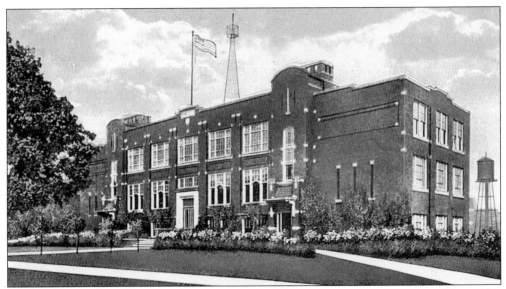

ARTHUR HILL TRADE SCHOOL. Located on the corner of Mackinaw and S. Michigan, this building was constructed in accordance with the will of lumber baron Arthur Hill. It was opened in 1913 and displayed windows depicting a variety of trades. A large central window showcased the letters "AH." In 1913 it was considered the safest, cleanest, most fireproof building in the city. In 1962 the school's name was changed to Arthur Hill Technical High School. Today a McDonald's restaurant occupies the site.

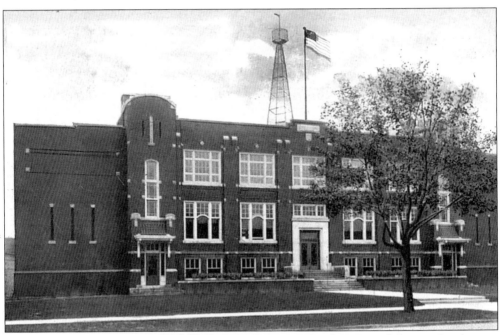

ARTHUR HILL TRADE SCHOOL WEATHER STATION. A local station of the weather bureau occupied two rooms at the trade school. It was equipped with instruments to record and register atmospheric data. The building had a 40-foot tower on the roof, which gave a good view of the city and the sky.

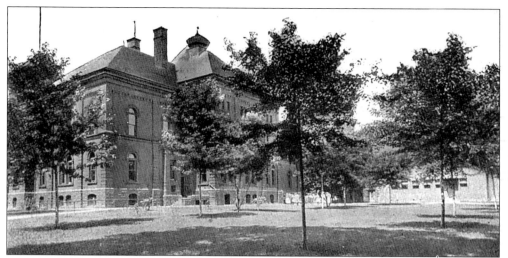

JOHN MOORE SCHOOL. John Moore School was named for Judge John Moore, who was a member of the first Board of Education of the Union School District (West Side). Located on the corner of Court and Harrison, it was erected on the site of the old Central School, which burned in 1895. The school included 16 classrooms and offices of the Board of Education. German was taught in the eight grades at the school. In later years, classes for Arthur Hill students were held in the building across the street from the high school.

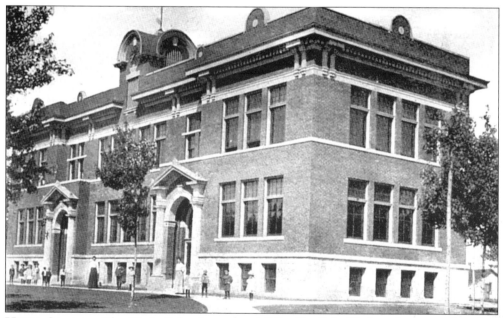

HERIG SCHOOL. The Herig School was named for Dr. E.A. Herig, who was a Board of Education member for 13 years. The brick building with eight classrooms was ready for occupancy in September of 1907. It featured sanitary wardrobes, plaque rails, and graded blackboards. There were automatic clocks in every room which were regulated by a master clock in the office. In 1907 the school had an enrollment of 301. The highest grade was sixth, and German was taught in all grades. In 1974 the school was razed and a new $800,000 school was erected at Bates and Houghton Streets.

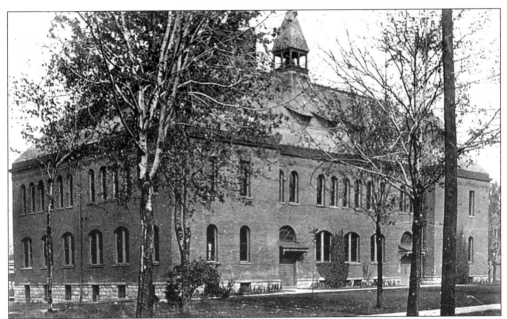

HOYT SCHOOL. The old "Academy" burned in 1871 and the new Hoyt School was built on the same site. This new school was a fine modern structure of brick, containing six rooms and space for 325 students. It opened on November 11, 1872. Twenty years later, the building was rebuilt and enlarged to accommodate 400 students. The cowboy star Tim McCoy attended school here.

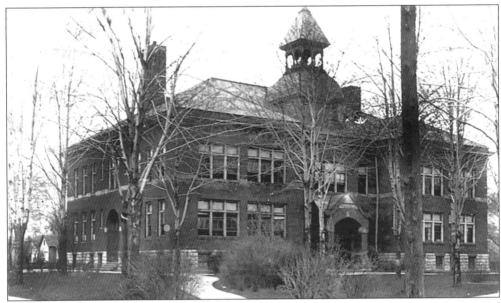

EMERSON SCHOOL. In 1872 a brick building which contained four rooms and accommodations for 210 pupils was built in the Sixth Ward of East Saginaw. The building was replaced and a larger two-story building featuring a large bell tower was built on Emily between Merrill and Mott. The school year was divided into three terms—to accommodate students who were needed at home during the harvest season and to allow primary students to avoid walking in the harsh winter weather.

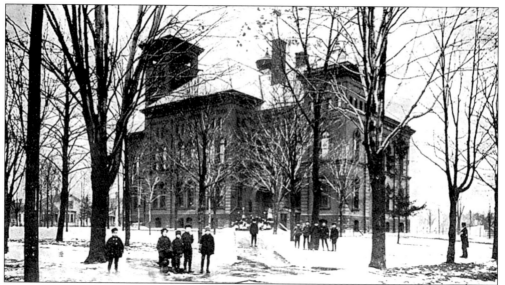

CENTRAL SCHOOL. This substantial brick building was built in 1866 at the corner of Lapeer and Park at a cost of $40,000. It had seven large rooms and accommodated 510 students. The cost was a great sum in the days when lumberjacks were working six days a week for wages of $20 per month. It was the largest school in East Saginaw and had seven departments: high school, grammar, intermediate, and four primary grades. (Courtesy of George Barrett.)

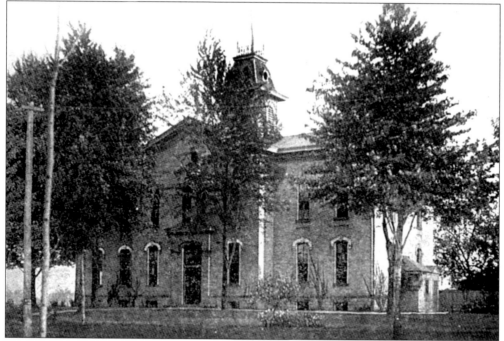

SWEET SCHOOL. When East Saginaw was divided into wards, Sweet School was located in the Seventh Ward on Lincoln and Webber. The school, a substantial two-story brick building with a high cupola, was named for William H. Sweet. Mr. Sweet, a former mayor of Saginaw City and a prosecuting attorney, was a member of the Board of the Union School District in 1891.

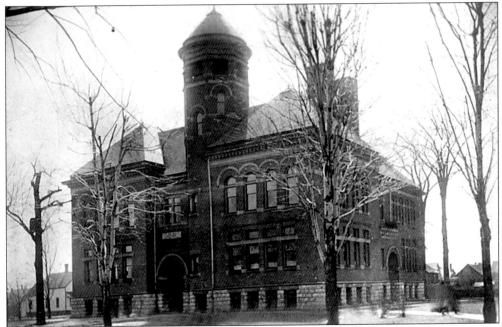

JONES SCHOOL. This school was named for Chester B. Jones, who was a dealer in lumber, shingles, and lath. He also was an East Saginaw school inspector. Other sources believe the school was named for Professor J.C. Jones, Superintendent of East Saginaw Schools, who inaugurated the free textbook system in 1885. The original two-room school was built in 1874. In 1959 it was replaced on the same Cherry Street site by a new brick elementary school.

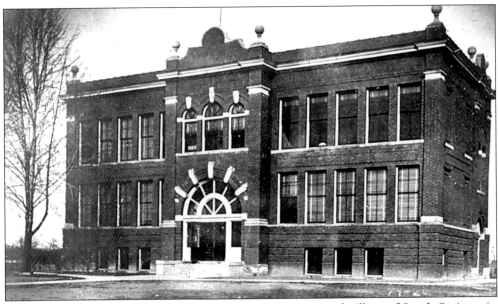

SALINA SCHOOL. The town of Salina became the incorporated village of South Saginaw in 1866. Later, in 1873, the village became part of the city of East Saginaw, contributing three or four churches and a fine graded school with 500 pupils and seven teachers. The school building was a substantial structure costing more than $10,000 and situated on Fordney Street.

74

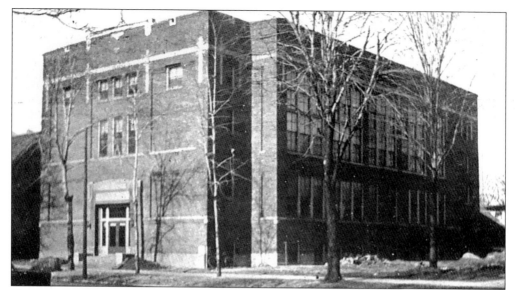

HOLY CROSS LUTHERAN SCHOOL. The Lutheran congregation of Holy Cross Church opened a school in 1861 in a small frame building on Hermansau Street. It was called a branch school because it was located in an area which shortened the distance children walked to school. In 1922 a modern three-story brick building replaced the old frame school. It served as Holy Cross School for 42 years and was located on Court Street beside the church. When this building was razed in 1968, construction began on a new one-story building connected to the church. (Courtesy of Pat Stoppleworth.)

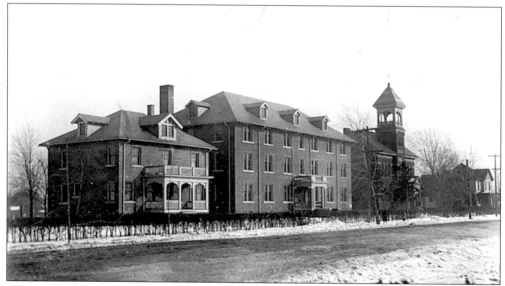

MICHIGAN LUTHERAN SEMINARY. The Lutheran Church Wisconsin Synod established a college preparatory school in 1910. The school is located on Court at Hardin Street. Beginning with one building, the school has continued to grow since its inception. A professor's residence, a dormitory, and a reception hall were added after its early days, when it was known as the German Lutheran Seminary. These structures have since been replaced with modern brick buildings.

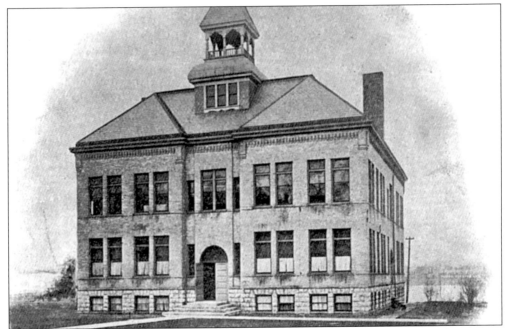

HOLY FAMILY HIGH SCHOOL. When Father Surprenant arrived in Saginaw in 1911, the Holy Family congregation was worshipping on the second floor of this school building. The school was completed in 1890 at 1515 S. Washington Avenue, across from Hoyt Park. There were 200 students at the school, and because of the crowded conditions and need for a separate school building, plans were drawn up for a new church building. (Courtesy of George Barrett.)

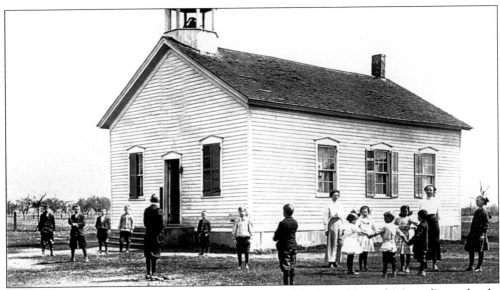

HEMMETER SCHOOL. Hemmeter School was one of Saginaw Township's earliest schools. The wood frame building was built in 1837. In 1868 it was named the Swarthout School, for school board member A.R. Swarthout. The name changed to Hemmeter School in 1893, when school officials named it in honor of William F. Hemmeter, a former postmaster and school board member.

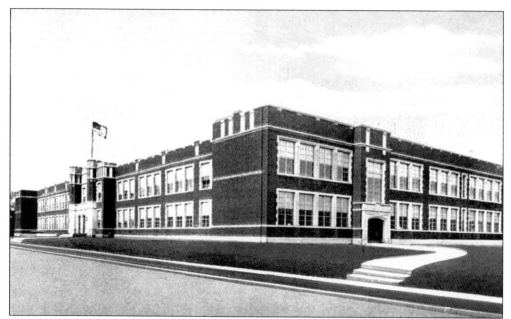

SOUTH INTERMEDIATE SCHOOL. In April of 1921, West Side voters approved a $950,000 bond issue for two junior high schools. The site chosen for South School was the block bounded by Brockway, Wright, Bliss, and Elm. It was a block north of the end of the Gratiot streetcar line. The planned capacity was 1,000 students living south of Court. Students in the seventh, eighth, and ninth grades were to attend the school when it opened for the 1922–1923 school year.

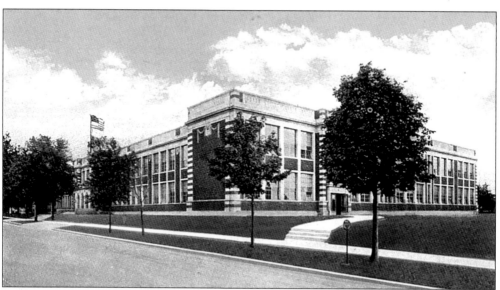

NORTH INTERMEDIATE SCHOOL. In 1921 a contract was awarded to the Spence brothers of Saginaw to begin construction of two new West Side schools. The contract specified $720,000 to be used for building and establishing these schools. North School was to be located at the site of the former Bliss School on N. Bond Street. The school was planned for 1,200 students in the sixth, seventh, eighth, and ninth grades living north of Court Street, and for the first five grades of children attending Bliss School, which was scheduled to be razed.

BLISS-ALGER COLLEGE. Fred Bliss and his brother-in-law, Francis Alger, opened their business and accounting college in Saginaw in 1907. Their college had four separate departments: Business, Stenography, Typewriting, and Telegraphy. Alger also compiled a bookkeeping and accounting course for colleges and high schools. The business institute, located at 207½ S. Franklin, changed hands several times and closed its doors in October of 1954.

SUMMER SCHOOL

Bliss-Alger COLLEGE.

SEND FOR SPECIAL RATES
ENTER ANY TIME
SAGINAW, MICHIGAN

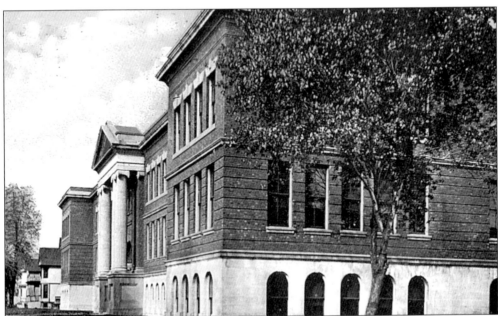

MANUAL TRAINING SCHOOL FOR BOYS. Wellington R. Burt, one of the wealthiest of the lumber barons, gave nearly $200,000 to the East Side School District to build the Manual Training School for Boys. Along with subjects for boys, it also offered classes for girls. The building's equipment included machinery and tools for wood and iron work for the boys, and sewing and cooking for the girls. The building also housed a gymnasium with locker rooms.

Six

CHURCHES

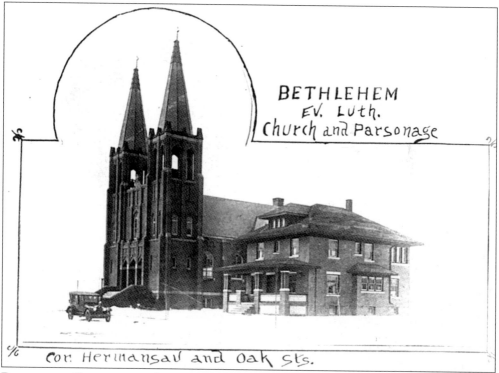

BETHLEHEM EVANGELICAL LUTHERAN CHURCH. In 1910 the congregation of Holy Cross wished to establish a permanent congregation in North Saginaw. The group agreed to purchase six lots for $1,500 in the area bounded by Oak, Hermansau, and Schaefer Streets. Construction for the church was completed at a cost of $26,000 and the cornerstone was laid on October 25, 1914. Pastor Andrew Zeile was installed in 1915 and served the congregation for 45 years.

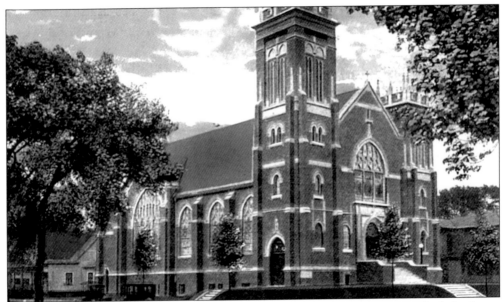

St. Paul's Evangelical Lutheran Church. The St. Paul's Evangelical Lutheran congregation was organized November 30, 1851, with 22 members. The first church was erected at the corner of Harrison and Ames Streets in 1857. The present structure, located at 1020 Court at the corner of Bond, was built at a cost of $8,000 and dedicated October 17, 1869. The church has long maintained a parochial school which provides religious instruction to the children and youth of the congregation.

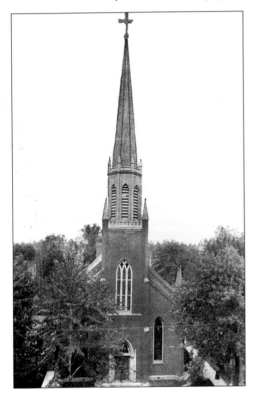

Holy Cross Evangelical Lutheran Church. This mother church of other congregations in the region was organized in 1849. Mayor Gardner Williams presented the organizers with two lots in Saginaw City, and the first church building, called a "salt block," was dedicated in 1851. It sat on the southeast corner of Court and Washington (now Michigan) and served until 1868 when a new church was built on Court and Fayette Streets at a cost of $18,000.

FIRST PRESBYTERIAN CHURCH.
Situated on the corner of Court and
Harrison Streets, First Presbyterian
was the very first church built in
Saginaw City. It was also the first
public building to be constructed in
Saginaw. Among the founders were
the Thomas Merrills and the Clark
Rings, who held many church
functions at the Ring home on N.
Michigan. The church's dedication
was held on December 12, 1852.
Additions have been made to the
original building to accommodate a
growing membership.

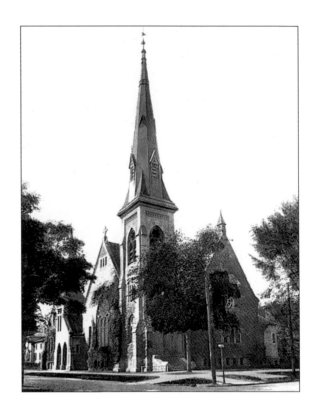

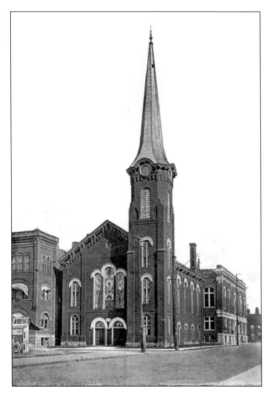

FIRST BAPTIST CHURCH. This church
was located on the northeast corner of
Jefferson and Germania. The congregation
moved into this red brick church with
gray stone trim on April 19, 1868. It was
heated by steam, lighted by gas, seated 600
people, and was built at a cost of $36,000.
In 1929, 61 years later, the building was
sold to Savings and Loan for $80,000.

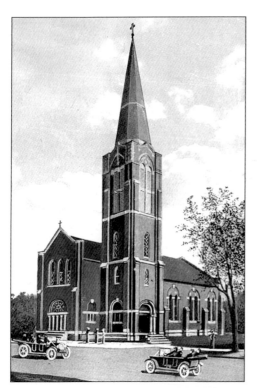

ST. ANDREW'S CATHOLIC CHURCH. This church is the mother church of the Catholic parishes in Saginaw. The first St. Andrew's church building was erected in 1862 and enlarged in 1867 when a parochial school was constructed. A priests' residence was later built next to the church on Michigan Avenue. The original church was moved to Hamilton Street and later converted into a parish hall. The new church was built at a cost of $50,000 and consecrated in 1913.

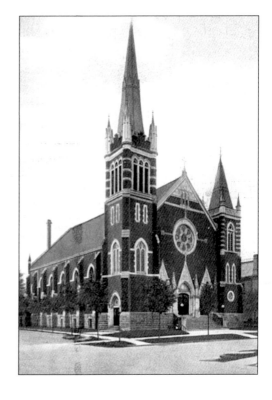

ST. MARY'S CATHOLIC CHURCH. The first church, located on the corner of Owen and Hoyt Streets, looked like a little clapboard schoolhouse. The second church was another frame structure dedicated in 1863. After 40 years, the second St. Mary Church building was moved across the street to make way for the current church, which became St. Mary's Cathedral in 1938. St. Mary's became known as the "Mother Church East of the Saginaw River."

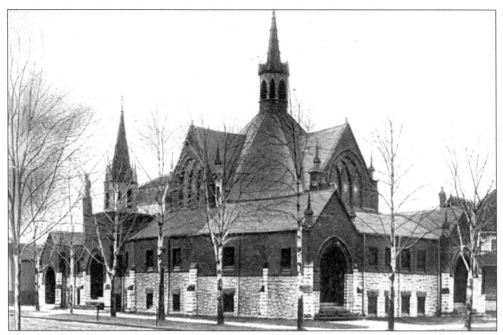

WARREN AVENUE PRESBYTERIAN CHURCH. Originally called the "First Presbyterian Church of East Saginaw," Warren Avenue Presbyterian Church was organized in 1867 with 32 charter members. The brick church on the corner of Warren and Millard Streets was completed in 1874 at a cost of $12,000. Nearly 20 years later, this church was destroyed by fire and the current building was built on the same site.

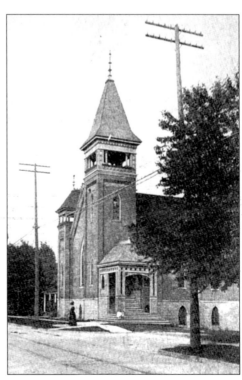

PRESBYTERIAN CHURCH, S. WASHINGTON. This church, built of paving brick, featured a high basement, arched stained glass windows, and an impressive bell tower that called citizens to worship. The church was founded in 1885 and was located at 2312 S. Washington Avenue on the corner of Williamson. A noted member of the church was the former governor, Wilber Brucker whose family home was down the street at 2414 S. Washington. (Courtesy of George Barrett.)

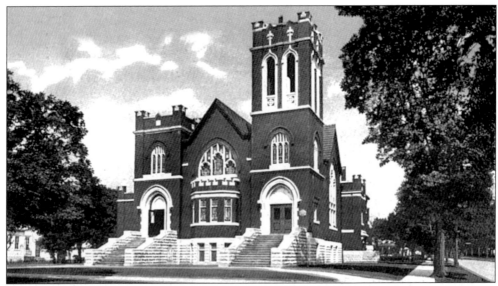

MICHIGAN AVENUE BAPTIST CHURCH. This structure at 203 S. Michigan (at Adams) on Saginaw's West Side was erected in 1908 at a cost of $54,000. The building was dedicated June 6, 1909, and had a seating capacity of 1,000. The style is of a composite of different types of church architecture. The materials were brick and concrete, with facing of dark paving brick and trimmings of stone. An early member, Latham A Burrows, served the church as organist and choir director for a number of years.

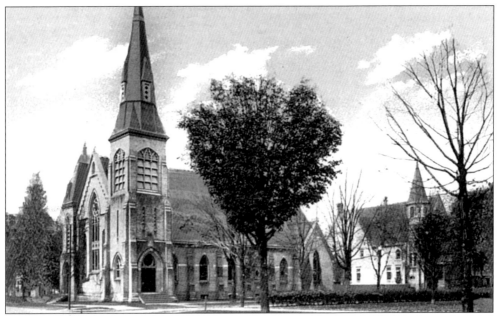

ST. JOHN'S EPISCOPAL CHURCH. St. John's Church was organized in 1851, and was the third congregation formed in the Saginaw Valley. Services were initially held in the old school house at Court and Fayette Streets, and also in the old courthouse. The first rector received a salary of $300 per year. The present church was built of brick and stone in 1883. The church is located at 123 N. Michigan on the corner of Hancock.

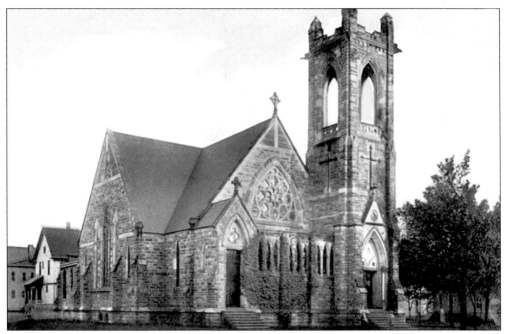

ST. PAUL'S EPISCOPAL CHURCH. The first church was built on the northeast corner of Warren and Lapeer on a lot donated by Jesse Hoyt. The wooden medieval style building was erected in 1864 and was lost to a fire in 1884. The decision for a location to rebuild split the congregation; some formed the All Saint's parish. In 1887 the old St. Paul's congregation began erecting a new stone church at Washington and Fitzhugh, which they dedicated in 1888.

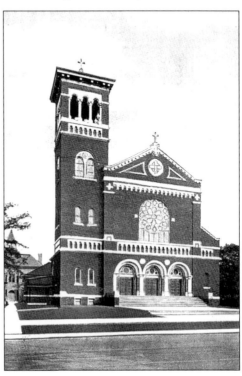

HOLY FAMILY CHURCH. The original Holy Family Church was organized in 1892 as a French speaking parish. Mass was conducted in Latin and French until 1919. The present church's cornerstone was laid in 1915, but World War I put construction on hold. The basilica type building was resumed in 1921, however building costs had increased because of the war. In 1923 the church was completed and dedicated. Rev. John B. Surprenant became the pastor in 1911 and served for 50 years. The interior of the church featured marbled walls, with paintings and statues done at the Vatican.

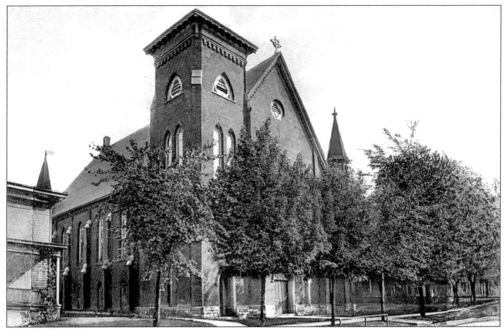

METHODIST EPISCOPAL CHURCH, S. JEFFERSON AVENUE. Property for this church was purchased on Jefferson Avenue and the cornerstone was laid in 1867. Dedication was held in 1869 for this handsome structure. It was built of red brick with gray stone facings. It featured arched stained glass windows, a slated roof and a corner spire 162 feet tall. The walnut upholstered interior was heated by hot air and lighted by gasoliers.

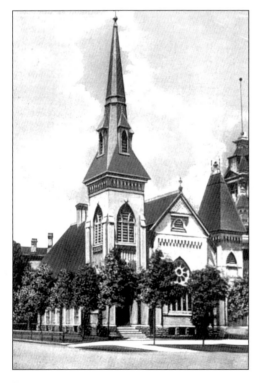

FIRST METHODIST CHURCH. In 1854, John Moore purchased land on Michigan Avenue for the construction of a Methodist church. Moore and his wife were among the first Methodists in Saginaw City. In 1859 the first church building was erected near the County Courthouse. It was later enlarged, and a parsonage was built. A stately new building was erected on the same site after the building and its entire contents were destroyed by fire in 1884. It has since been torn down.

Seven
BUSINESS AND INDUSTRY

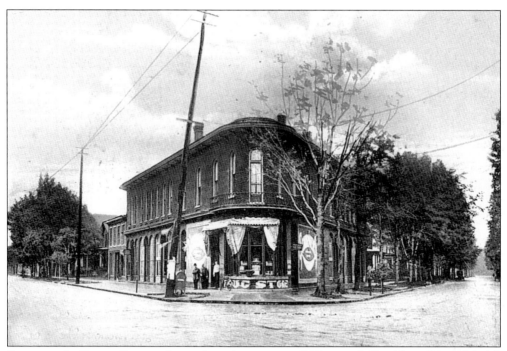

SCHIRMER'S DRUG STORE. Located at the corner of Hoyt and Sheridan, this red brick building's unique feature was a curved second floor balcony over the entrance. The Schmelzer family owned the building. It was first used as a grocery store; later John Schmelzer sold furniture here. Julius and Frederick Schirmer founded their business in 1883, and rented this building before purchasing it in 1923. It remained Schirmer's Drug Store for 77 years. The business closed in 1960, and the building was razed in 1963.

MARQUETTE MOTOR WORKS. The old Mershon-Schuette-Parker lumber mill at N. Washington and Sixth Streets was given—for no charge—to the Rainier Auto Company as an inducement to locate in Saginaw. When Rainier collapsed, a young General Motors took over the plant and named the car the Marquette. When only a few Marquettes were being built, General Motors wrote off the venture and used the plant to produce mortar shells for World War I.

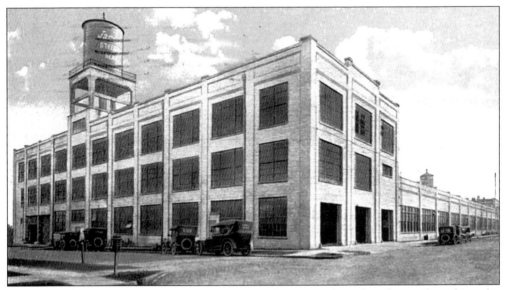

JACOX STEERING GEAR. In 1906 John Jackson, Edgar Church, and Melvin Wilcox formed a company on Hamilton Street to build auto parts. Buick Motor Car Company was its main customer, but the Buick's wobbling steering system made cars sway out of control. The Jackson, Church, and Wilcox firm developed and patented the Jacox steering gear, which was a flexible steering system that made turning safe and comfortable. Buick later bought the Saginaw plant.

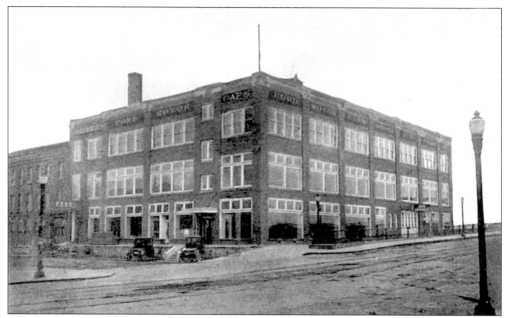

HUBBELL AUTO SALES CO. The home of Hubbell Auto Sales was located at the foot of the Genesee Street Bridge, at Water Street. In 1923, this was a headquarters for Ford motor cars, trucks, tractors, and parts. The president and general manager was E.F. Hubbell. One winter day after the new facility was completed, it experienced a devastating fire.

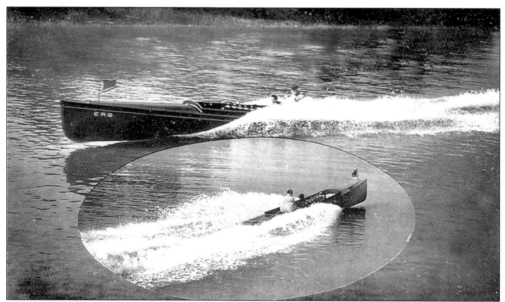

ERD MOTOR COMPANY. In 1902 John and Harry Erd opened a small machine shop on the corner of Niagara and Hancock Streets. They began by manufacturing and repairing marine motors. Because of increased demand for their product, a number of moves became necessary. By 1909 the company was incorporated and moved to a large plant at Niagara and Mackinaw, where they expanded from producing marine motors to manufacturing truck and tractor motors. At that time, the company was turning out about 15 motors per day.

A.T. FERRELL & CO. This company was organized to manufacture a variety of grain-cleaning machinery. Its cleaners, known as "Clippers," were used to clean seeds, grains, and beans, and were usually operated by women. The machines were sold all over the world, in addition to every state in the Union. Organized in 1891, the business was located at 1621 S. Wheeler and lasted into the 1930s. The building now is occupied by Self Serve Lumber.

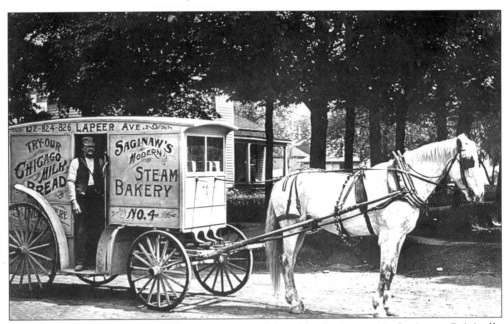

APPEL STEAM BAKERY. In 1912 this was one of the older businesses in Saginaw. Originally known as the Schust Baking Company, it later became the Appel and Wesphal Baking Company. It was reorganized as the Appel Steam Bakery, located at 824–826 Lapeer Avenue. The bakery specialized in fine rye and white bread, making some thirty varieties. "Mamma Bread," "Chicago Milk Bread," "Home Made," and "Steam Bread," were a few of the special brands. (Courtesy of the Wm. J. Culver Collection.)

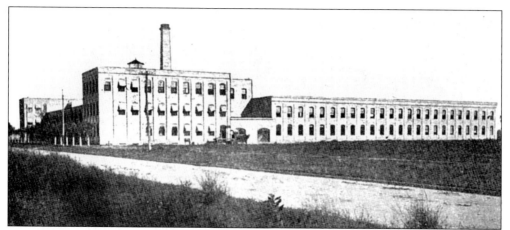

LUFKIN RULE FACTORY. This business came to Saginaw from Ohio in the 1890s to make log rules for the lumber industry. After the lumber boom ended, the company made other measuring instruments, such as measuring tapes, wood, and steel rules. The company employed a large number of young women in the plant on Hess Street. In 1967 the company moved to North Carolina. (Courtesy of George Barrett.)

LEE AND CADY. This three-story brick building on Water Street is viewed behind piles of snow on Tuscola Street after the 1912 snowstorm. The wholesale grocery company was organized in the 1860s as the Valley Coffee and Spice Mills. A large trade developed after the addition of groceries and lumbermen's supplies. The company changed names a number of times and in 1911 became Lee & Cady, Saginaw Branch. (Courtesy of George Barrett.)

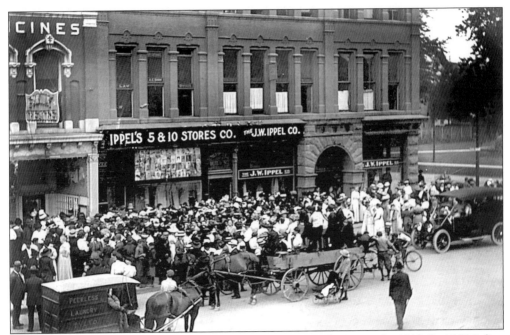

THE J.W. IPPEL CO. This view depicts the opening of Ippel's Annex in 1910. In 1905 Julius Ippel's dry goods business moved into the building constructed by lumber baron Thomas Merrill on the corner of Court and Michigan. The dry goods store had wooden floors and overhead tracks that made a clicking sound throughout the store. Along the tracks ran cash cars carrying sales receipts and money to the office. The cash car then returned to the sales clerk and customer with change. In 1948 the system was replaced with pneumatic tubes. The building was destroyed by fire on January 29, 2002.

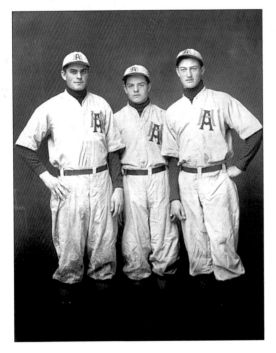

IPPEL BROTHERS. This real photo shows the Ippel brothers in baseball uniforms when they were athletes at Arthur Hill High School. The brothers inherited the dry goods business from their father, J.W. Ippel, after his death in 1922. They had just returned from service in the armed forces during World War I when the business became theirs. The store, located in the three story Merrill Building, was purchased in 1980 by Richard and Sally Haines. Sally is the daughter of Eugene Ippel and the granddaughter of J.W. Ippel. (Courtesy of Sally Ippel Haines.)

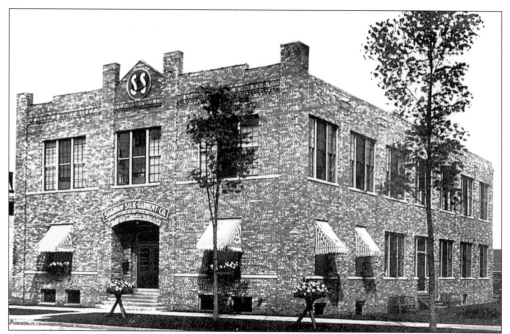

THE SILK GARMENT CO. (THE DAYLIGHT FACTORY). This factory was located at 1900 N. Michigan. The Garment Co. was in business from 1901 to 1920 and produced ladies' silk and lace waists and silk dresses. During the Spanish influenza epidemic of 1918–1919, the Red Cross moved into the building and used it as an emergency hospital.

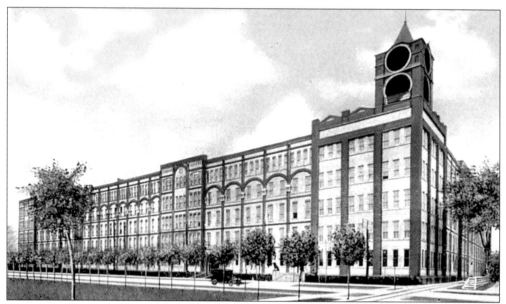

HERZOG ART FURNITURE CO. Located at 1909–2000 S. Michigan Avenue, this business began in 1900. The factory, constructed of sandstone brick, was five stories high and employed 375 men. The business produced special and fancy furniture, including ladies' desks, music cabinets, fancy tables, library tables, etc. Their patented cabinet for holding phonograph records was the most complete on the market.

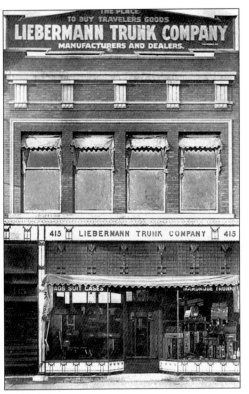

LIEBERMANN TRUNK CO. Julius R. Liebermann founded the company in 1893. After two previous locations and a devastating fire, Mr. Liebermann opened a store at 415 E. Genesee in 1912. He was warned that women might not come to his store because there were 14 saloons in the same block. Customers did come, however, to purchase luggage, leather goods, trunks, handbags, and gifts. Liebermann's was a Saginaw mainstay for almost 90 years. (Courtesy of Pat Stoppleworth.)

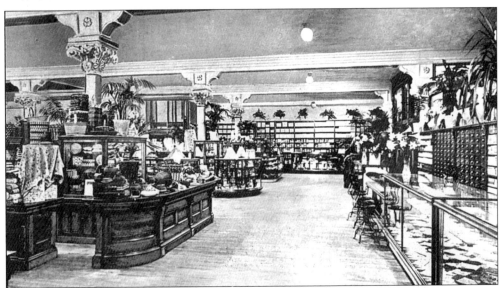

M.W. TANNER CO. Formerly known as the Saginaw Dry Goods and Carpet Co., the Tanner Co. moved from the Bearinger Building to a new four-story building adjoining the old store on Franklin Street. It was dubbed "the Daylight Store," because day and night every corner of the store had perfect lighting. Providing dry goods, women's and children's garments, millinery, men's furnishings, carpets, draperies and dressmaking, no store in Michigan was better equipped to serve the public more than this one.

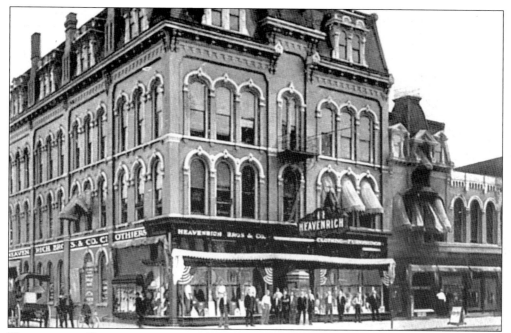

HEAVENRICH BROTHERS & CO. This clothier shop was located at 301–309 Genesee at Franklin Street. It was a well known company which began business in 1878. Besides clothing and men's furnishings, they offered other departments including boots and shoes, ladies' shoes, a boys' department, and a high-class tailoring department. The four-story building had nearly 18,000 feet of floor space. The company clothed gentlemen of fastidious taste as well as plain laboring men.

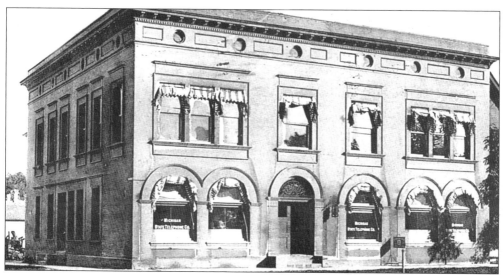

MICHIGAN STATE TELEPHONE CO. This red sandstone building housing the phone company was located at 309 S. Washington. According to the 1939 telephone directory, a residence could have a four-party line. Businesses could apply for a one- or two-party line. Rates ranged from $2.25 to $3.50 per month for residences and $6 or $7 for a business. The directory also gave explicit directions for using a dial telephone.

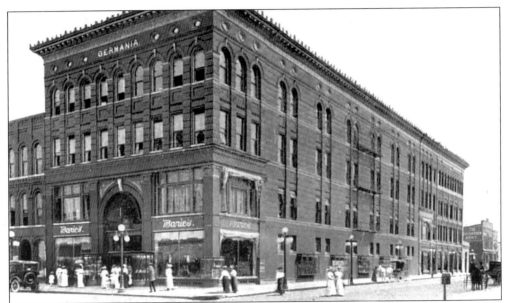

BARIE DRY GOODS CO. William Barie began wholesaling dry goods and notions in a three-story brick building on S. Baum Street, formerly the Aldine Hotel. In 1899 the William Barie Dry Goods Co. moved into a spacious building at Genesee and Baum, which had been erected especially for them by the Germania Society, on property bequeathed to it by Anton Schmitz. The retail trade of the company showed marvelous gains and "Barie's" was regarded as one of the leading department stores in Michigan.

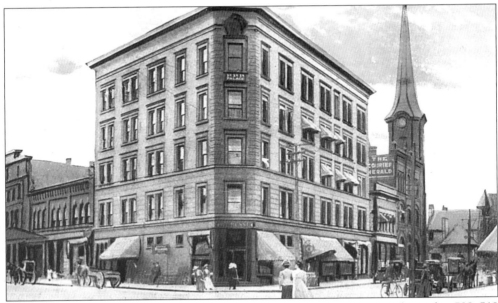

WIECHMANN BUILDING. The original Wiechmann Department Store was located at 508–510 Genesee Avenue. William C. Wiechmann opened the store in 1901 and was praised for keeping in touch with the ideas of the season, for being first to get novelties, for studying business economy, and for keeping his prices at rock bottom. In later years the business expanded into the former Avery Building and had entrances on both Genesee and Jefferson Avenues.

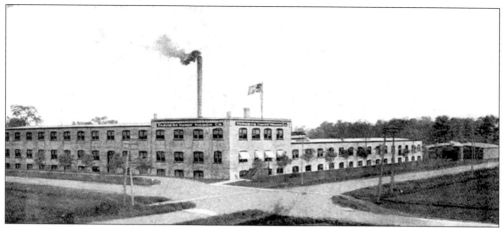

FARMERS HANDY WAGON CO. The Farmers Handy Wagon plant was located on Sheridan and Hess Streets. In the early 1900s, this company was a leading producer of wagons for farms, parks, and mill yards. Owner Charles W. McClure began manufacturing silos to store feed for livestock when farmland began to replace forests. The Saginaw Silo and the Silo Filler became so popular with farmers that the company turned out 6,000 units in 1905 and opened additional plants in four states.

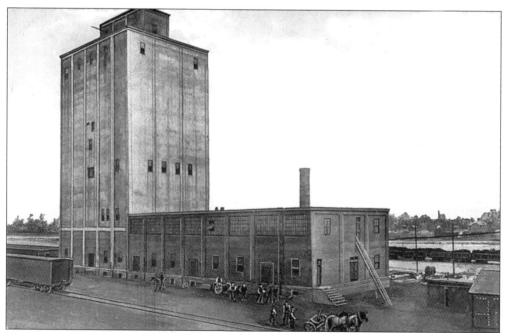

BEAN ELEVATOR. In the 1940s Saginaw had the largest bean elevator in the world, handling 80 million pounds of beans annually, one-third of the nation's crop. When Eisenhower's presidential campaign train rolled into the New York Central station on West Genesee in 1952, the chairman of Saginaw's Republican Party came on board with a crock of beans prepared by the chef at the Bancroft Hotel. Ike was pleased with the gift, as he said that beans were one of his favorite foods.

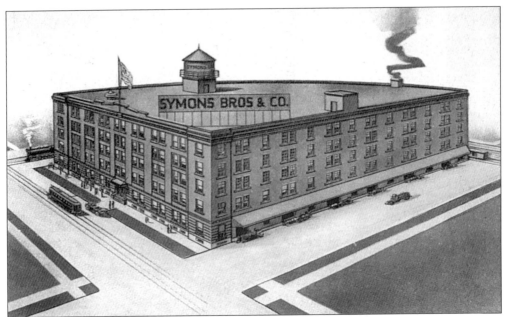

Symons Brothers & Co. Located at 501–513 S. Washington, this firm dates back to 1877. In the early 1900s it was doing an annual business of $1.5 million and carried the largest stock of goods in the Saginaw Valley. The business dealt with wholesale grocery items, furnishings, knit goods, and work clothing.

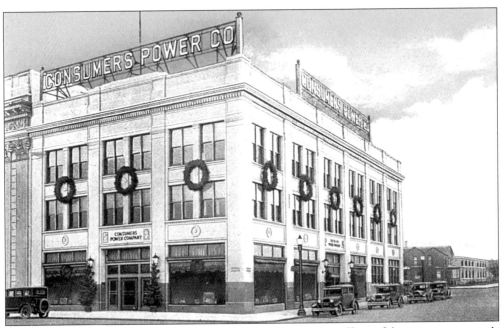

Consumers Power Co. This three-story building housed the offices of the power company's division managers. Located at 600 Federal, at the corner of Warren, it also had a show room for Frigidaire appliances. The gas and electric distribution superintendents' offices were located in the building. In 1974 the Liebermann Trunk Company business was located here.

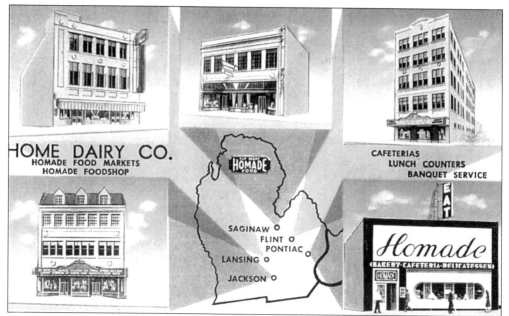

HOME DAIRY CO. The first Home Dairy was opened in May of 1918 in a rented building at 403 Genesee where a beer and lunch business had operated. Prohibition ended that business. The Home Dairy Co. also owned Park & Shop Super Food Markets on N. Niagara Street and Gratiot Avenue. There were also food stores in Lansing, Flint, Jackson, and Pontiac.

HOME DAIRY CAFETERIA. The business was located at 403–405 E. Genesee. Downtown workers were welcomed to the lunch counter by a huge lighted "EAT" sign on the building. In 1934 a cafeteria was added, where the tables were adorned with fresh roses. Downtown shoppers stopped at the Home Dairy to look over the baked goods while waiting for the city buses which stopped there on E. Genesee.

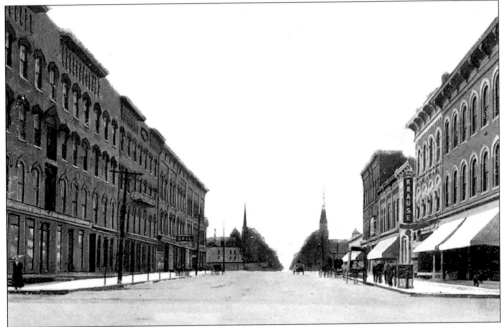

PAUL KRAUSE CLOTHING CO. This store at 404 Court Street was established in 1903. It was distinctively the most progressive, as well as the best-lighted and trimmed, clothing store in the city. This store catered to professional men, businessmen, working men, young men, and youths, and made a specialty of its children's clothing department. It carried up-to-date goods provided by American, German, and French clerks.

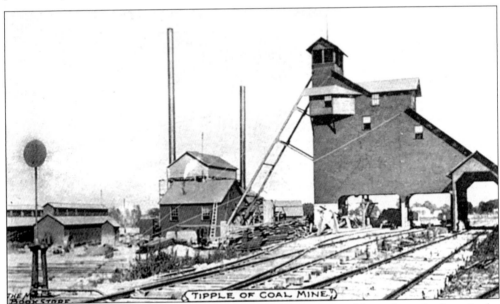

COAL MINING. Seen here are the tipple and powerhouse of one of the early coal mines. In the early 1900s, Saginaw had 30 mine shafts which produced 5,000 tons of excellent grade coal daily. Most of these mines were within or close to the city limits. Saginaw's first mine was the W.T. Chappell Mine on the Genesee Plank Road. (Courtesy of Pat Stoppleworth.)

Eight
RIVERSIDE PARK

ENTRANCE TO RIVERSIDE PARK. Riverside Park was established by the Union Street Railway in 1894 and operated by its successors, The Saginaw Valley Traction Co. and Saginaw Transit Co. Pictured here is a streetcar which crossed the Bristol Street Bridge and traveled from Saginaw's South West Side to enter the park along the heavily wooded area. The Great Depression caused the demise of the popular park, which was later acquired by Arthur M. Hickey, a leading Saginaw auto dealer.

LIGHTED ARCH AT RIVERSIDE PARK. Originally slated to be located along the Cass River, plans were changed and Riverside Park was situated on 80 acres on the banks of the Tittabawasee River. It was owned by the Saginaw Valley Traction Co. and was laid out with a dancing pavilion and refreshment stands. The lighted arches at the entrance guided visitors into the park.

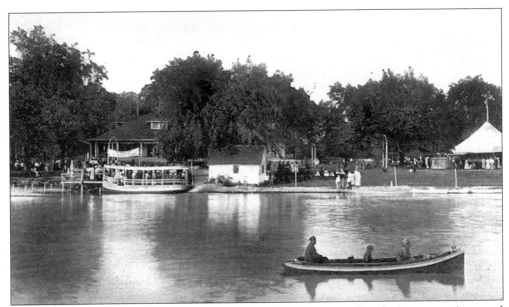

POPULAR SUMMER RESORT. Along with rides, dancing, roller-skating, canoeing, and picnicking in the amusement area of Riverside Park was a hot dog stand operated by Mr. John L. Hay. Hay was thought to be the inventor of the hot dog. He introduced the tasty 5¢ hot dog at the park around the turn of the century. Hay was a redhead, and was known as "Big Red" to his customers. For a number of years, Hay's little stand was called the home of the first hot dog. In later years the stand was used as a ticket office.

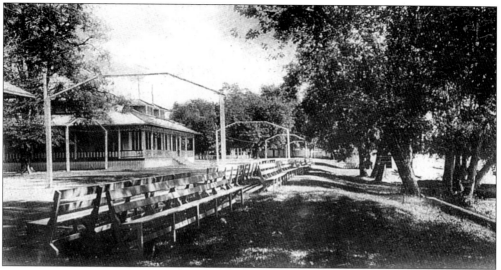

CASINO AT RIVERSIDE PARK. During the summer of 1901, large crowds enjoyed evening entertainment including vaudeville, comedy, or dancing. The Casino building became too small for the growing crowds, so a larger, more updated Casino was erected in 1902. The original Casino was moved to the exit area and used by passengers waiting for streetcars leaving the park.

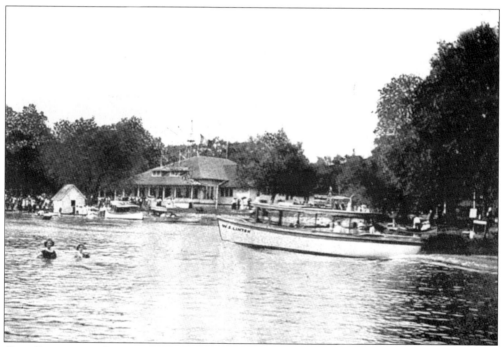

OUR BEAUTIFUL PARK AT RIVER SIDE. The crowds here are enjoying a day at the popular summer resort on the Tittabawassee River. The *W.S. Linton* is speeding along carrying sightseeing passengers. The swimmers in the foreground share the waters with the boats, as the swimming area was not roped off to protect the swimmers.

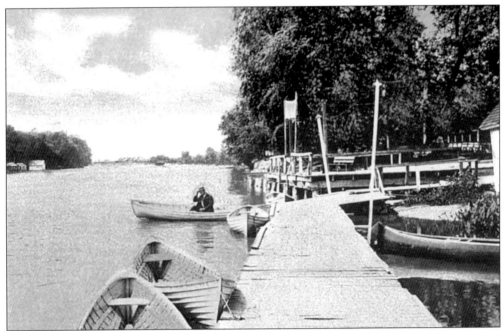

RIVERSIDE PARK BOAT LANDING. A canoe could be rented at the park for a small fee, usually five cents. Visitors came dressed in their best attire. The man pictured here is wearing a suit and his favorite straw hat. Across from the boat landing can be seen the many houseboats, which were summer homes to many residents.

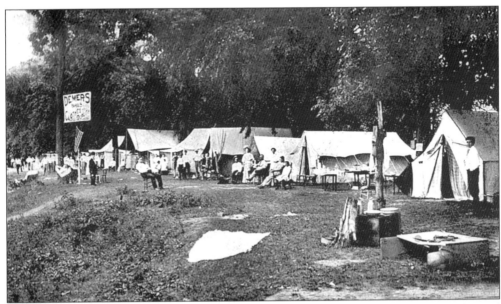

CAMPERS ACROSS FROM RIVERSIDE PARK. An area known as Demers Landing was located on the Tittabawasee River bank. Here was a camp of tents where families spent the summer months away from the city. These tents were not as substantial as houseboats, which were located on the opposite bank. The families who spent the summer here could be near the amusement park all day.

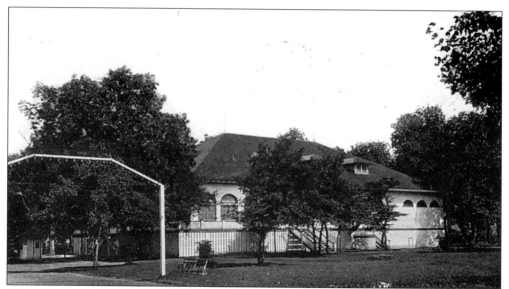

NEW LARGER CASINO. Very few people came to Riverside Park without visiting the Casino. Entertainment, vaudeville shows, and dances were held here. Some of Saginaw's own stars performed at the park. Among them were the comedy team of Bickel and Watson. Couples danced to the tunes of Saginaw's own Isham Jones.

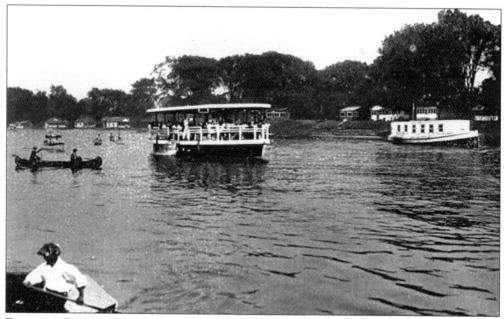

BOATING, RIVERSIDE PARK. The Tittabawassee River was the scene of a variety of pleasurable activities. Visitors could rent canoes by the day or by the hour, or for 5¢ they could enjoy a half-hour ride on the *Recreation*, the sight-seeing craft. The swimmers at the park did not seem to be bothered by all of the boat traffic.

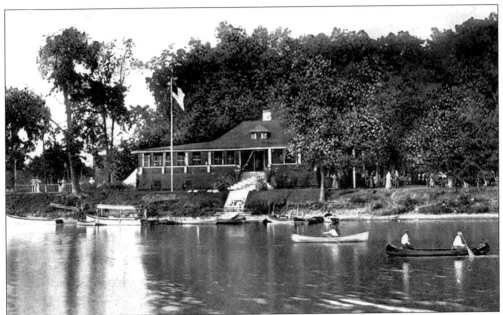

ORIGINAL CANOE CLUB. The Saginaw Club was launched in the summer of 1904. A clubhouse was built on the banks of the Tittabawassee at the west end of Riverside Park, at the foot of Maple Street. It was called the Riverside Beach, and its sandy shoreline attracted swimmers each summer. Members kept their canoes at the club house and used them to paddle through the "cut" into the Shiawassee River.

RIVER BANK AT RIVERSIDE PARK. Families could bring their lunches and enjoy a day of picnicking at this popular resort. They could relax on the river bank and watch the canoes and swimmers in the water. A card mailed in 1907 asked, "Do you remember the afternoon we took the satchel full of apples out to this park? We sat here along the river bank until the ticket window opened for the show."

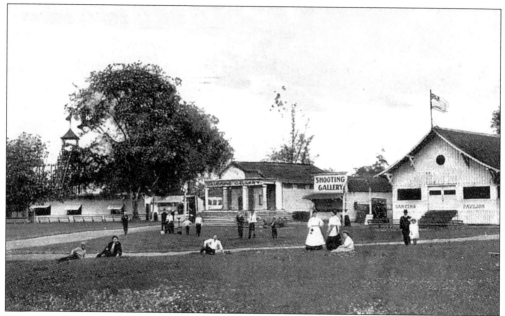

DANCING PAVILION. On the left of this card is the Figure Eight Roller Coaster. This ride could accommodate as many as 40 riders at one time. The Laughing Gallery was the place to see oneself in a variety of curved mirrors. Next to it was the bowling alley. The Dancing Pavilion held marathon dances during the 1930s. In August of that year, a 17-year-old girl collapsed and died after three continuous weeks of dancing. This event brought an end to the marathon dances.

CIRCLE SWING. In 1905 the Circle Swing was installed. The 70-foot tower had six radiating arms on 25-foot cables. The cables swung six cars up and out at great speeds. Daredevil riders enjoyed this attraction, and luckily no accidents occurred here.

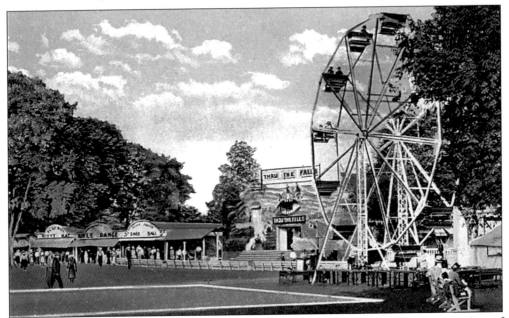

AMUSEMENT SECTION, RIVERSIDE PARK. In addition to swimming and boating, a variety of rides and games were available at the park. Visitors could ride on the ferris wheel after buying a string of tickets, or they could play one or all of the available games. Here they could ride "Thru the Falls," try their hand at the rifle range, throw a ball at the rag dolls at the "Kitty Kat," or, for 5¢, play "Skee Ball."

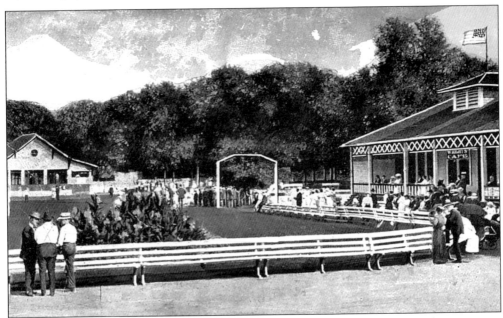

WRIGHT'S CAFÉ. In 1905 a large modern restaurant was built. Caterer Bert Wright from Wenona Beach came to Riverside Park, and the restaurant was called "Wright's Café." There were long dining tables and soda and lunch counters, where dinners or snacks could be ordered. In the center of the building was a bandstand where patrons were entertained with musical numbers.

Nine
SAGINAW RIVER

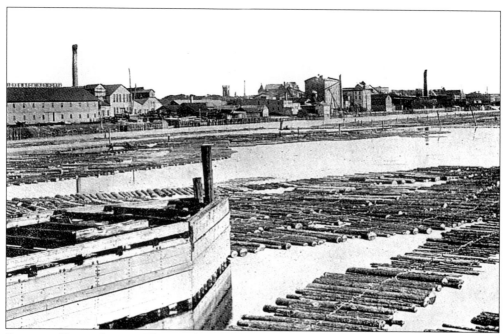

SAGINAW RIVER SCENE. The Tittabawassee, Shiawassee, Cass, and Flint Rivers, along with their tributaries, provided the only practical routes for bringing pine logs out of the forests. There were as many as 40 sawmills on the Saginaw River, and the logs floated down were marked with the log marks of the owners' companies. This card shows rafted logs ready to be towed to the mill. The logs were held secure with rope and hardwood pegs driven into them.

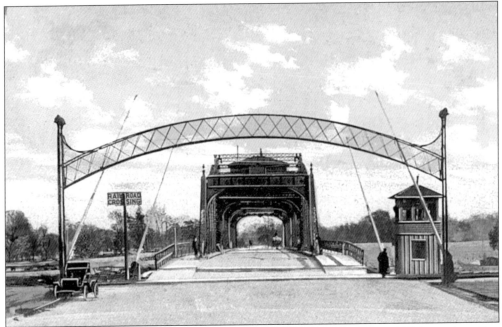

COURT STREET BRIDGE LOOKING EAST. When the bridge was built in 1897, it was kept free of trolley tracks, and was used by car owners and pedestrians. The railroad tracks in front of the bridge run along Hamilton Street. In 1938 plans were made to rebuild the bridge as a modern steel and concrete structure. In the 1990s it was modernized again and renamed the Andersen Bridge.

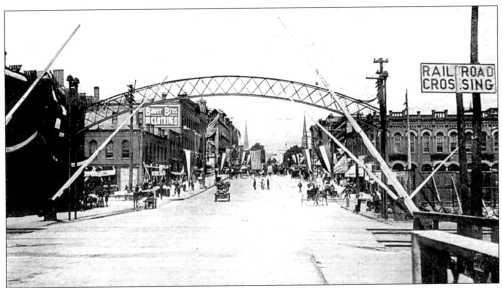

COURT STREET BRIDGE. One of the conditions of consolidation of the two Saginaws was the building of three bridges. A wide, modern bridge was built at the foot of Court Street and a connecting roadway was paved across the middle ground and Emerson Bayou to Washington Street. In 1897 the thoroughfare was completed and opened for traffic. This view looking west shows flag-draped storefronts, perhaps celebrating the 4th of July.

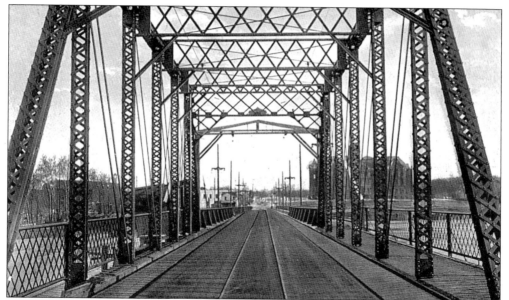

BRISTOL STREET BRIDGE. In 1865 this bridge was built as a toll bridge. It was longer than the bridge at Genesee Street and had two draws, one near each end. About 1885 it was bought by the Central Bridge Co., rebuilt, and used by the cars of the Union Street Railway. It was one of the main arteries of travel across the river. In the 1890s a steel swing span was added, and in 1911 the bridge was entirely rebuilt by the street railway company. In 1912 the ownership passed to the city.

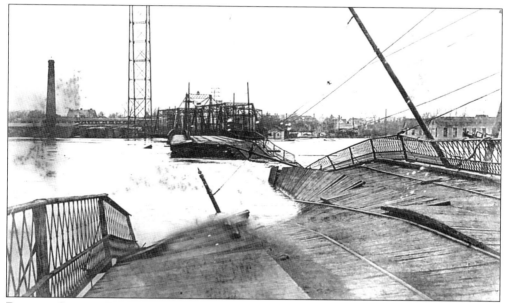

BRISTOL STREET BRIDGE AND FLOOD. In 1911 the Bristol Street Bridge was rebuilt by the street railway company at a cost of $30,000 and ownership was passed to the city. The flood of March 1916 resulted in the complete destruction of the bridge. The steel swing span and a lumber yard can be seen in the background of this postcard. The related message indicated that the photo was printed in the news of the day.

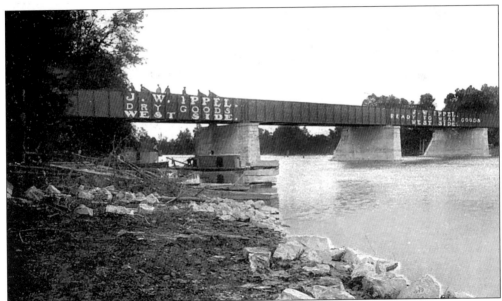

GRATIOT ROAD BRIDGE. This bridge replaced the old Paines Bridge which crossed the Tittabawassee River on Gratiot Road. With the help of some prominent West Side businessmen, $71,000 was pledged toward the construction. In 1909 the new bridge was dedicated, and a huge celebration was held beginning at the bridge and continuing to the Saginaw County Courthouse. Julius W. Ippel was chairman of the celebration. This card showing the bridge was an advertising card for the Ippel Dry Goods Store. Note the houseboats in the river.

HOUSEBOATS. As late as the 1960s, there were still houseboats on the Saginaw River. An effort was made to rid the area of them and relocate the families. Some officials complained that raw sewage was being discharged in the river from the floating sub-standard housing. Many families had relied on houseboats as their only means of shelter after the depression years of the 1930s.

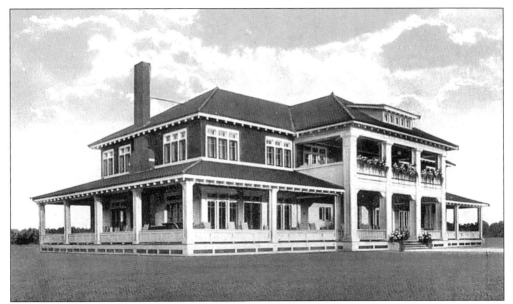

CANOE CLUB ON OSAKINA ISLAND. A club house with a red tile roof was built on Wright's Lagoon, at Osakina Island of Ezra Rust Park. It was dedicated in 1915. The site is on the east side of the Saginaw River, just south of the former Court Street Bridge (now Andersen Bridge). A landing for canoes was constructed on the river bank, along with a housing for members' canoes. A catering service was provided by the club to service the dancing parties and social functions held there.

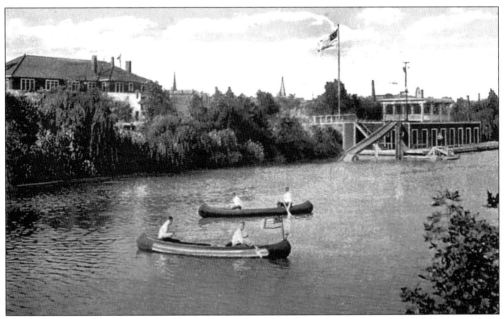

CANOE CLUB LANDING. In 1913 the large new club house was erected and tastefully furnished. A landing for canoes and boats was constructed on the river bank close to the side of the club house, with proper housing provided for all canoes owned by the members. Here we see canoe club members enjoying an afternoon on the river.

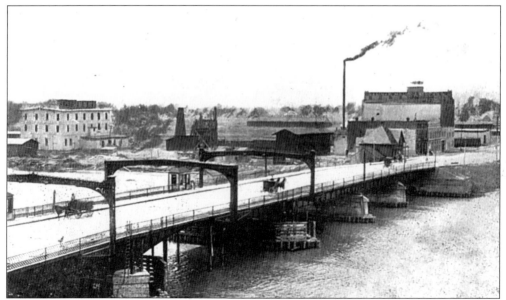

FIRST GENESEE AVENUE BRIDGE. Before the first Genesee Bridge was built in 1864, a rope ferry carried passengers and goods across the river. Traffic on the Genesee Avenue Bridge in the early days was by horse and cart. Traveling to East Saginaw, one could see the logs piled up on the river bank, the Pere Marquette Coal Mine, and the beginnings of commercial buildings.

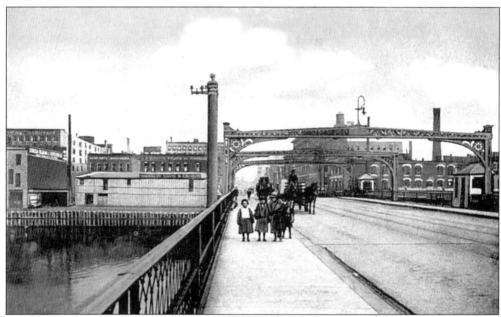

GENESEE BRIDGE OVER RIVER. This scene does not foretell of the tragedy of October 28,1885, when a portion of the bridge collapsed. Four people drowned, several were reported missing and 35 injured people were pulled from the river. The cause was a fire on a tug boat. It was a minor blaze, but many rushed against the railing, causing the railing to collapse. Viewers were hurled into the water beneath. The Saginaw Bridge Co. was cited for not having the bridge in proper repair.

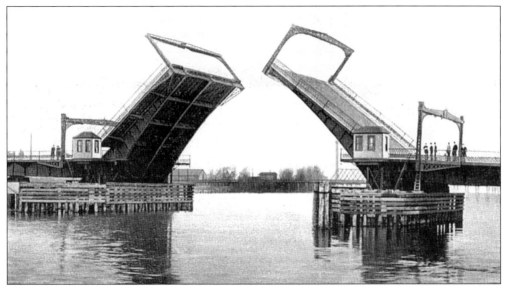

LIFT BRIDGE, GENESEE AVENUE. The new Genesee Avenue Bridge was opened on Labor Day 1905 and was nearly 600 feet above sea level. It featured a pedestrian walkway, bridge tenders' houses and streetcar tracks used by the Saginaw Valley Traction Co. During the lumbering days, the bridge was opened often to accommodate the river vessels. Sightseers were always anxious to see the bridge being raised. Shown here are pedestrians waiting for the bridge to be lowered.

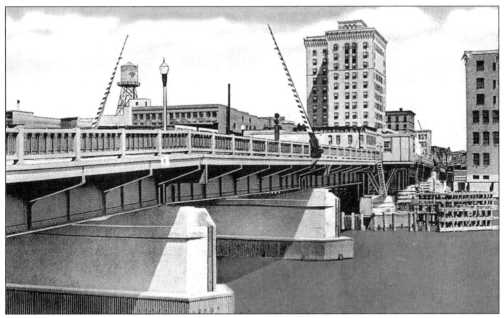

1938 GENESEE AVENUE BRIDGE. When the Lift Bridge, built in 1905, was replaced and completely rebuilt in 1938, it was a modern structure. However, it still needed to be opened to allow for river traffic. This card noted that the bridge spanned the largest river in the United States which emptied into fresh water. Note the old wooden pilings from the former bridge. In 1973 this bridge was completely replaced and it was no longer necessary to be opened.

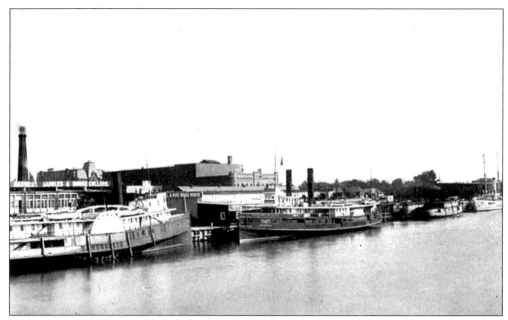

RIVER VIEW AND BOAT DOCKS. Along the Saginaw River one could see a variety of ships: schooners, steamboats, and scows, often docked at the many piers. In the background on this card can be seen the words: Lumbering, Tools, Harness, Saddles & Horse Collars. Two of the ships pictured are a sailing ship and a side wheeler.

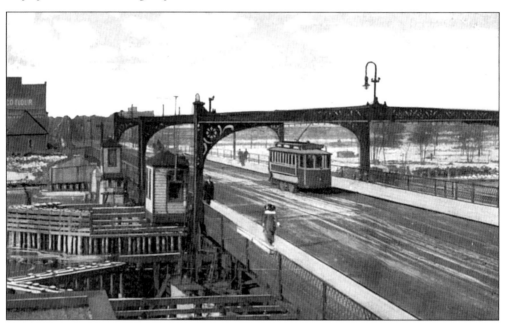

GENESEE AVENUE LIFT BRIDGE. This is a good view of the bridge pilings and the bridge tenders' houses. The bridge tenders were on duty to raise the bridge for river traffic. The walkways were wide and safe for the bridge walkers, who paid a toll to cross the bridge. The Saginaw Valley Traction Co. paid an annual fee to the city to continue running its streetcars across the bridge.

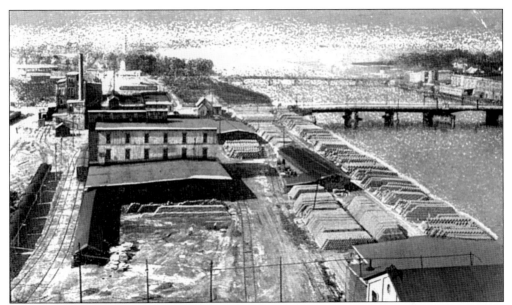

SAGINAW RIVER, SALT BARRELS. Barrels of salt waiting for shipment are shown stacked on the river bank in this early card. Along with lumbering, salt was an important early industry in Saginaw. Excess steam from the lumber mills was the energy source for salt production. In 1888 Saginaw County produced over one million barrels of salt. When the cheap energy supply from the lumber mills waned, salt making as a big business ended.

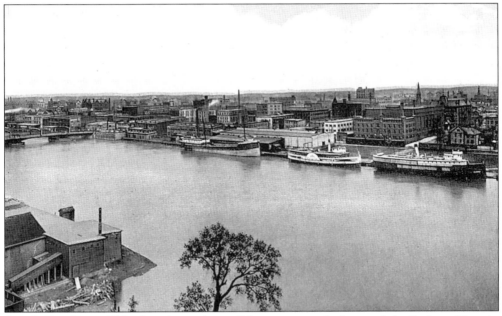

BIRD'S EYE VIEW. This view shows three of the many vessels that used the Saginaw River in the early 1900s. The middle ship is the side wheel steamer, the *Wellington R. Burt*, which was built in 1877 and took passengers from Saginaw to Lower Saginaw (Bay City). The other vessels carried lumber from the area. A sawmill is shown in the foreground of the card. The Genesee Street Bridge is pictured in the distance.

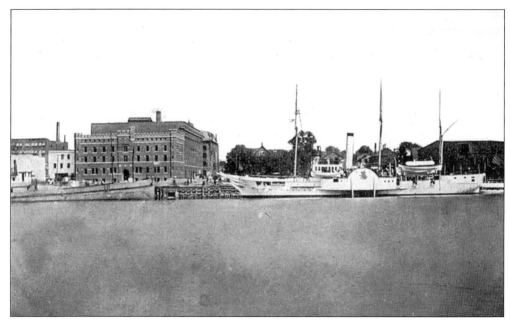

GOVERNMENT BOAT *WOLVERINE* AT ARMORY DOCK. Among the vessels that plied the Saginaw River were cargo ships carrying lumber and grain from the area, side wheelers carrying passengers, and a government ship. Seen at the Armory Dock is the *Wolverine*. The Armory is pictured on Water Street facing the river. Behind the Armory is the new Auditorium.

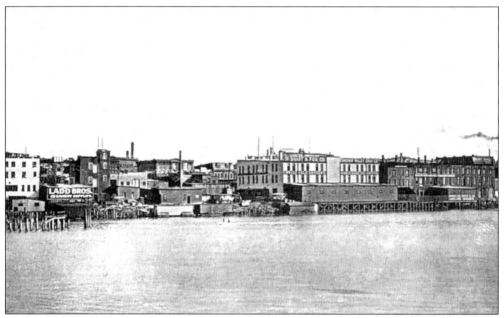

VIEW FROM THE WEST SHORE. Many early businesses were located along Water Street in East Saginaw. Two of these, seen from across the river, are Ladd Brothers Creamery Supplies and Dudley Butter Co. The large warehouse is that of Smart & Fox Co., which was located at the foot of Tuscola Street. They were dealers in wholesale groceries and later added a wholesale drug department.

Ten

REAL PHOTOS

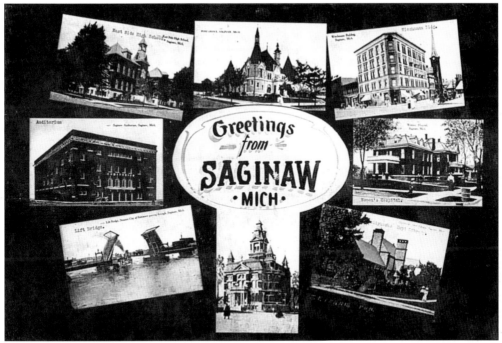

GREETINGS FROM SAGINAW. This early card illustrates eight familiar scenes of Saginaw in the early 1900s. Seen here are prominent buildings and the Genesee Avenue Lift Bridge. Among the stately structures are the County Courthouse, Women's Hospital, Post Office, Wiechmann Building, Hoyt Library, East Side High School, and the Auditorium.

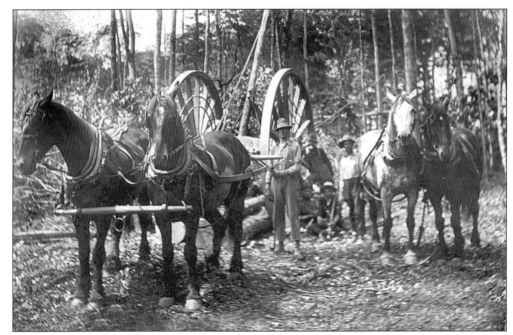

BIG WHEELS. Important to Saginaw's lumber industry were the Big Wheels. After the forests were scouted and chosen for the best trees, the loggers moved in to harvest the timber to be sent to a sawmill. In the 1870s, Sylas C. Overpack of Manistee invented the "Big Wheels" that could haul 4,000 board feet of logs out of the woods to a stream or railroad siding. The "Big Wheels," pulled by horses, made the summertime harvesting of trees possible.

LUMBERMEN'S MONUMENT. William B. Mershon, one of Michigan's early conservationists, was mayor of the consolidated Saginaws in 1894–1895. One of his favorite projects was the Lumbermen's Memorial, which stands on a high bank above the Au Sable River (Tawas area). He conceived of the idea for the monument and spent many hours handling the details. It portrays a river driver, a timber cruiser, and a tree feller.

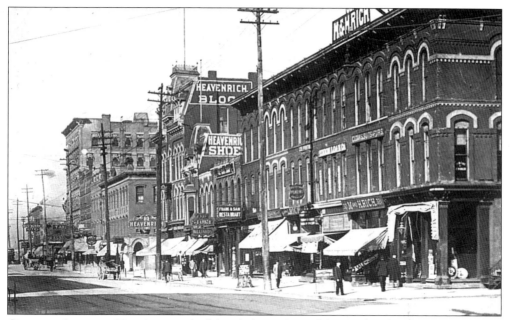

GENESEE AVENUE. Here is a wonderful real photo view of the north side of Genesee Avenue looking west from the tower block. Trolley tracks are visible, as are the horse-drawn carts. A variety of merchants conducted business along this busy area of East Saginaw. M & H Rich advertised cloaks, suits, and furs. Heavenrich's sold men's furnishings. Restaurants, billiard parlors, a printing company, and hotels add to the diversity of the area.

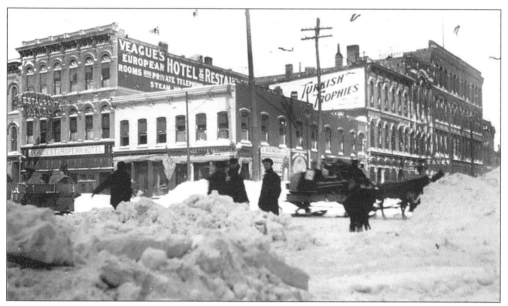

1912 SNOWSTORM. This picture was taken on February 22, 1912. The winter scene shows the activity at the intersection of Washington and Genesee. Horse-drawn sledges are moving goods along the streets of East Saginaw. In the background is the Veague's European Hotel, which in later years became the site of the Morley Arcade. The two-story corner building later became the site of the Second National Bank.

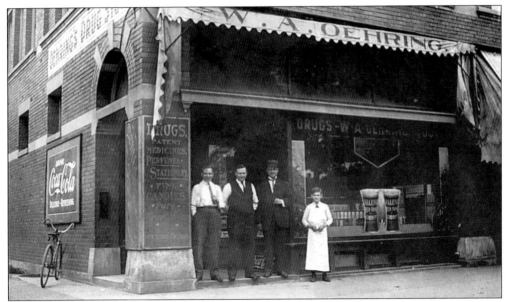

W.A. Oehring's Drug Store. In 1912 this sturdy brick building located at 1301 Court Street, at the corner of S. Mason, was the home of the Oehring Drug Store. Of the advertised items here were Allen's Red Tame Cherry Drink, which sold for 5¢, Coca Cola, patent medicines, candy, and perfume. Later businesses at this location were Farnum's Cut Rate Drug Store, and today, the Lamp Shade Nook.

East Saginaw Home. This early 1900s real photo postcard sent to Indiana advertises a steel furnace. "$63 worth of coal heated this ten room house in Saginaw, Mich. for one entire year including the terrific cold of last winter, when the mercury stood for days at 22 degrees below zero. A Quaker Steel Furnace #435 was used. A Quaker Steel Furnace will serve you equally as well."

122

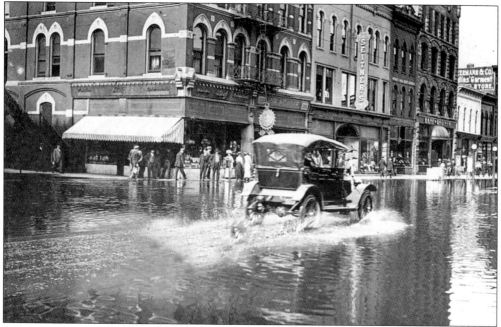

HIGH WATER, MAY 1912. On May 24, 1912, pedestrians are seen walking on the raised plank sidewalks in front of the stores. The message, written in June, details the events of that spring. The writer stated that there had been nothing but rain since Easter and that the picture did not do justice to the flood. The writer mentions that the farmers are just beginning to plant and the fear is that people will starve the next winter.

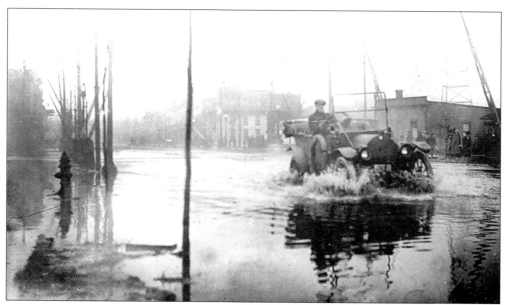

FLOOD OF 1916. This scene of the high water on W. Genesee Avenue is dated March 30, 1916. The pedestrians on the plank walks watch the auto driver create waves driving through the flood waters. The message on the reverse side of this card states that all of the autos had clean wheels at that time.

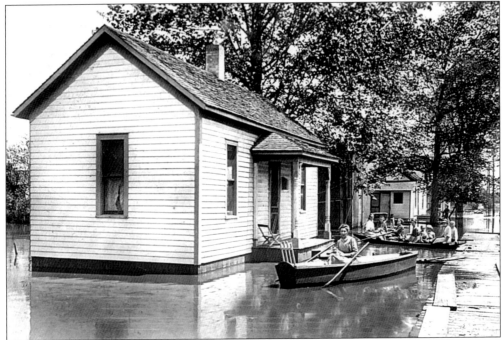

MAY 1912 FLOOD. The flood of May 1912 caused homeowners to take to boats. The plank walk is above water, but not by much. This flood scene in this area of Saginaw's East Side was not unique, as the river flooded often here. These dwellings were in the Birch and Harris Street area of South Saginaw, which was close to the river. (Courtesy of Herman Rindhage.)

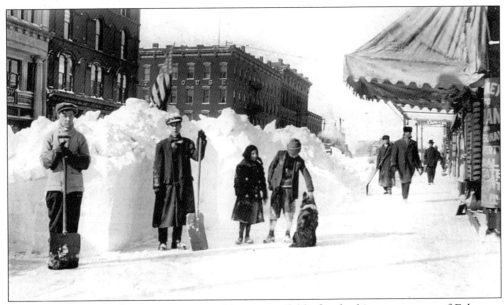

SNOW SHOVELERS. There were no snowblowers available for the big snowstorm of February 22, 1912. All work was done by strong young men with snow shovels. The walks along Genesee Avenue east of Washington have been cleared, and an American flag has been placed on top of the snow pile. In the distance, the top two floors of the Bancroft House are visible in the photo.

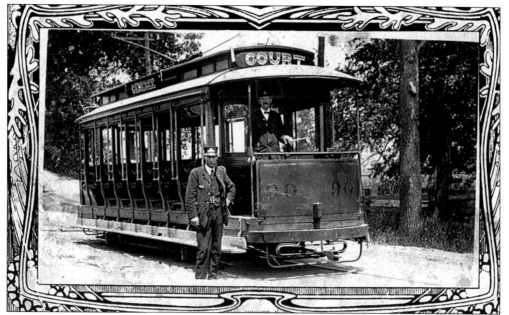

TROLLEYS. In the early 1900s, this was the main method of transportation for Saginaw's residents. Streetcar tracks lined all of the main streets. The Saginaw Valley Traction Company bought the former horse car operation, the interurban service, and the Union Street Railway Company, thus making it the sole owner of all of Saginaw's streetcars. Open air trolleys carried residents to Riverside Park during the summer months. (Courtesy of George Barrett.)

"SAGINAW BOAT" AT RIVERSIDE. Here a family, including members of three generations, has gathered for a picture in the cutout boat at Riverside Park. The picture was probably taken around 1915. Grandma is holding a flag, which most likely indicates that it was a 4th of July celebration. (Courtesy of the Wm. J. Culver Collection.)

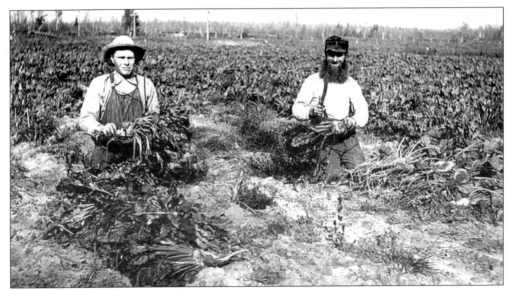

SUGAR BEET WORKERS. After the decline of the lumber industry, there was an interest in using the "stump lands" to raise sugar beets. Early migrant labor was used to work in the fields. Entire families "worked the sugar beets." The crop needed to be thinned, hoed, and cultivated. When the beets were harvested, they were topped by hand and then piled in the field to be loaded in wagons for delivery to the factories.

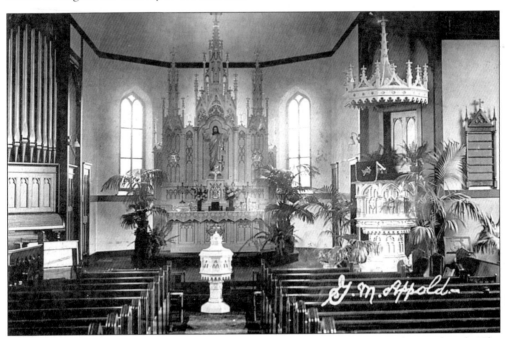

CHURCH INTERIOR. Here is an interior view of a typical early German Lutheran church. The interior shows an ornate white altar centered with a plaster Christ figure. The baptismal font and the raised pulpit also add to the ornate look. The picture was probably taken on Palm Sunday as the plants indicate. On the left is the pipe organ, and the hymn board hangs on the wall on the pulpit side.

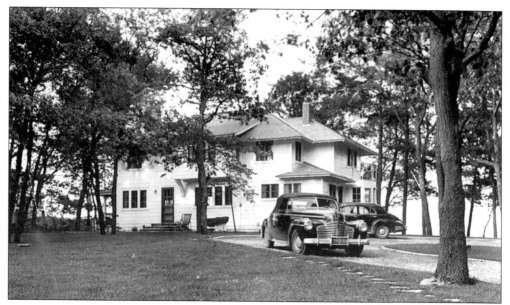

H.J. Stenglein Cottage at Point Lookout. This was the site of the Spic & Span sales meeting in June of 1943, according to the message on this card. Spic & Span was developed by Harold Stenglein and his wife from Mrs. Stenglein's grandmother's recipe for wall-cleaning soap. Spic & Span caught on immediately and acquired the reputation as one of the best household cleaners on the market. It was sold to Proctor and Gamble in 1945 for several million dollars.

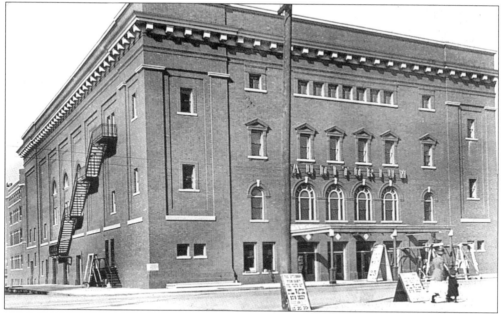

Saginaw Auditorium. A few years after the dedication of the Auditorium, some changes were made to the building. A fire escape was installed and a roof was built over the entrance doors to give patrons a shelter before they entered the building. Notice the billboards advertising coming attractions. This is a Pesha photo. Pesha produced photos of many of the important structures and places around the city.

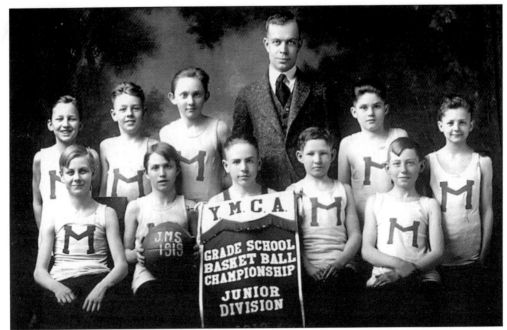

YMCA Basketball Championship. In 1919 this group of young basketball players from John Moore School won the grade school championship. As indicated on the back of the card, the team members are, from left to right, as follows: (back row) Robert Smith, Ed MacKinnon, Red Bell, Coach Johnson, Henry Boutell, and Ed Alderton; (front row) Gilbert Meade, Ed Arnold, Jim Lehand, Morris Swift, and Elmer Bohnhoff.

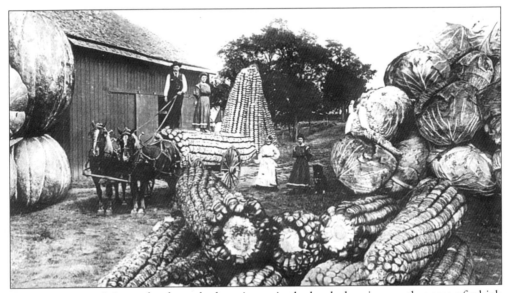

Exaggeration. It is good to have the last picture in the book showing another area of which Saginawians can boast. The fields in the Saginaw Valley have always been noted for their fine crops. In summer, residents visit the local markets to purchase home-grown produce directly from the farmers. The area's corn, cabbages, and pumpkins are large, but not quite as huge as those shown here.

Is this a young 1925 Green Bay Packer? No, it's actually Ruth Straubel Hartman, a young girl who lived on North Ashland Avenue, getting into the spirit. (Courtesy of Ruth Straubel Hartmann.)

Out for a ride on her tricycle, Terry Meeboer enjoys an afternoon on Broadway in front of the family tailor shop. Just across the street is the Midwest Fish Company, a good place to purchase fish for dinner or to watch the workings of a commercial fish operation. Kneeling next to Meeboer is Cliff Goodletson, her babysitter. (Courtesy of Dorothy Meeboer.)

Terry Meeboer and her grandmother stand across the street from 236 North Broadway, home of Bay Meats and other businesses at various times. (Courtesy of Dorothy Meeboer.)

125

Robert Kreuser, son of William, displays his shoe repair skills in his shop at 236 North Broadway. This was the second location of the business started by his father. He and his family lived upstairs from the shop. (Courtesy of Robert Jr. and Larry Kreuser.)

Lawrence "Stix" LaHaye stands outside his well-known electric shop at 335 South Broadway. Barney's A&W is visible in the background. A favorite of the many stories about Stix recounts an event that took place before one Christmas. Discouraged with the lack of city holiday lights on Broadway, he used his own talents and tools to string Christmas lights for several blocks. (Courtesy of Pat LaHaye.)

Four men stand in front of Tweet Plumbing, established in 1924 by Andrew Tweet. Various taverns moved into the building over the following years. Larry and Ben Frye restored the building to look much like it did as a plumbing shop, and they received several awards for their efforts. (Courtesy of Arlene Tweet.)

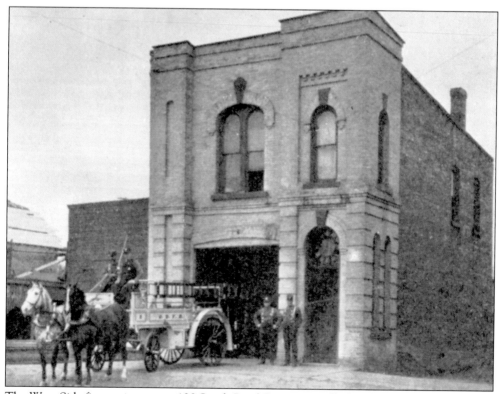

The West Side fire station sat on 120 South Pearl Street, just off of Walnut Street (Photograph from On Broadway, Inc. collection.)

Donald Kennedy, a Broadway "Beat Cop," stands next to the Duchateau Building in the early 1950s. Kennedy was a West Side resident and a policeman for 25 years, known for his gruff voice, big smile, and hearty laugh. Incidentally, he is shown carrying a measuring stick, not a nightstick. (Courtesy of Theresa Kennedy.)

Here is one of our favorite characters! (Courtesy of Marie Duchateau.)

Pictured here is an afternoon at Duchateau's Saloon. (Courtesy of Marie Duchateau.)

Activities in the saloon included playing cards. (Courtesy of Marie Duchateau.)

photo, the building was one of the newest on the block. It also housed Shaughnessy Drug Store on the first level. (Courtesy of the Junion Family.)

Dr. M.J. Junion, one of the city's well-known dentists, displays his new office in 1931. The former location of his office is now the Coppertop Restaurant dining area. At the time of this

Joe Kabat (at right) waits on a customer. Visible behind them is an x-ray machine that was used to determine foot size. These machines were later phased out because of concerns over their safety. (Courtesy of Larry Kabat.)

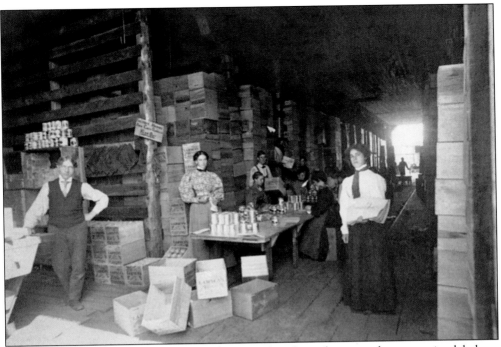

Time for a break at Larsen's canned goods store. This photo shows employees putting labels on the canned food items. (Courtesy of Greg Larsen.)

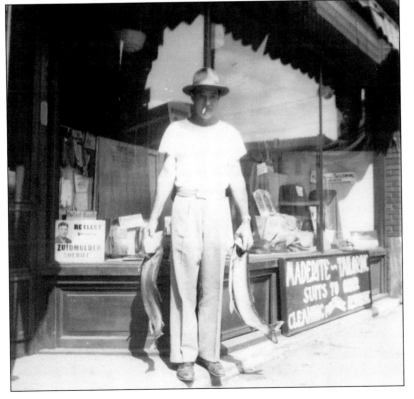

A 1950s photo shows Gerald Meeboer with his catch, ready for cooking. He had caught the fish in Door County earlier that day and brought them back packed on dry ice. (Note the life-like position of the frozen fish!) His father, Garrett, opened the Maderite Tailoring Shop at 233 North Broadway. (Courtesy of Dorothy Meeboer.)

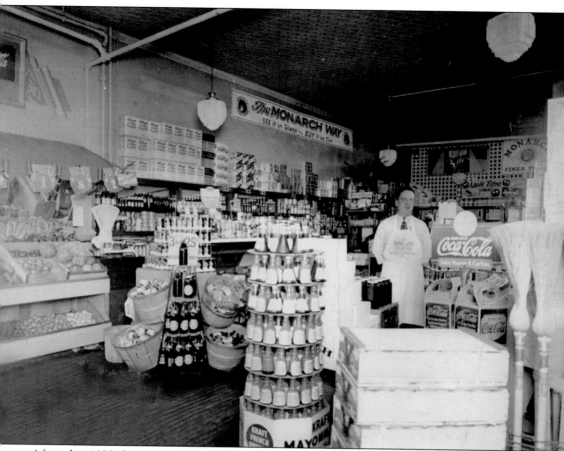

After the 1933 fire at neighboring Oldenberg Furniture badly damaged the Tom Camm building, banker Frank Planert approached Al Callahan and said, "I'm going to put you into the grocery business." The Camm building was restored, with Joe Hoida providing Callahan with new shelves and counters. Planert purchased goods for Callahan from Lee Joannes, a wholesale grocer on the east side. Callahan soon repaid his debts and in 1950 started Badger Wholesale. (Courtesy of Bob Callahan.)

Apple or blueberry? Bill Janquart would sell you one of his specialties. He was the owner of the Tasty Bake Shop, open for business from 1933 to 1951. His wife, Leone Janquart, is glazing doughnuts by the dozen. Doughnuts, always a popular item, were delivered to many churches, schools, events, and stores. (Courtesy of Kate Janquart-Baeten.)

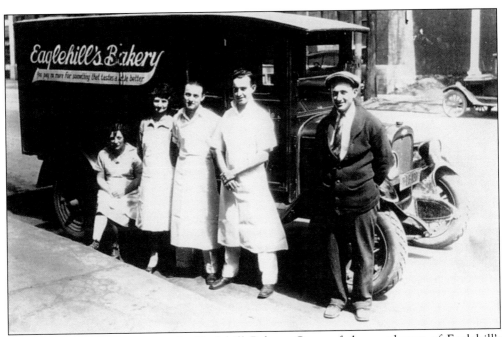

Bill Janquart got his start at the Eaglehill Bakery. Some of the employees of Eaglehill's Bakery pose in front of a delivery truck. Bill Janquart (second from right) later took over the business and changed the name to the Tasty Bake Shop. (Courtesy of Maxine Dernehl.)

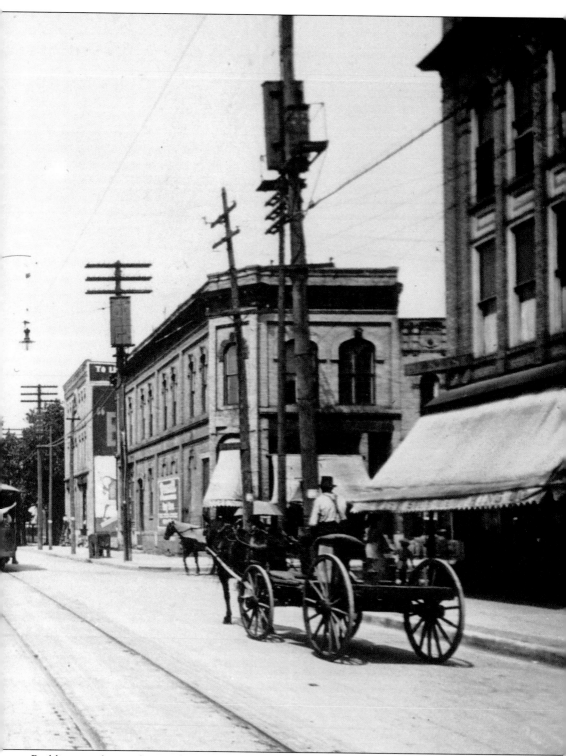

Building; on the northwest, the Commercial Hotel; on the northeast, Manuel Brunette; and on the southeast, the Tom Camm building. (Courtesy of Neville Public Museum of Brown County.)

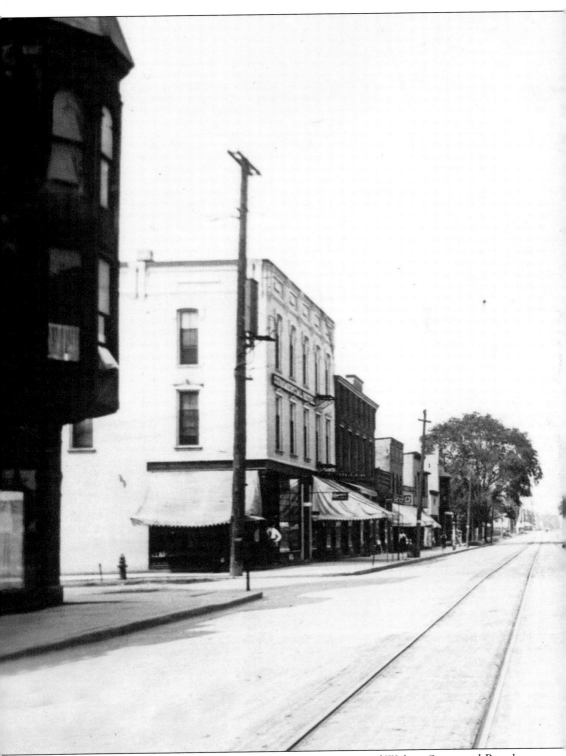

Looking much less busy in 1900 than today is the intersection of Walnut Street and Broadway. Buildings located there at the time were the following: on the southwest corner, the Grey

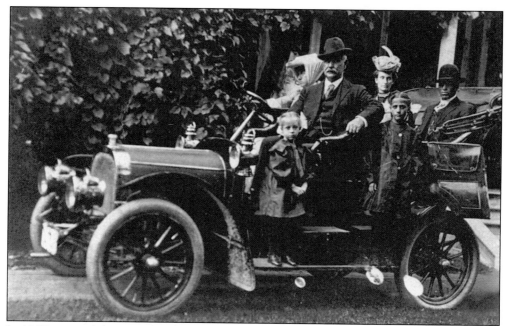

In 1907, automobiles were mostly a toy for the well-to-do. Charles J. Anderson and his family proudly display their car in front of their West Mason Street home. Anderson was a well-known architect in the area. (Courtesy of Neville Public Museum.)

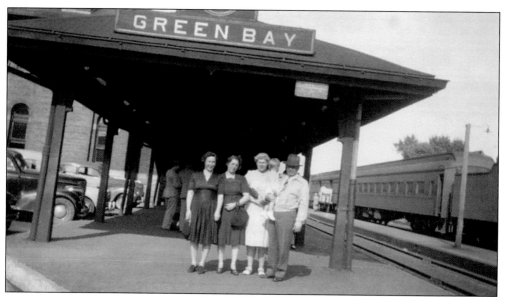

In the 1940s, passenger train service was far more common than it is today. These ladies have come to greet someone at the Chicago & North Western station. Today the station is the home of Titletown Brewery. (Courtesy of Marie Duchateau.)

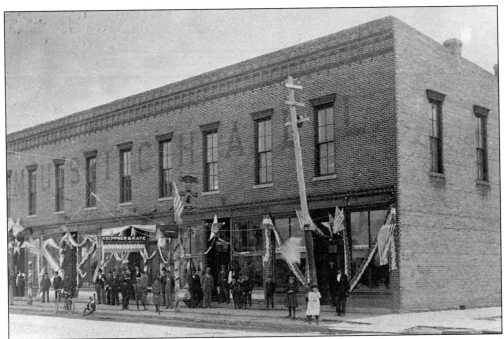

While Fort Howard had no official theater, the "Music Hall" on West Walnut Street served a similar purpose. The second floor served as a public-meeting site and dance hall, while the first floor was occupied by various businesses. The building is still in use today, 91 years later. (Courtesy of Neville Public Museum.)

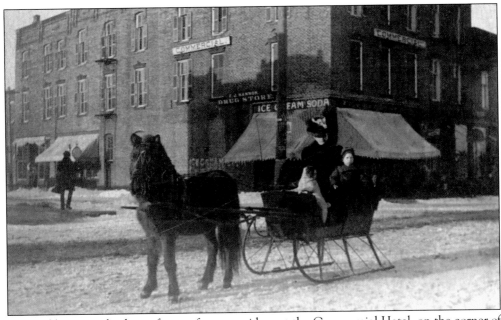

Pictured here is a sleigh out for an afternoon ride past the Commercial Hotel, on the corner of Broadway and West Walnut Street (c. 1900). The hotel was famed for its second-floor family dining room. Also visible to the left is Jacob VanderZanden's first jewelry store, marked by a small awning. (Courtesy of Neville Public Museum.)

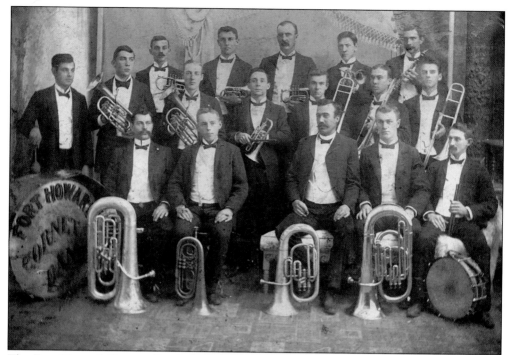

The Fort Howard Coronet Band shows off for this photo taken in 1894. Pictured from left to right are the following: (front row) Herman Buengner, Ludolf Hansen, G.A. Grosse, Fred Stuebe, and Charles Phillips; (middle row) Fred Krause, Grant White-Conductor, Roy Hudson, Otto Hinkle, and Homer Maes; (back row) George Lewis, J. Gray, Grant Krause, unidentified, Bill Grosse, Tod Burns, and Paul Brandemihl. (Courtesy of Carol LeClercq-Paul.)

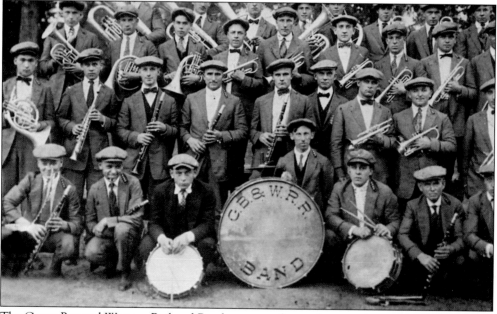

The Green Bay and Western Railroad Band was one of several groups that entertained residents just after the turn of the 20th century. The band is shown here in 1910. (Courtesy of Bill Paape.)

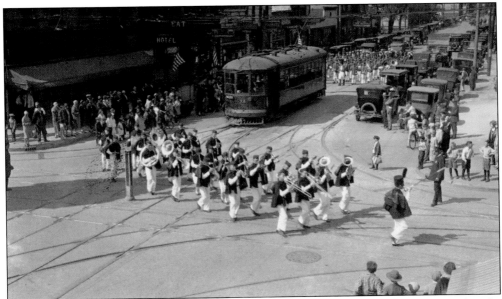

In 1926, a band competing in the first high school band tournament in Green Bay makes the turn from Broadway onto Walnut Street. The post in the center of the intersection is an old-fashioned traffic light. Cities soon learned that this location could be problematic. (Courtesy of Neville Public Museum of Brown County.)

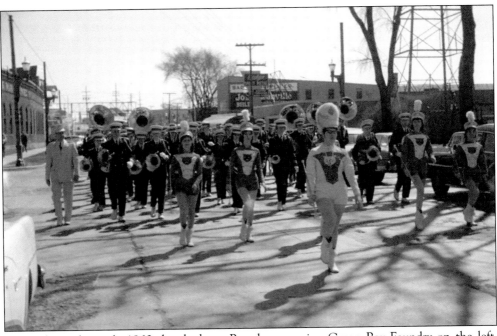

A parade in the early 1960s heads down Broadway passing Green Bay Foundry on the left. (Courtesy of Pat LaHaye.)

Seven

LIFE ON BROADWAY

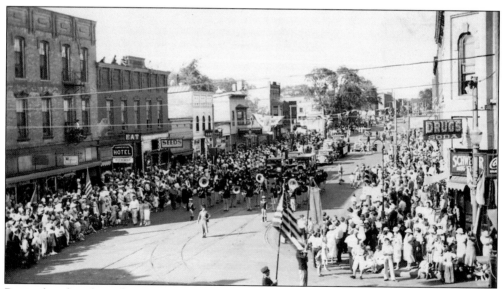

Bystanders found windows, tops of buildings, and fire escapes convenient places from which to view the American Legion perform in this 1934 parade. Visible to the right is Schweger's Drugstore, a childhood memory of many who stopped there for goods ranging from sodas to medicines. Schweger's better-known later location was across the street in the Gray Building. (Photograph from author's collection.)

Arnold Van Den Wymelenberg opened Van's Hardware at 410 Dousman in 1917 where he worked for 63 years. When he needed more storage in the early 1960s, he built a warehouse on Chestnut. While digging the foundation, the contractor found the remains of what later turned out to be one or possibly more soldiers from Fort Howard. (Courtesy of Ruth Vanden Wymelemberg-Merkey.)

Peter Platten and his family owned three large farms on the West Side. The money they earned from the farms allowed them to venture into other businesses. They opened grocery stores, meat markets, and other enterprises. In 1909, the Plattens purchased one of the first cars on the West Side. Five years later, they founded the West Bank and Trust in the Platten Building. (Courtesy of Peter Platten, Jr.)

A favorite "eatery" in the Jorgensen building was often the meeting place for these 1940s central west-side businessmen. Seated on stools to the left are machinist W. Farenbach, a grain and feed store owner along the riverfront Harry Bartles; and Carl Truenbach, owner of a gas station at 716 Walnut. (Ladies are unidentified.) The men are: (stnading at the back) Johnson, a butcher on Walnut; Louie Kocian, a barber on W. Walnut; Bob Thompson, retired railroad-man; Frank Planert, shoe store (now Rothes); Pete Moulke, president of West Side Bank; Esber Farah, groceries and vegetable stores; Harry Brehme, bar and "well-liked" restaurant; Ed Schweger drug store; Milt Mickelson, gas station; Frank Walker, cleaners (now OBI building); George Aude, second-hand furniture store; Basset, manager Fairmont Dairy; and Gus Verheyden, electric shop; and the manager of the West Theater; (seated) Ed Wolfe, restaurant owner; man partially hidden is unidentifiable; Clyde Cauenberg, jeweler; Al Callahan, grocery; Syd Sheffer, photo shop; Larry Kaiser, West Side Bank; Al "Peanuts" Farenbach, Machine Co. (Pearl Street); Frank Heinen, Walnut Furniture; and Bill Van Ess, Cement Co. (Velp Ave.). (Courtesy of Wally Conard)

On August 5, 1917, these gentlemen were ready to travel in their Kissel Kar. Their destination was Camp Douglas, a three-day journey. The group consisted of some well-known names, left to right, Wm. Sorensen, Eugene Davidson, Henry Nelson, Henry Selmer, and Walter Rehder. Sorensen and Rehder were tailors who helped start the White Store; Davidson was a salesman and photographer; Selmer founded Selmer Construction; and Nelson owned Nelson Machinery. These men were involved with the South Side Improvement Association, often recognized for their work in saving Tank Cottage, Wisconsin's oldest wood home. (Courtesy of Lucile Rehder)

Learning the trade of vegetables was just the start of William Larsen. From the simple sale of vegetables to the industrial art of canning, Larsen was a leader. The death of a civic leader, bank president, Fort Howard mayor, and entrepreneur in 1922 left a legacy of the well-known Larsen Canning Company for his sons. The first functional shop of his was established in 1890, and in 1988 integrated with Dean Foods, an expanding company founded in Illinois. (Courtesy of Greg Larsen.)

The family of Joel Fisk was one of the most prominent in the entire district. As a young man, Joel was successful in lumbering and fishing. Always interested in the development of the Borough of Fort Howard, he joined Francis Desnoyers in platting the village. Descendants of Fisk still live in the area. (Courtesy of Betty Fisk.)

Felix Lurquin and his wife emigrated to Fort Howard from Belgium in 1866. They arrived without money, but succeeded in establishing themselves through hard labor. In 1879, Felix became a citizen of the United States. On April 15, 1880, he was elected to the office of City Street Commissioner and City Marshall of Fort Howard. The combined position paid a salary of $35 per month. The following year the offices were separated and Felix was elected City Marshall, at a salary of $20 per month. (Courtesy of Mary Ann Defnet.)

In 1947, four men started meeting for coffee at Martha's Restaurant at 519 South Broadway. The gatherings grew into the nationally known Martha's Coffee Club. The Green Bay Packers were a favorite topic of discussion. In 1967, the members began collecting money for the Christian Children's Fund. Displaying their Packer bumper stickers are (first two unknown), Paul Mazzolini, Howard Blindauer, Maurice Robinson, and Ben Starr (Bart's father). (Courtesy of Mike Blindauer.)

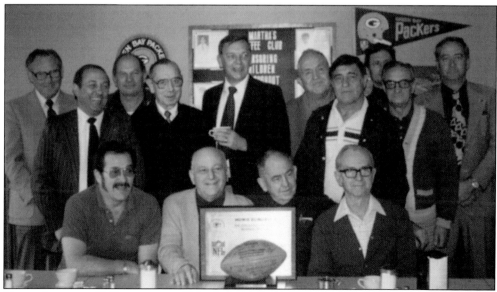

Shown here at a 1960s meeting of Martha's Coffee Club are the following, from left to right: (front row) Jim Coleman, George Cary, Howard Blindauer, and Les Rose; (back row) George Bielfeldt, Don VandenBranden, Dick Sturzel, Charles Burkman, John Ebert, Lee Riebe, Ben Naze, Mike Blindauer, Al Baker, and Irv Johnson. (Courtesy of Mike Blindauer.)

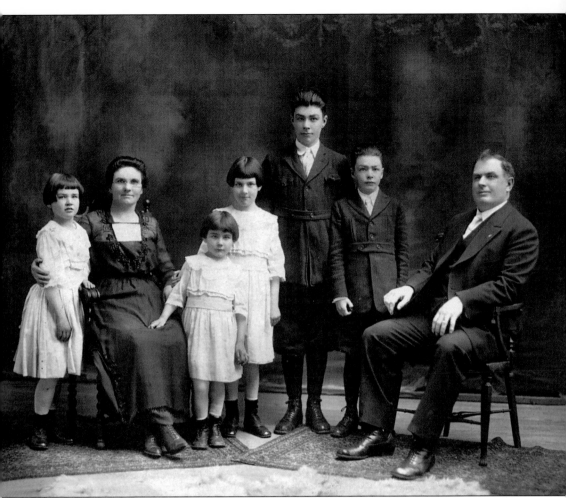

This portrait of the Harry Hanrahan family was taken on May 24, 1920, in Harry's later years after his football days. The Hanrahan family no longer ran the Huffman House and opened a bakery on the 200 block of South Broadway. Pictured from left to right are daughter Ruth, wife Mary Ann, daughter Harriet, daughter Marion, son William, son George, and Harry Hanrahan. (Courtesy of Ruth Hanrahan Hudson.)

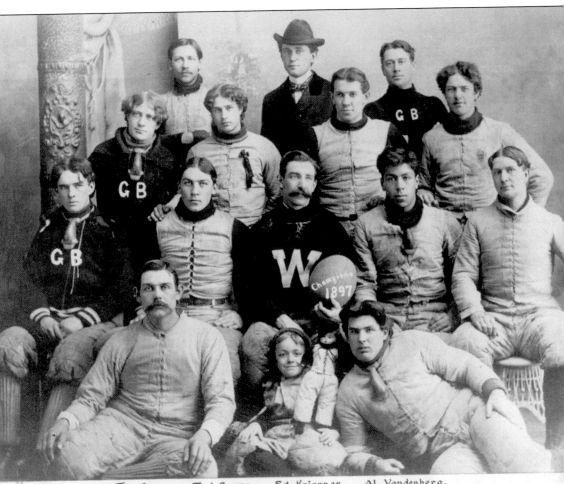

Top Row – Tod Burns, Ed. Krippner, Al. Vandenberg,
2nd. Row – Fred. Hurlbut, H. Vandenbrook, J. Grosbeck, W. Johnson.
3rd. Row – F. Flatley, John Gray, Tom Silverwood, W. Skenadore, Jim Flatley.
Bottom Row – J. Peas, Cl. Gross, H. Hanrahan.

Football in Green Bay began on the city's West Side. Some of the first players were railroad workers who lived in the vicinity of present-day St. Patrick's Church. Harry Hanrahan was a proud member of this 1897 championship team (4 wins and 1 tie). Fred Hurlbut, who moved to Green Bay as a trainer, is credited with starting football in Green Bay. (Courtesy of Neville Public Museum of Brown County.)

Clarence Heidgen was the last blacksmith on Broadway. His grandfather started the shop, and the practice was passed on through three generations. In this April 1993 picture, Clarence is still practicing his trade at the age of 83. He was well known and much loved; his shop was always a good place to stop in to warm up and chat. (Courtesy of Peg Eisenreich.)

Unbeknownst to most, Clarence had saved a large sum of money. He made many anonymous donations, the largest being the replacement of the steeple on St. Patrick's Church. The full extent of his generosity was unknown to most until after his death. A healthy debate had been held in the parish about spending money on a steeple while there were so many impoverished in the neighborhood. Clarence's anonymous contribution ended the debate. (Courtesy of Peg Eisenreich.)

Caroline Tank (1803–1891) immigrated to the United States from the Netherlands in 1850. Called simply "Mrs. Tank" by those around her, Caroline left her royal title and finer way of life in the Netherlands to walk beside her missionary husband in the City of Fort Howard. The stories and memories are many, as she was an influential and respected community member. Contrary to some stories, Caroline was a warm and friendly person who cared about the Fort Howard community. (These contradicting stories may have something to do with Caroline never fully learning the English language, leaving her somewhat isolated from others.) Mrs. Tank donated thousands of dollars to charities throughout her lifetime, but the full extent was not discovered until after her death. (Courtesy of Heritage Hill State Park.)

Six

INTERESTING PEOPLE

William Van Langendon symbolizes the pride and history of the West Side of Green Bay. He was a much-loved florist known by everyone. Many of the buildings and homes in this book were known by him, for he brought flowers to their doors. We would now like to bring these pictures with their small stories, our "flowers," to you. (Courtesy of John Van.)

Built in 1875 by an immigrant German family of the same name, the Huffman House located on North Broadway was a landmark of the Broadway District. The building still stands today. (Courtesy of Marion Knight.)

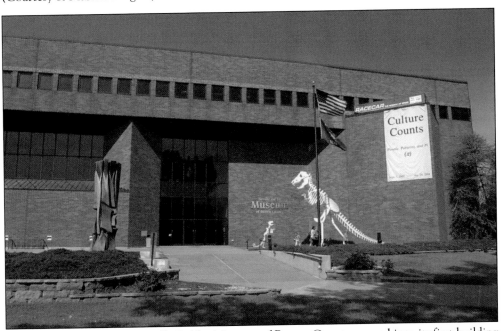

Established in 1915, the Neville Public Museum of Brown County moved into its first building in 1927 and then into this contemporary 58,000-square-foot building in 1983. A general museum of art, history, and science, the Neville collects, preserves, and exhibits significant objects relevant to Northeast Wisconsin and the Upper Peninsula of Michigan. Some of the images in this publication are from the Neville's collection of over one million photographs. (Courtesy of the Neville Public Museum of Brown County.)

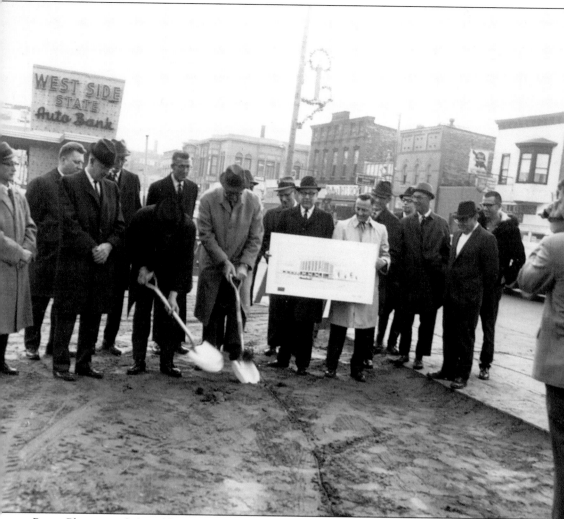

Peter Platten and Arnold Van Den Wymelenberg turned the first shovels of dirt for the construction of the new M&I Bank building at the corner of Walnut and Broadway in 1969. Pictured here, from left to right, are the following: (front row) Karl Feldhausen, Peter Platten, Arnold Van Den Wymelenberg, L.G. Mueller, and A.J. Paul; (back row) J.D. Van Groll, Norbert Greatens, R.E. Burke, Richard D. Hoagan, Chas. Mathys, George Bielfeldt, Howard Fleck, Robert Surplice, and others unidentified. (Courtesy of M&I Bank.)

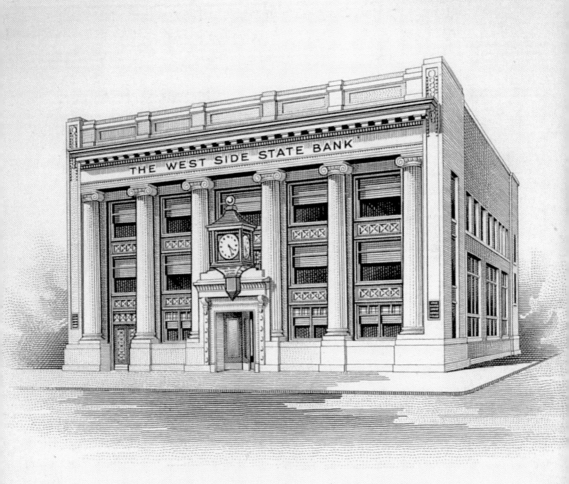

THE WEST SIDE STATE BANK

The WEST SIDE STATE Bank

GREEN BAY, WISCONSIN

The first West Side Bank opened on Broadway in 1914 on 310 W. Walnut. The bank moved to the building shown in this drawing in 1939. The Platten family played an important role in the bank, as they had a part in its founding and served within as leaders. The West Side Bank was the first in the city to open following the Great Depression. Peter M. Platten II, president at the time, provided money to replace the funds that panicking customers had withdrawn. (Courtesy of M&I Bank.)

The first YMCA in the Green Bay area was on the West Side. The Rev. Daniel Curtiss and Caroline Tank built a small structure on the southwest corner of Third and Chestnut in 1870. Twenty-five young men enjoyed its beginnings. (Courtesy of Bernie Moran.)

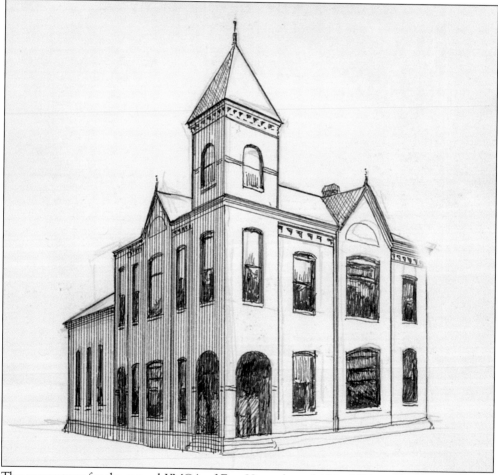

The cornerstone for the second YMCA of Fort Howard was laid in 1891 on the corner of West Walnut and Chestnut. The building provided young men with a large gym, beautiful parlor, and a place to seat 250 people. A fire in 1908 destroyed part of the building. (Courtesy of Bernie Moran.)

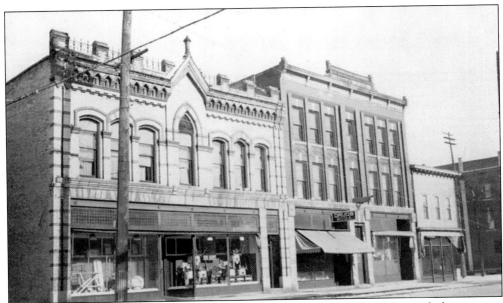

Felix Lurquin purchased the Fink Building at 410 Dousman in 1893. Together with the structure he had built to the east of the Fink Building, he called them the Lurquin Block. The building housed many well-remembered stores, including Van's Hardware and Quinn's Department store. This postcard shows the buildings in 1914. (Courtesy of Mary Ann Defnet.)

Operating his store from 1909 to 1922, "Grandpa" Felix Duchateau cared for his jewelry at the south end of the Duchateau building. He sold items from clocks to hatpins, as can be seen in the jewelry case. (Courtesy of Marie & Ray Duchateau.)

Ansgar Hall, built in 1891, served as a popular social center and community hall for the Danish settlers arriving in the late 1800s and early 1900s. The hall stood next to the Junction Hotel for many years, but progress dictated that both would eventually outlive their usefulness. Ansgar Hall was torn down in 1956. (Courtesy of Neville Public Museum of Brown County.)

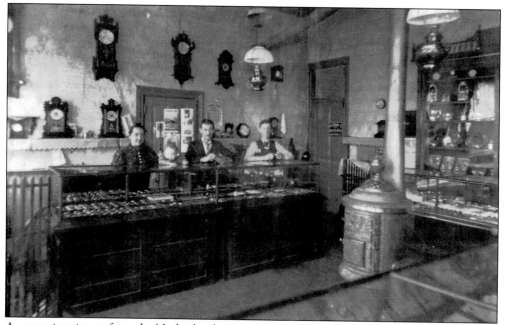

A young immigrant from the Netherlands named Jacob Vander Zanden opened his first jewelry store in the Commercial Hotel building in 1893. Jacob sold clocks and watches, visible in the glass case. The business moved in 1908, and today is owned by Jacob's great grandson. (Courtesy of Robert and Tom Vander Zanden.)

John Edward Virtues opened his first hardware store at 107 North Broadway around 1908. In 1927, Virtues joined forces with fellow hardware man J.L. Lemerond and formed the Lemerond-Virtues Hardware Co. The two combined their stock and opened their joint business in Lemerond's former store at 115 North Broadway. (Courtesy of Laural Virtues Wauters.)

This 1930s photo shows the Tweet Brother's Plumbing store at 147 North Broadway. The building today has been remodeled and is home of the String Instrument Workshop. (Courtesy of Arlene Tweet.)

Henry Nelson built and operated well-known Nelson Machinery on Pearl Street. He was a member of the South Side Businessmen Association. This photo was taken as land was being cleared for the new M & I Bank in 1969. (Courtesy of M & I Bank.)

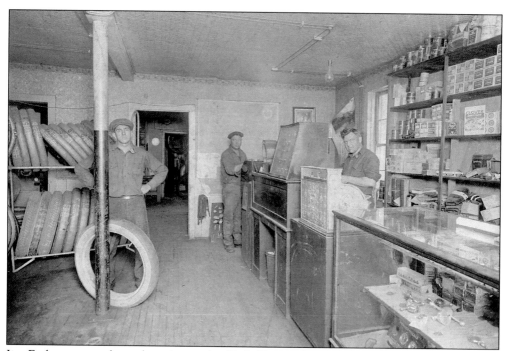

Jim Early operates the cash register at his Early Tire and Battery sometime in the late 1920s. William Early stands at the back of the shop, and Al Swette stands near the "thick" tires on the left. At the end of Prohibition, the shop converted to a bar. (Courtesy of Eileen Blaney.)

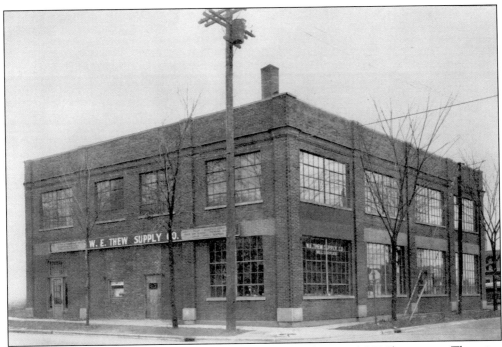

This 1949 picture of W.E. Thew on Broadway was originally a Model T Show room. There is a steep ramp in the back of the building (which still exists today) where they used to winch the cars up to the shop on the second floor. The second floor shop would upholster the cars (Model Ts came without upholstery) before they were put in the first floor show room. (Courtesy of Guppo.)

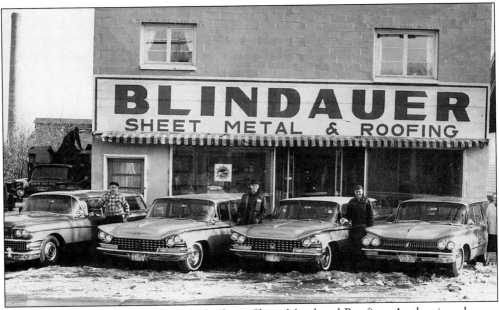

In 1947, Howard Blindauer opened Blindauer Sheet Metal and Roofing. At the time, he was a fledgling in the roofing business. Pictured here in the 1960s are, from left to right, "Howie," Jerry, Mike, and Dorothy Blindauer. (Courtesy of Mike Blindauer.)

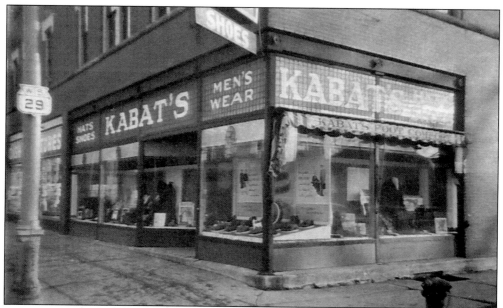

Kabat's Footwear and Shoe Repair was founded in 1909. The firm started as Kabat and Peck, a men's clothing store, and soon expanded into shoes. Three generations of the Kabats family have served the area. In the 1930s, Joe Kabat operated a road business, selling shoes from Green Bay, through Northern Wisconsin, and up to Upper Michigan. Kabat's was known for specialty and prescription shoes. (Courtesy of Lawrence F. Kabat.)

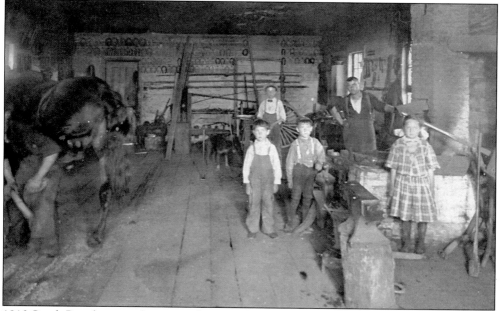

1910 South Broadway was home to a livery stable owned by Emil Rothe. As cars became more prevalent in the early 1900s, the demand for shoeing horses declined. His last customer was the Fairmont Dairy, which still delivered milk by horse and carriage. The two young boys in the picture are Clyde Rothe (left) and his brother, Bernard (right). Their father Emil stands behind them. (Courtesy of Nancy Rothe Quigley.)

Fire damaged the King's X Supper Club and neighboring Jaynard Printing in 1977. "Boots" Baker, owner of the King's X, purchased and remodeled Jaynard. He removed the upper level of both buildings. Baker also removed part of another nearby building in order to create a parking lot. (Courtesy of the *Green Bay Press Gazette* collection of the Neville Public Museum of Brown County.)

William Kreuser owned the shoe shop at 157 North Broadway. He started the business around 1900, and later passed it on to his son Robert who moved it across the street. Typical of the time period is the transom door. (Courtesy of Larry Kreuser.)

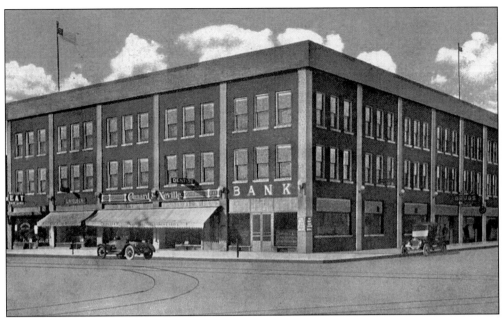

Peter F. Platten was the engineer of the Platten building on the southwest corner of Broadway and Dousman. Afterwards, the Plattens wondered what to do with the corner of the building. They invested $50,000 and started the West Side Bank. (Courtesy of Brent Weycker.)

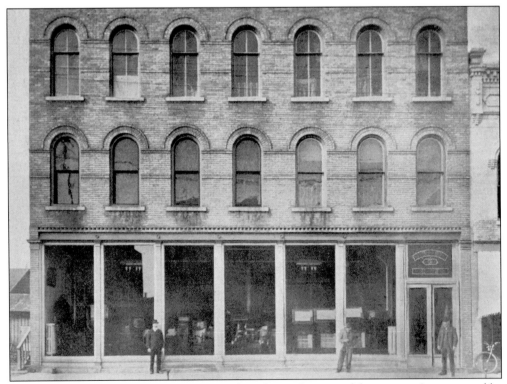

This furniture store stood at 311–315 W. Walnut during the turn of the century. It was owned by Otto M. Oldenberg, who can be seen on the sidewalk. (Photo from On Broadway, Inc. collection)

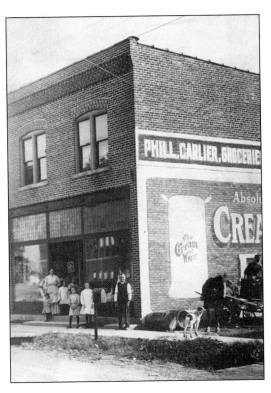

This brick building across from West High School is familiar to many of its current and former students. It was built by Phil Carlier in the early 1900s. He poses in front of his grocery store with his family. Pictured from left to right are wife Kate, Leone, Marie, Mabel, Stella, and Phil. Also visible are Rover and their horse, Jim. Notice the reflection of West High School in the windows of the store. (Photo from author's collection.)

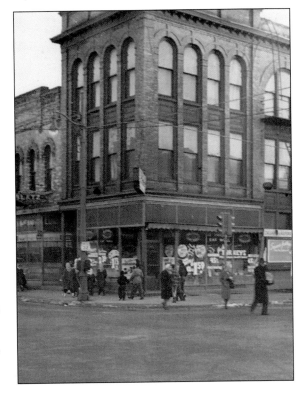

The Tom Camm building was erected on the southeast corner of Walnut and Broadway in 1905. Callahan Grocery opened on the first floor in 1932, and closed in 1950. Photos of many parades and events, including the 1934 American Legion parade, were taken from the second floor of this building. The Camm Building is easily recognizable in old photos by its pinnacle roof. (Courtesy of Robert Callahan.)

W.G. Janquart, the author's father, operated the Tasty Bake Shop at 311 North Broadway from 1931 until 1951. The bakery delivered to many of the small grocery stores in the area. The hardworking employees of Larsen Canning were among the bakery's most frequent customers. A few years after becoming Jaynard Printing Company, the second floor was lost in a fire, and today the remaining portion serves as the dining room for Tesch's Bistro. (Courtesy of Bernie Moran.)

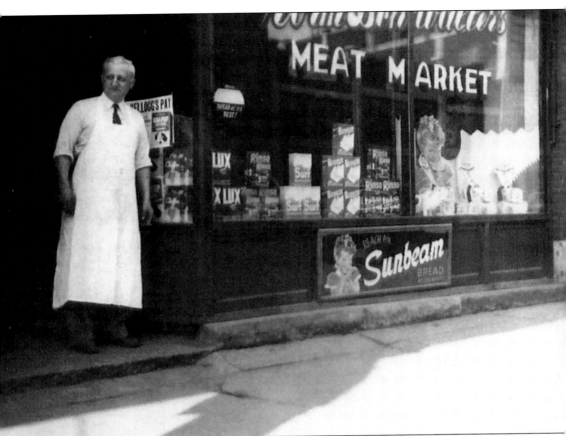

Norm Schwaller opened his meat market at 319 North Broadway in 1936. Norm and his assistant, Bert King, operated on Broadway for 20 years. Long-time area residents may remember having their meats cut fresh to order at Schwaller's. Norm never prepackaged any of his meats, as was the practice with other shops and supermarkets. (Courtesy of Schwaller Family.)

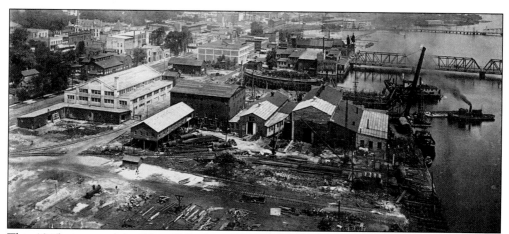

This 1915 picture of the West Side along the river shows part of the Northwest Engineering company. Northwest built industrial cranes for construction use. The cranes were used around the world. (Courtesy of Neville Public Museum of Brown County.)

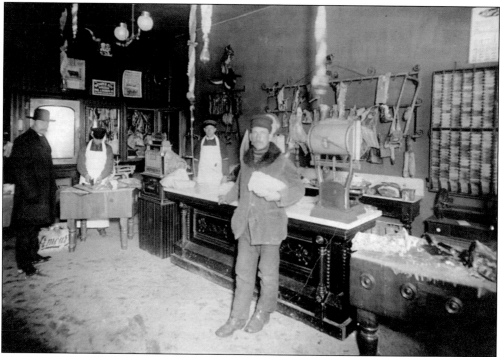

The Schefe Meat Market was a well-known place on the south side, with many regular customers who sang its praises. It opened prior to the turn of the century at 616 South Broadway. Their second store, pictured here, was located at 712 South Broadway. The market and other neighboring buildings were torn down during the construction of the new Mason Street Bridge in the early 1960s. (Courtesy of Jim Engebos.)

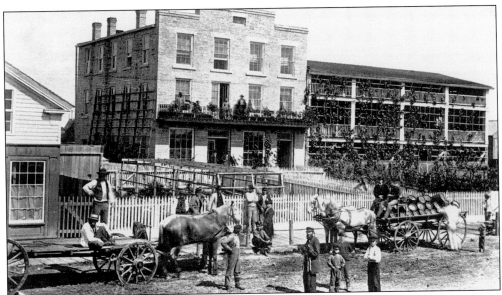

The Francis Blesch Brewery started business in 1850. Blesch had been trained in brewing and cooperage in his native Germany before he immigrated to the United States in 1849. The brewery ran until shortly after his death in 1875. Blesch Brewery was the oldest known industrial building standing in Green Bay until it was razed in 1998. (Courtesy of Neville Public Museum of Brown County.)

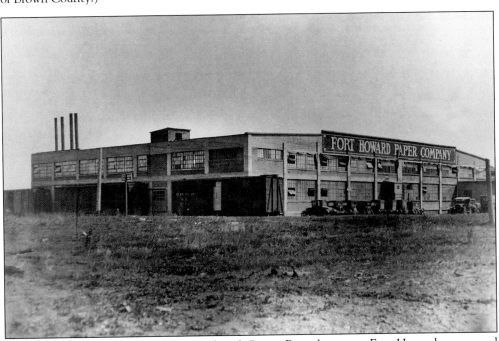

After the 1895 merger of Fort Howard and Green Bay, the name Fort Howard was erased from the map. In 1920, August E. Cofrin brought the name back with the founding of his Fort Howard Paper Co. At one time, it was one of the better known paper mills in the world. The mill became part of the James River Corporation and is today owned by Georgia-Pacific. (Courtesy of Tim Rinn.)

Fairmont Creamery became a part of Broadway in 1915. In this picture, Alice In Dairyland poses on one of Fairmont's trucks in the 1950s. A giant milk bottle on top of the creamery would illuminate at night, leading children to ponder if it was actually filled with milk. In fact, it actually provided Fairmont's water supply. The creamery closed in 1982. (Courtesy of Ed Schuch and Ray Wilson.)

The massive equipment you see in this photo serves the same purpose as the small compressor in the bottom of your refrigerator today. Herman Wreckleburg works on the ammonia compressors in the engine room of Fairmont Dairy. Herman was the chief engineer, and with several others, worked for his boss, Ed Schuch. In the 1940s, the compressors were steam driven, and later they were converted to use electricity. (Courtesy of Herman Reckleburg Jr.)

Among the many buildings that housed Leicht's Transportation was this one at 123 South Broadway. It was built in two sections, at 119 and 123. This early 1910s photo also shows the Heidgen Blacksmith Shop. (Courtesy of Russ Leicht.)

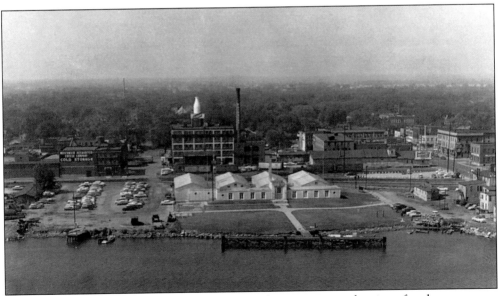

The Naval Reserve started in Green Bay in 1923. This picture was taken just after the reserve was built at this location on the Fox River in 1947. They remained there for 30 years, before moving to a smaller office on Oneida St. (Courtesy of Neville Public Museum of Brown County.)

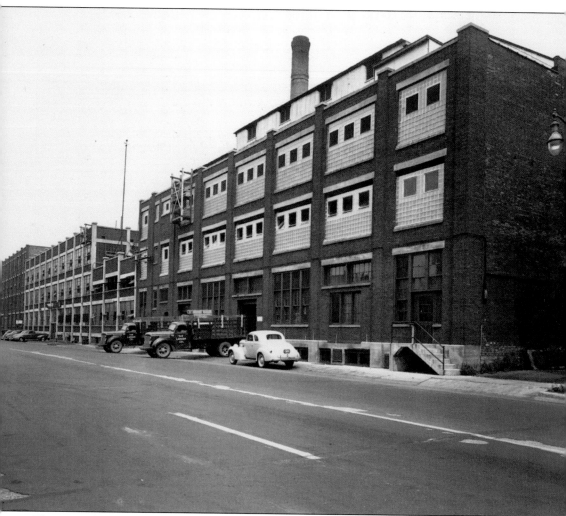

The original Larsen's building was replaced in 1908 with this brick and concrete structure. Over a period of time, Larsen's took over neighboring businesses such as Kraft Cheese and grew into this 1940s view stretching from 316–520 N. Broadway. The company operated under various names over the years, from Larsen's to Dean Foods and most recently, Agrilink and Birdseye. Throughout all the changes, the Larsen family remained closely involved with their company and the community. (Courtesy of Greg Larsen.)

The Kress family founded Green Bay Box Co. at 1406 S. Broadway. Frank Kress took over his father's struggling wooden box factory and converted the company to a successful corrugated box business. The company has since expanded, including mills in Arkansas and several other states. Also visible in this aerial photo is Sneezer's Snackroom. (Courtesy of John Kress.)

In the late 1800s, William Larsen moved from the grocer business to wholesale distribution, and soon expanded into growing and canning vegetables. The Larsen Company's first home, shown here, was built in 1890. (Courtesy of Greg Larsen.)

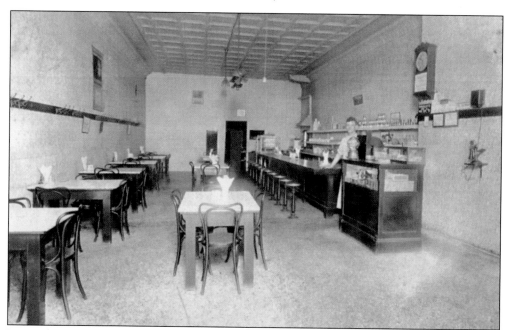

Located at 127 North Broadway, Mike and Emma's Café was a well-liked place to stop. The café is shown here in 1925. Mike and Emma Noel also lived on Broadway. (Courtesy of the Noel family.)

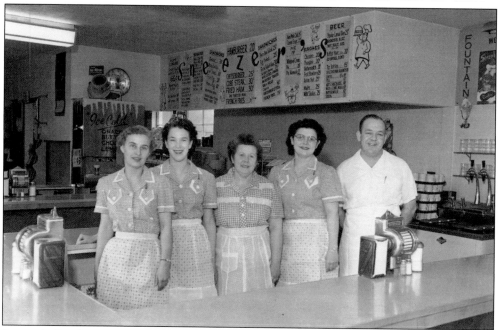

Sneezer's Snackroom was run by Norman Jahnke and was located at 1342 South Broadway. Jahnke later moved the business to 1608 South Greenwood. Shown here is the staff, c. 1958. At the time, the menu featured 20¢ hamburgers and 25¢ canned beer. A bottle of beer, either Old Imperial or Oconto, would set back a thirsty customer just 20¢. (Courtesy of Neville Public Museum of Brown County.)

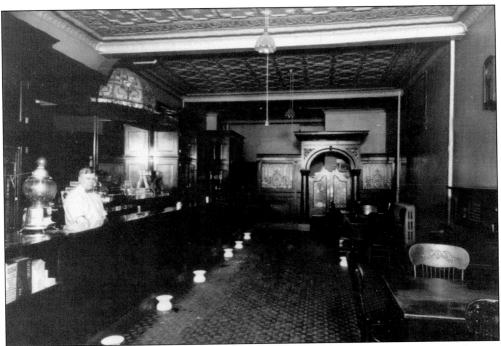

By 1909, the Howard House was replaced by the Duchateau Building, with the Duchateau family living in the large apartment upstairs. The family ran a fine saloon on the first floor. The grandeur of the Victorian era was reflected in the Tiffany lamps, ornate woodwork, and swinging doors visible in this photo. The Duchateau family ran the saloon until the 1940s. (Courtesy of Marie and Ray Duchateau.)

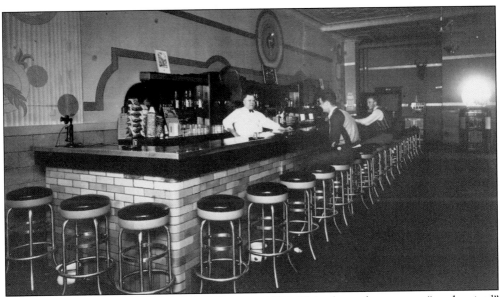

The Duchateau family remodeled the saloon in 1939. This photo showcases a "modernized" look. With the exception of the tin ceiling, much has changed in the appearance of the bar in comparison to 30 years earlier. Alphonse Duchateau is tending bar. (Courtesy of Marie and Ray Duchateau.)

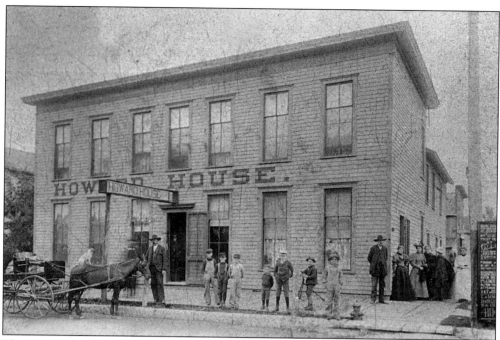

The southeast corner of Broadway and Dousman was the location of the Howard House. The dog on the back of the pony joins the rest of the individuals posing for this 1890 picture. (Courtesy of Neville Public Museum of Brown County.)

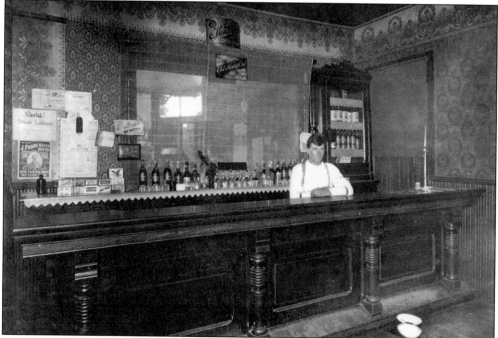

Inside the Howard House, Joe Tilly tends bar. A Van Dyck Beer ad hangs on the wall denoting one of the area's old breweries. The building was later torn down and replaced with the Duchateau Saloon. (Courtesy of Marie and Ray Duchateau.)

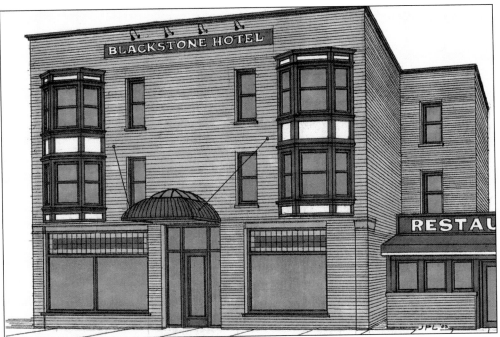

The Blackstone began as a small but fine hotel at 117 Dousman Street. This drawing shows the Blackstone before it was destroyed by fire on February 12, 1963. A small restaurant carrying the Blackstone name was built on the same property. It was a favorite spot for the working man to "catch a coffee." (Courtesy of Joe Lawniczak.)

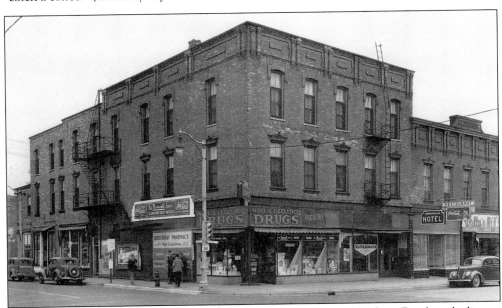

The Commercial Hotel sat on the northwest corner of Broadway and Walnut. Family-style dinners were served upstairs. Customers formed lines stretching down the street waiting to get a meal for $1.50 per plate. This 1930s photograph shows the various businesses operating on the street level, including Broadway Pharmacy, Verheyden Electric, and the James Hat Building and Shoe Repair. The building was razed with the widening of Walnut Street. (Courtesy of Fran LeClercq.)

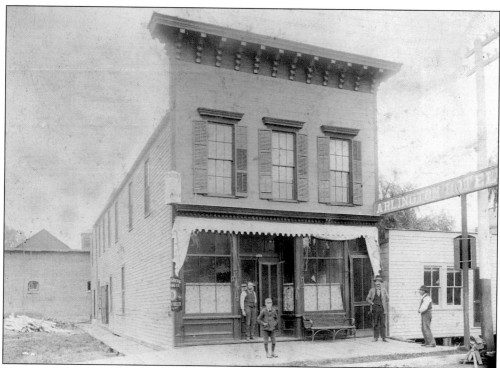

This 1870s picture of the Arlington House at 233 North Broadway gives us a glimpse into the lumbering era. Built by Fred Goethe, it served lumberjacks and railroad workers. The sign reads "Meals at all Hours, 15 cents, Good Barn in Connection." The original Arlington was razed and replaced in 1924 with a brick hotel of 18 rooms. The second building still stands today. (Courtesy of Eban Goethe.)

The Junction Hotel was built in the early days of railroad service in Green Bay. The hotel functioned mainly to serve the passengers of the two railroads meeting there, the Kewaunee, Green Bay, and Western Railroad, and the Chicago and North Western Railroad. In 1962, the hotel was razed after a major fire. (Courtesy of the Otto Stiller Collection of the Neville Public Museum of Brown County.)

There were two Broadway Houses on the West Side. This 1883 photograph shows the much lesser known of the two. Travelers to Fort Howard would have found a good night's lodging at this Broadway House. It was located between Dousman and Hubbard Streets and faced East. (Courtesy of the Neville Public Museum of Brown County.)

This Broadway House was established in 1882. It was a brick structure with 16 rooms, and a frontage of only 25 feet on Dousman Street. In 1887, three stores were added on the street level. A third story was added in 1912. At some point, the name was changed to Broadway Hotel, the name by which it is better remembered. The hotel was razed in 1962. Note the boardwalk and dirt road in front of the hotel. (Courtesy of Marie Duchateau.)

Five

BUSINESSES

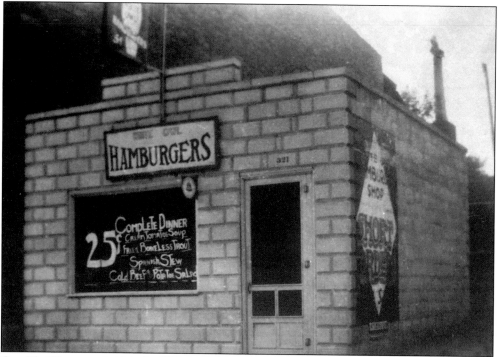

Got 25¢? Come on in! It's the White Owl Hamburger Shop where Norb Boetcher was known for great service. From reading the menu in the window, it is amazing what 25¢ would buy in the 1930s. Buildings like this, usually cement block, thrived during the Depression Era. The White Owl was razed in 2000, but Norb and his good food have not been forgotten. (Courtesy of Norbert Boetcher.)

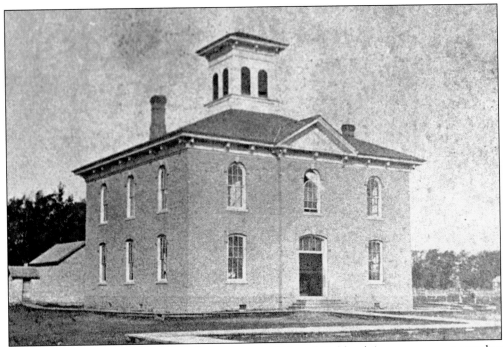

The Tank School stood on the northeast corner of 5th and Oakland Avenue, on property that once belonged to the Tank family. Today a new school of the same name stands in the same vicinity. (Courtesy of Neville Public Museum of Brown County.)

Helen Ferslev was principal at Jackson School between 1951 and 1967. She says,"When I first went to Jackson school as principal in 1951, it was a two room building, and they were adding an addition . . . the next year we had six classrooms. Before I left there were two more additions. That was the beginning, and after that the area really began to grow." (Courtesy of Green Bay Public Schools.)

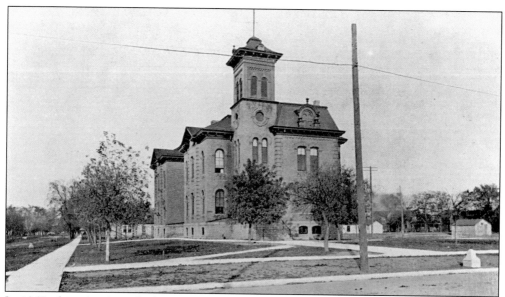

In 1868, this school was built on Dousman Street between Chestnut and Maple. The school served as the Fort Howard High school, until a new high school (McCartney) was built on South Ashland. In 1895, the school was enlarged to eight rooms. In the late 1920s, the Dousman School was replaced by a new school known today as Fort Howard. (Courtesy of Neville Public Museum of Brown County.)

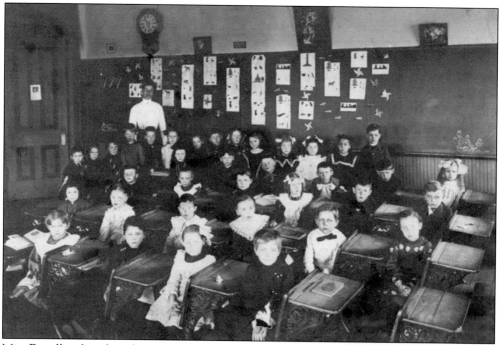

Miss Farrell gathers her class at the Dousman School for a picture. Written beneath this photo were the words "Stella's 1st grade picture." (Photograph from author's collection.)

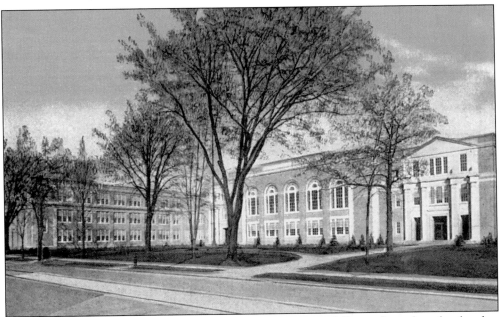

The West High School we see in this 1942 picture is quite different from the school today. Although much has been added to the building, much of the original structure is still preserved. (Photograph from author's collection.)

This 1918 photograph is taken in front of West High School. Written on the back of this photograph is the following: "Garter's Galore!—This is the one all the men around Green Bay like—And I rather do too—Of course if professor Cole knew what his graduates were doing, he'd have something to say!" (Photograph from author's collection.)

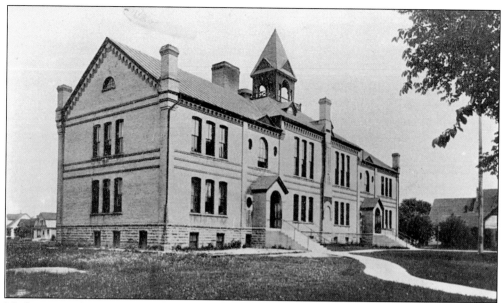

McCartney School on South Ashland began in 1890 as Fort Howard High School. With the merger of Fort Howard and Green Bay, it became Green Bay West High School. In 1910, a new high school was built on Shawano Avenue, and the old building became McCartney Elementary School. (Courtesy of Neville Public Museum of Brown County.)

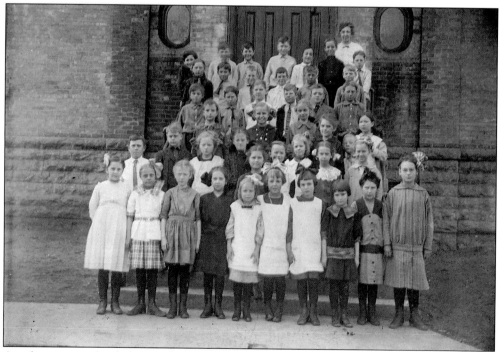

An elementary school class in their "Sunday best" poses on the steps in front of McCartney Elementary, c. 1914. McCartney served as the home of a unique program housing all eight grades there. Compulsory education ended at age 14 in those days, and many students went on to learn a trade. (Photograph from author's collection.)

Reverend Michael J. O'Brien poses with St. Patrick's graduating class of 1919. Father O'Brien led the planning and development of St. Patrick's School. The school's first enrollment was over 300 students and grew quickly. St. Patrick's was the first Catholic school on the west side and was regarded as one of the best schools in the area. The sisters of St. Dominic staffed the school. The school building was razed in late 1975. (Courtesy of St. Patrick's Catholic Church.)

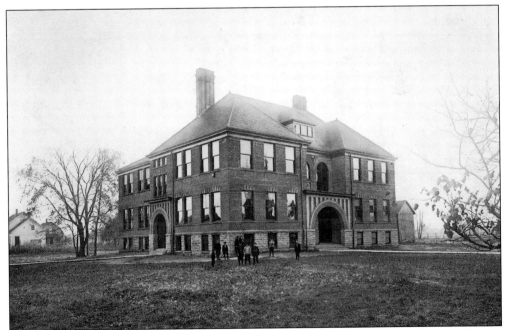

The Elmore Grade School once stood on the corner of Elmore and Vroman. This building no longer stands, and a larger school of the same name now stands on Bond and Ethell. (Courtesy of Green Bay School District.)

Colonel Samuel Ryan arrived at Fort Howard in 1826 to minister to the settlers. He, along with Pastor John Clark who had come to minister to the Oneida Indians, established the Methodist Church. After many setbacks, the congregation was able to build their church on the corner of Broadway and Hubbard in 1872. The church pictured above was built in 1890 after they outgrew their original building. (Courtesy of Donna Schlei)

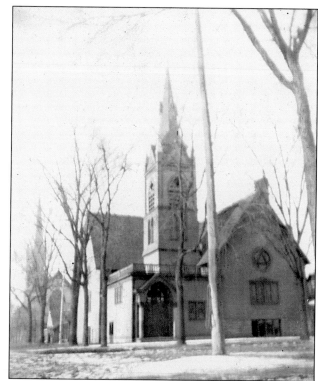

Here is an interior view of St. Patrick's church from the choir loft. Needless to say, many of the decorations were green. (Courtesy of St. Patrick's Catholic Church.)

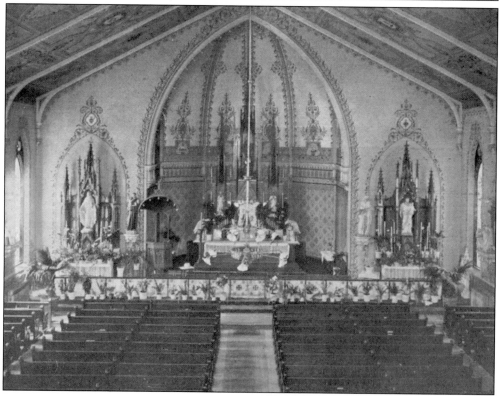

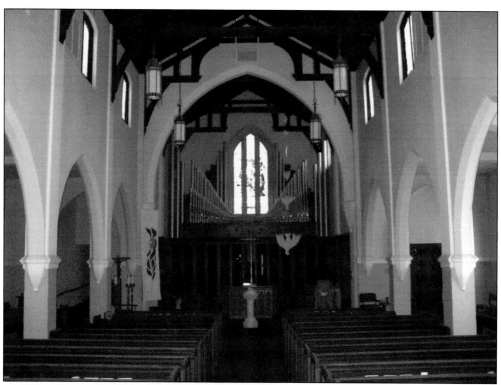

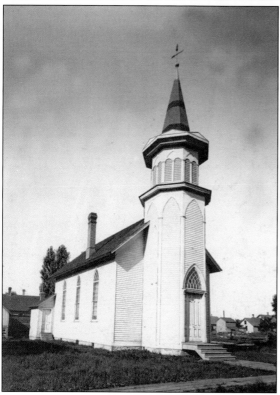

The altar inside the current Trinity Lutheran Church is of Scandinavian influence. The ceiling, mimicking the inside hull of a ship, is reflective of their shipping culture. The church initially offered services only in Scandinavian, but by 1931, all services were held in English. Today, the church's motto is "Rooted in Christ, Rooted on Broadway." (Photograph from On Broadway, Inc. Collection.)

Otto Tank attempted to establish a Moravian community in Green Bay similar to one he had seen in Germany. After some initial success, the community broke apart. Tank's widow, Caroline, later donated land for construction of a church for the remainder of the community. Construction started in 1867, and was dedicated in 1869. The former west side Moravian Church is one of only two churches built before 1869 still standing in Green Bay. (Courtesy of Marilyn Smith.)

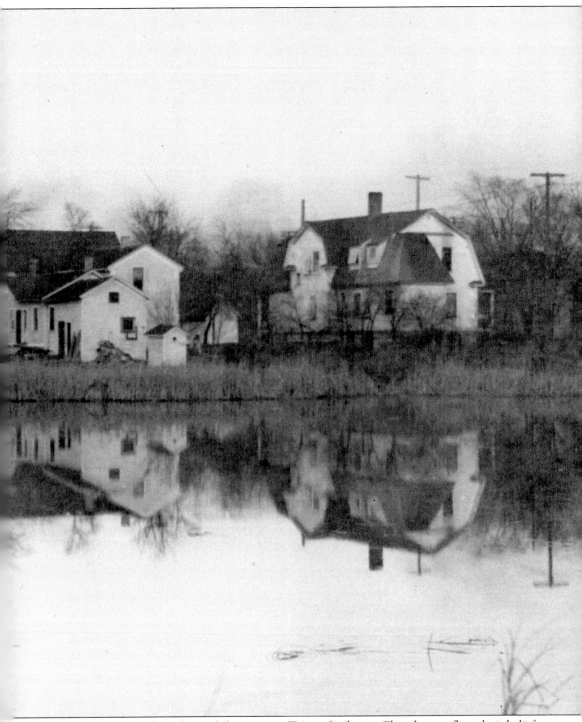

exists today. Its members changed the name to Trinity Lutheran Church, to reflect their belief in the one Triune God. Here the church is beautifully reflected against an inlet of the Fox River that was later filled. (Courtesy of Dick Solboe.)

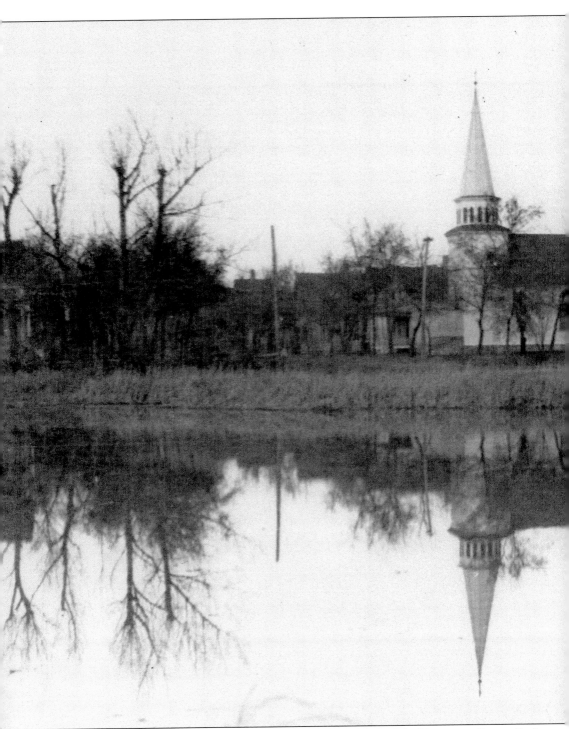

On January 6, 1867, Norwegian immigrants gathered and established the Norwegian Evangelical Lutheran Church of Fort Howard. The first church was built on the 300 block of South Broadway. The structure expanded in 1874 and moved across the street to its present site in 1896. The original wooden church was dismantled in 1915 and replaced with the fine brick building that

The First Baptist Church of Fort Howard was located at 122 North Chestnut. The steeple was easily discernible due to its height and decoration and was a source of pride for West Side residents. (Courtesy of Neville Public Museum of Brown County.)

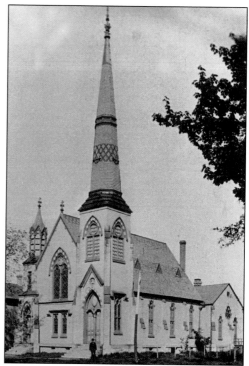

The steeple and shorter tower of this church no longer exist, and there are extensions of the building on each side. The former First Baptist Church building now houses Green Bay's Community Theater. (Courtesy of Bernie Moran.)

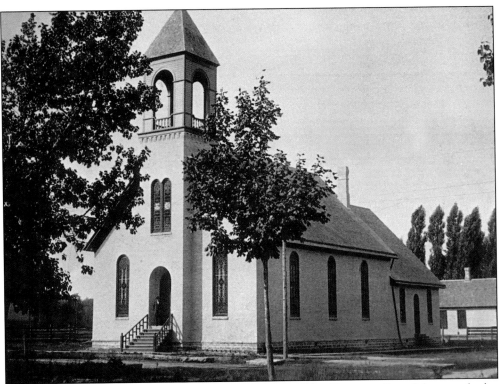

The First Presbyterian Church was organized in 1876, and by Christmas Eve of that year had moved into its first home. In 1892, the church moved to its current location at the corner of Ashland and Walnut. The original building at that site served until 1925, when the current building was constructed. First Presbyterian is the only Presbyterian Church on the West Side of Green Bay. (Courtesy of Neville Public Museum of Brown County.)

Fort Howard Congregational, located on the southwest corner of Chestnut and 3rd Streets, was dedicated in January of 1857. Reverend Jeremiah Porter, who was also involved in the Underground Railroad with his wife, was the first pastor of the church. The original congregation spoke both English and Scandinavian. Although Mrs. Niels Otto Tank was a Moravian, she gave $300 yearly to Fort Howard Congregational from 1883 until her death in 1891. (Courtesy of Bernie Moran.)

Four

CHURCHES AND SCHOOLS

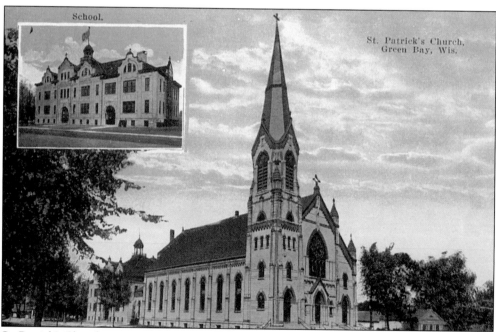

St. Patrick's Church can trace its origin to the Irish Catholics of Green Bay and Fort Howard who wished to establish their own church, separate from the French church of St. John's. The first St. Patrick's was built in 1865 for $2,600. The present church (pictured here) was built in 1893 at 211 North Maple. St. Patrick's school was finished in 1905. (Courtesy of Brent Weycker.)

The H.J. Selmer house at 126 North Oakland dates from 1922. It is one of the few examples of the Prairie School style of architecture in the Green Bay area. The house exhibits the horizontal emphasis that is characteristic of this style. The Selmer house remains at its original location as a single-family home and is in excellent repair. (Photograph from On Broadway, Inc. Collection.)

The Rehder home was lot 4, block 2 of the Tank family Third Edition, and the street was called 5th Avenue until 1895. Walter Rehder family bought the house in 1903 from Julius Sims. The Rehders renovated the home in 1911, turning it into the bungalow style we see today. Walter Rehder was a member of the South Side Improvement Association and one of the men who began the White Store. (Courtesy of Lucile Rehder.)

Scovill, and the Mertens. Crossing the street and returning East was Morris Hoopengardner, the Olson family, Leo Wilson, the Sieferts, Jay Norman Basten (District Attorney), Leo Sawaski, James Prinevile, the Breth family, and the Phillips family (Phillips was a Green Bay School Prinicpal). (Photograph from On Broadway, Inc. Collection)

This block of Oregon was carved through for horses and buggies, not the cars of today. The homes were built in the turn of the 19th century and remain mostly unchanged. Among the neighborhood residents in the 1940s, staring on the left side of the street and heading west, were the Cornilisons, the Fairbairn family, Dr. McMillan, George Hougard, Vern Lewellen (former manager of the Packers), the Curran family, the Bayes, Jim Engels, the Friese family, Gerorge DuPlaise, Walter Bodilly, Dick

Built in 1903, this charming home sits at 301 South Ashland. Built in the Dutch Colonial Revival style, the structure is unusual in the elaborate nature of the design for such a modest sized home. James and Elizabeth McKone purchased the house in 1913. The home was remodeled in 1988, with contributions from Elizabeth McKone and her daughter.(Photograph from On Broadway, Inc. Collection.)

Austin Larsen, son of the founder of Larsen canning company, built this home in 1909. The home predates the Prairie School style of architecture, a unique style to Green Bay. It borrows from several architectural schools of the period. The flat-roofed, stucco-clad house is two stories, although the exterior appears otherwise. (Photograph from On Broadway, Inc. Collection.)

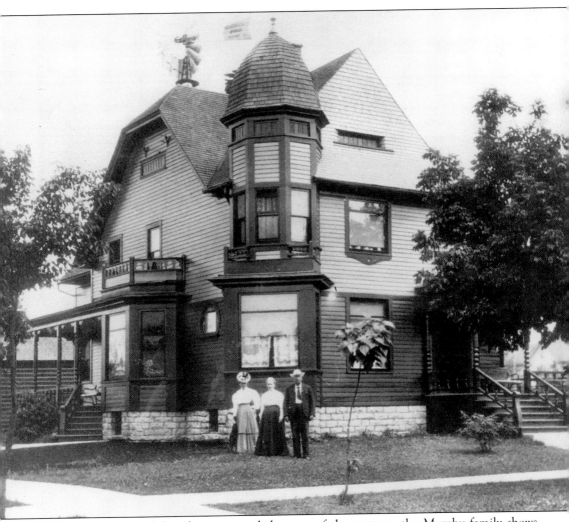

Standing in front of their house around the turn of the century, the Murphy family shows off their spacious Victorian home at 803 North Broadway. Pictured are William R. and Mary Murphy with their daughter, Mary. The small porch on the left side of the second floor was built for daughter Mary, who had tuberculosis. (Courtesy of Mary Murphy.)

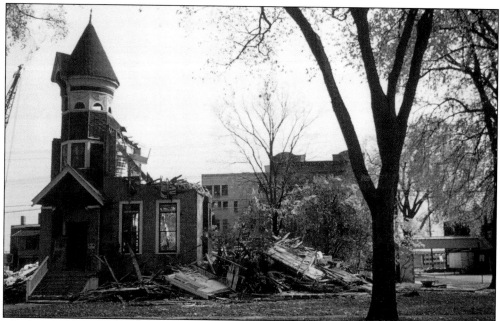

This house was razed in 1976. The city lost another fine example of the Victorian Era. Fairmont Dairy can be seen in the background. (Courtesy of Eileen Blaney.)

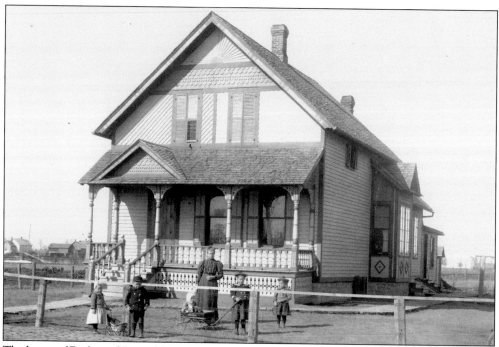

The home of Ferdinand De Volder sits on the 1000 block of Dousman Street. On his way back from one of many trips to Belgium, Felix Lurquin brought 20-year-old Ferdinand De Volder in the 1880s. De Volder would later become his son-in-law. In this 1902 picture is Nettie (Lurquin) De Volder with their five children, pictured here from left to right: Florence, Joseph, Edward (in wagon), Rose, and Catherine. The home was built in 1890. (Courtesy of Mary Ann Defnet.)

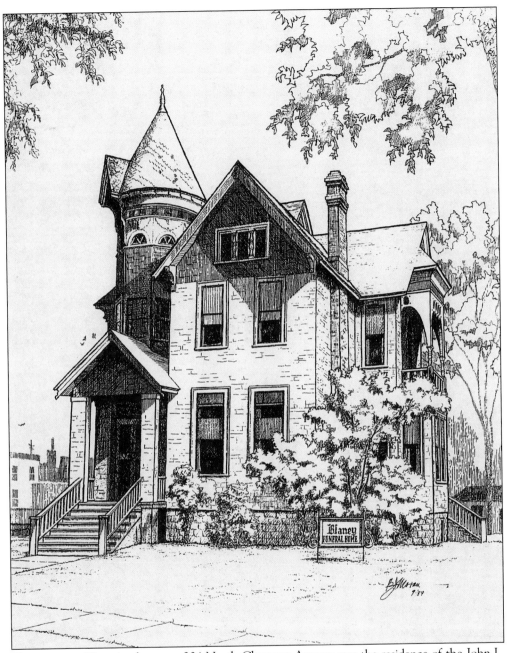

This gracious Victorian home at 204 North Chestnut Avenue was the residence of the John L. Jorgensen family, who owned the dry goods store on Broadway. With its fine turret, high chimney, and second floor balcony windows, it exemplifies the architecture for this period. Jorgenson hired an artist from Germany to carve the furniture and woodwork, including the mantles of the home's four fireplaces. There was a large crystal chandelier in the home, and the ceilings were crossed by beams with ornate wreaths in between. The home itself had been built with a back-plastering technique that allowed the home to remain warm in winter with minimal heating, even by today's standards. Their property changed hands a few times before it was bought by the Blaney family and became Blaney's Funeral Home. (Courtesy of Bernie Moran.)

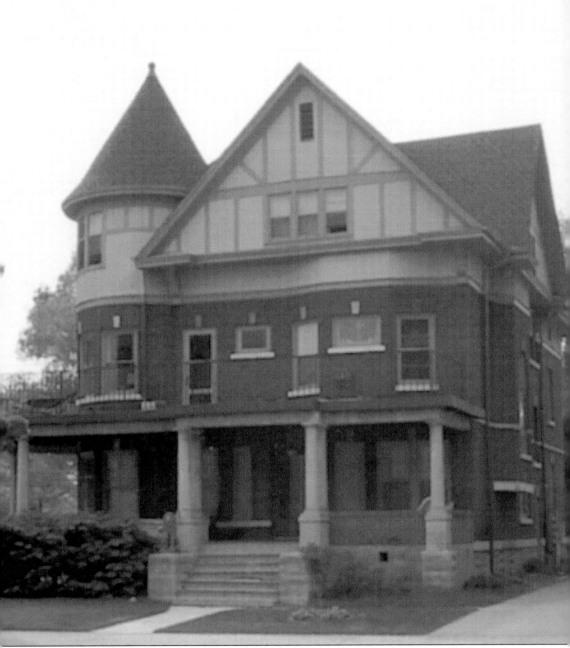

John Brogan was a big man who lived in a big house. His late Queen Anne-style home was the largest in the district. Born in 1865, Brogan established his office in Green Bay in 1907. He worked on railroad construction, dams, and bridges. He became one of the foremost business men in this section of the state. Later in life, he lost parts of his limbs to diabetes. Afterwards, he was most remembered for sitting in his porch window, waiting for neighborhood children to stop by so he could ask them to "sneak in the kitchen and get me a cookie." (Photograph from On Broadway, Inc. Collection.)

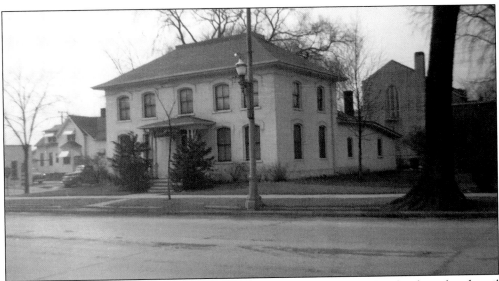

Francis Beattie built this home at 336 South Broadway in 1850, where his daughters lived until 1930. Clifford Lyndahl bought the home in 1946 and used it for his funeral business. The home was remodeled in 1958 and an addition built in 1966. In 1981, the home was razed and the Lyndahl business moved to Lombardi Ave. (Courtesy of Dale Lyndahl.)

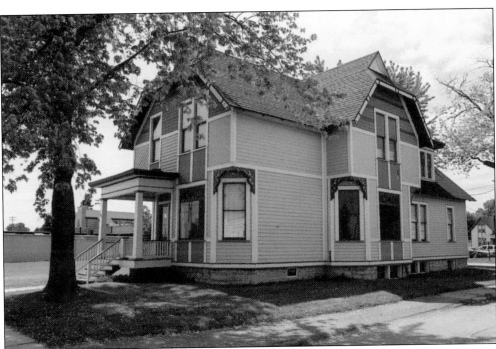

This South Broadway home belonged to Joseph H. Taylor, who was one of only two men to serve as mayor of both Fort Howard and Green Bay. The dwelling, built in 1887, is a variation on the Stick Style, characterized by stick-like framing boards that delineated distinct exterior surface areas. (Photograph from On Broadway, Inc. Collection.)

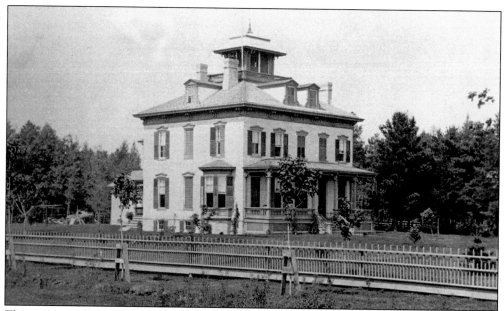

The mansion of Andrew Elmore stood north of Mather before it was razed in 1924. A successful businessman and philanthropist, Elmore moved to Fort Howard in 1863. Elmore platted some of the property and named the streets after his family and friends. Elmore's son James was the First Mayor of Fort Howard, Mayor of Green Bay, and mayor of the consolidated cities. (Courtesy of Neville Public Museum of Brown County.)

This early brick front house was built in 1880 by Gustar Genzel on Dousman St. With original brick exterior, foundation of cut stone, and an unpaved driveway, his house is an example of how sometimes things stay the same. (Photograph from On Broadway, Inc. Collection.)

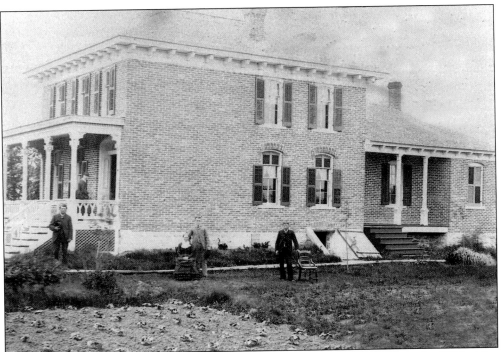

Felix Lurquin purchased approximately four acres of land from Andrew Elmore for $350. After his original house burned in 1876, Lurquin built the still-standing brick home facing Dousman Street. It was considered one of the finest homes in Fort Howard at the time. Relatives in his native Belgium dubbed it "Felix's Castle." (Courtesy of Mary Ann Defnet.)

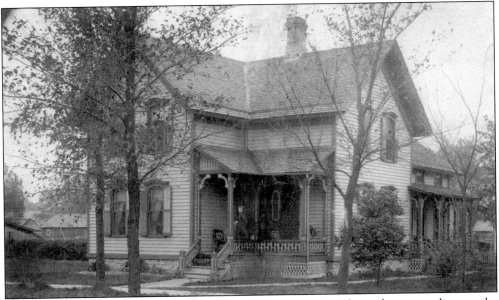

Residents David and Julia Davidson built this home in 1881. Julia is shown standing on the porch. This area of Fort Howard was fast becoming a residential area, and farm buildings such as those visible on the left were fast disappearing. Interesting to note are the decorative trim above the windows and the wooden sidewalk. (Courtesy of Jim Engebos.)

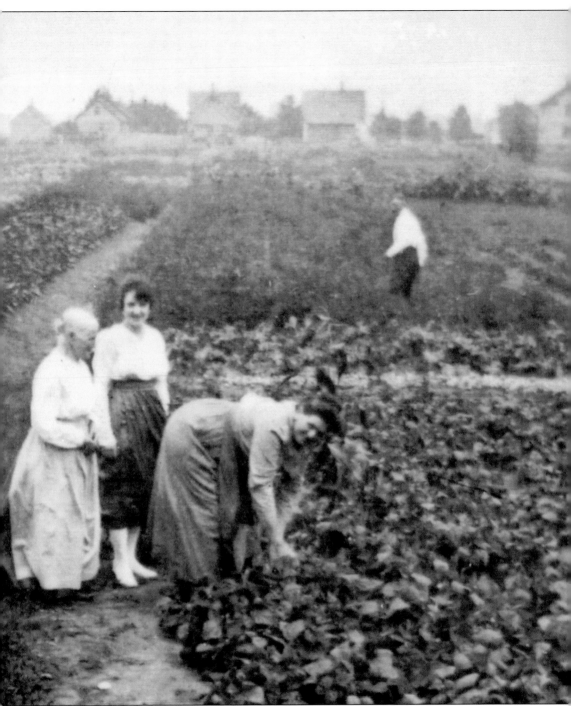

the town of Fort Howard, and even selling them to boarding houses, hotels, and private homes along Pearl Street, the main street of the time. William Larsen, who started his own produce business, also contracted to buy fresh vegetables from the Lurquin gardens. (Courtesy of Mary Ann Defnet.)

In a sight not often seen today, a family works together in the garden. From left to right are Agnes Lurquin, Louis Lurquin, Rosaline (Devroy) Lurquin, Dorothy Lurquin, Frances (Deuster) Lurquin, and Joseph Lurquin. Members of the Lurquin family helped to maintain a plot on their property, reaching from Dousman Street to Elmore Street. Rosaline Lurquin (center in dress) spent the most time in the garden, preparing the crops, "wheelbarrowing" the goods herself to

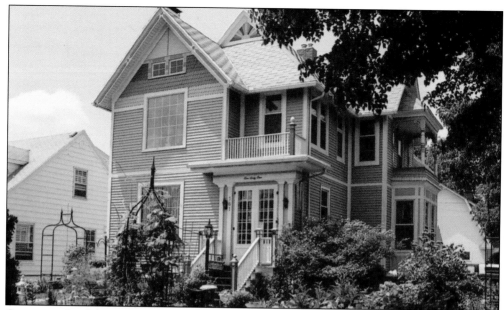

One example of the Queen Anne style is the Antoinette Blesch home. Antoinette's son Frank built the home for her after she was widowed. Unlike many other Queen Anne homes in the area, this house retains the original siding and ornamentation. A wrap-around porch has been removed and the original front entrance has been replaced with French doors. (Photograph from On Broadway, Inc. Collection.)

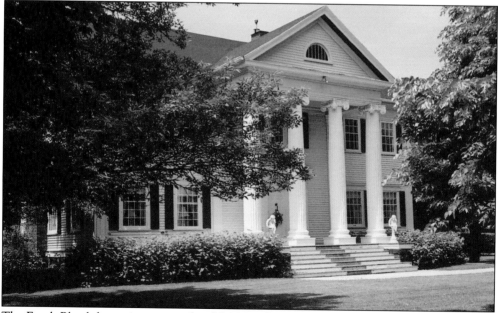

The Frank Blesch home is an example of the Neoclassical Revival style. Characteristics of this style include full height classical columns and full porch. Frank Blesch was the son of Francis and Antoinette Blesch, founders of Blesch Brewery, the only brewery in Fort Howard. Frank started a dry-goods store called the Jorgensen-Blesch Company with his brother-in-law John Jorgensen. (Photograph from On Broadway, Inc. Collection.)

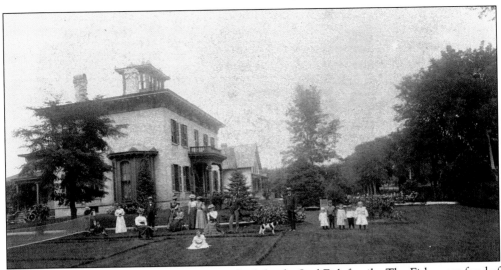

This 140-year-old Italianate-style home was built by the Joel Fisk family. The Fisks were fond of throwing parties on their large beautiful lawns and gardens. The girl sitting in the grass is Mary Fisk. Mary was often asked by her playmates how much property her father owned; she would reply, "From here to the sunset." (Courtesy of Neville Public Museum of Brown County.)

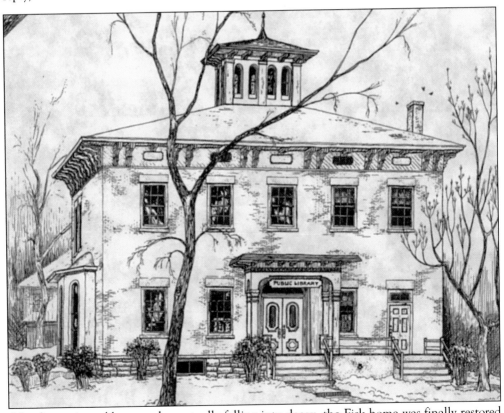

After becoming a library and eventually falling into decay, the Fisk home was finally restored in 1992. Today the building still stands on the corner of Oakland and Walnut and is used as an office building. (Courtesy of Bernie Moran.)

Before this house on Ashland became a residence, it was used by the military garrison of Fort Howard. When Otto and Alice Straubel bought the house in 1919 for $2,000, the house was already 75 years old. The only other home in the area was the seven-gabled Chappell house. (Courtesy of Ruth Straubel Hartmann)

Otto became devoted to the remodeling of the home. The original entrance to the house faced north—he moved it to the west and added a front porch. He also added shutters, a kitchen in the rear, and a wing to the south. The home, built in 1844, still stands today and is one of the oldest in the area. (Courtesy of Ruth Straubel Hartmann.)

The Robert Chappell home was another one of the oldest homes in the area. Built in 1856, the home was an early example of a style using a combination of side and cross gable designs. Chappell was the first president of the borough of Fort Howard. Residents referred to it affectionately as the seven-gabled house. (Courtesy of Bernie Moran.)

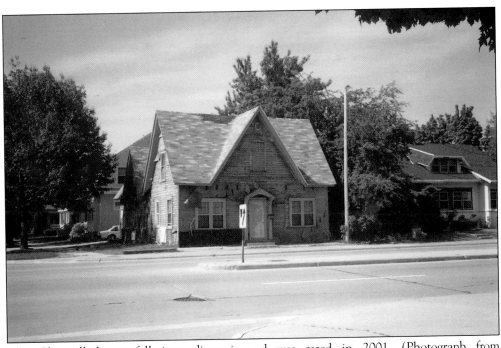

The Chappell home fell into disrepair and was razed in 2001. (Photograph from author's collection.)

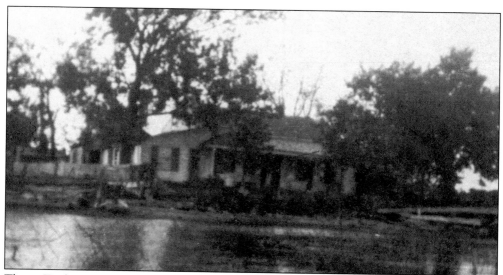

This is Tank cottage as it originally stood on the banks of the Fox River. The home has since been removed. (Courtesy of Neville Public Museum of Brown County.)

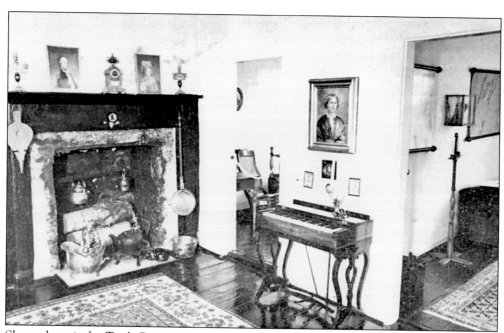

Shown here is the Tank Cottage interior, as the original may have been. (Photograph from author's collection.)

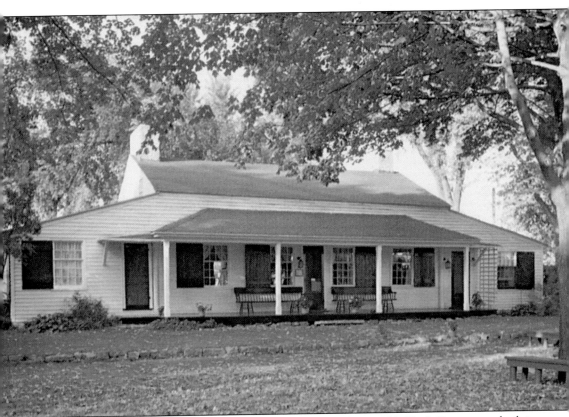

Pictured here is the Tank Cottage when it sat at Tank Park, c. 1950. Tank Cottage was built in 1776 on the banks of the Fox River. It is believed to be the oldest standing residence in the state of Wisconsin. Fur trader Joseph Roi and his brother Amable were the original inhabitants. They lived in a weaving of twigs and bows covered with mud plaster, as it was considered a temporary dwelling. The permanent residence was bought by Otto Tank, a missionary, in 1850. He and his wife, Caroline, added prayer wings to the home. Fifty years later the South Side Improvement Association prevented the cottage from being destroyed. Their efforts helped move the cottage to Tank Park. Jennie M. Erickson, a local resident who played around Tank Cottage when it was still on the Fox River, reminisced at the age of 91 how the cottage "was a beauty spot—built on a slope surrounded by huge trees and water lilies floating in the water near the shore." (Photograph from author's collection.)

Three

HOMES

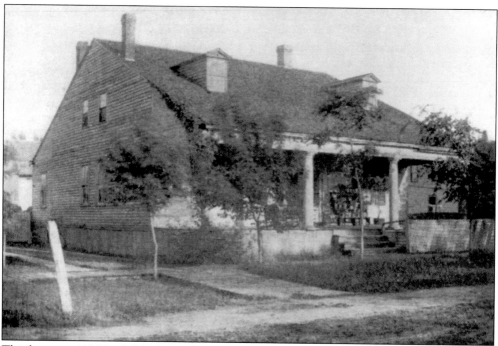

This home at 410 North Maple is referred to as the Surgeon's Quarters. It remains one of the last of the old Fort Howard buildings, and is located just blocks from its original site. In 1868, the North Western Railroad obtained titles to the old Fort Howard buildings, and rolled them back from the river to nearby west side lots. With its colonial appearance, this building is easy to recognize and appreciate. (Photo from author's collection.)

Looking north behind the buildings of Larsen's Cannery, Donald Larsen's car is parked second from left. Greg Larsen said of his father's car, "He wore it out and used it so long that you could see through the floorboards. As kids we'd throw stick matches through it and watch them spark as they hit the pavement." (Courtesy of Greg Larsen.)

"Betsy" stands before one of Leicht's office buildings at 118–120 North Broadway. Betsy had a "brother" called Big Ben, one of the first high-powered, noisy diesel tractors in the area. Big Ben had a carry-all trailer used to move cranes—likely for Northwest Engineering Co. The year 2003 marks the 100th anniversary of Leicht Transfer and Storage in the area. (Courtesy of Russ Leicht.)

Lawrence P. La Haye, better known as Stix, began La Haye Electric on 335 South Broadway in 1932. These are some trucks in action in the 1940s. (Courtesy of Pat La Haye.)

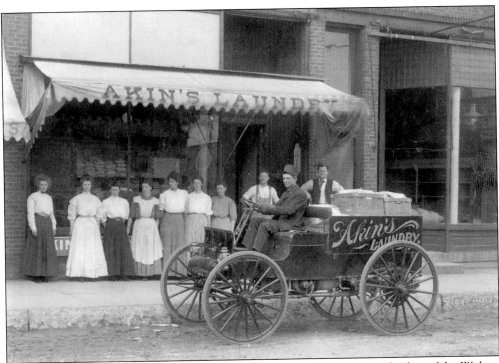

Vehicles came early to Green Bay's West Side. Akins Laundry, located at the foot of the Walnut Street Bridge, was one of the first businesses to use them. This photo shows their new delivery vehicle. Mayme Hoppe, mother of Phyllis Taylor, worked at the laundry in 1910. She was proud to tell her children that she earned $2 a week. (Courtesy of Phyllis Taylor.)

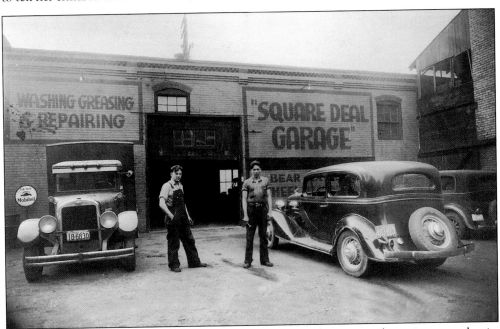

"C Weycker for Service" states this 1936 photograph. J. Schevers was the assistant mechanic. The garage was located at 327 North Broadway. (Courtesy of Brent Weycker.)

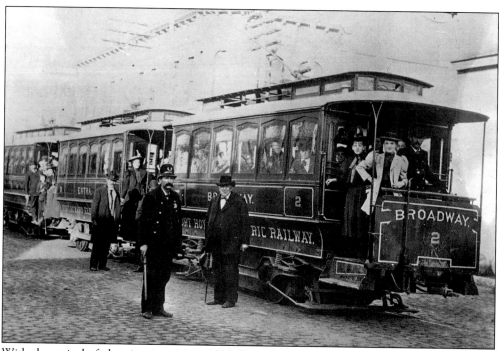

With the arrival of electric streetcars in 1893, Fort Howard led the way to a new mode of transportation in Brown County. Banker David McCartney, in a suit and with his cane alongside one of his trolleys on Broadway, received a franchise permit to open the Fort Howard Electric Railway. (Courtesy of the Otto Stiller Collection of the Neville Public Museum of Brown County.)

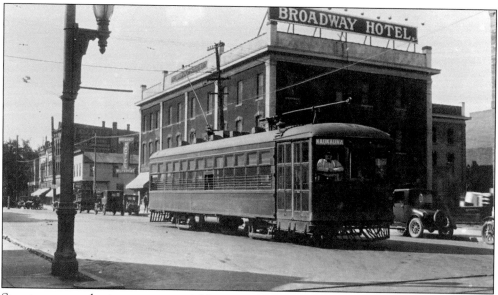

Streetcars were also important to neighboring communities. Half-hourly service was provided to Duck Creek and East De Pere and hourly service to Kaukauna. In this 1925 photo, motorman Arnold Hendricks poses inside his streetcar. Behind him is the Broadway Hotel, which was a popular gathering place in the city until it was razed in 1962. (Courtesy of Otto Stiller; Collection of the Neville Public Museum of Brown County.)

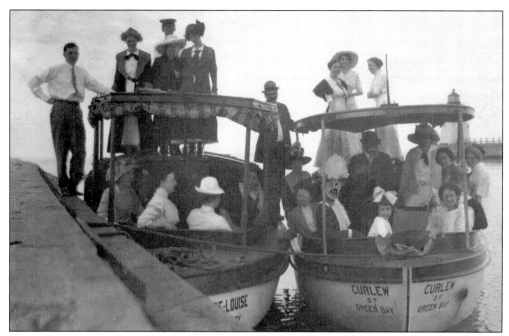

Shown here is a party given in honor of Alice Henderson and Otto Straubel before their marriage in 1913. The Straubels were a well-known west-side family. Otto and Alice took their "yacht," the *Curlew*, on their honeymoon up to Door County and later used it for Sunday afternoon excursions. It was their favorite form of entertainment. (Courtesy of Ruth Straubel Hartmann.)

This view of the Fox River harbor in 1961 shows the Dousman-Main Street draw bridge. A ship can be seen docked on the opposite side of the bridge next to the grain elevator. The grain elevator later burned down. This bridge—now replaced—cost the city only a half-million dollars. (Photograph from author's collection.)

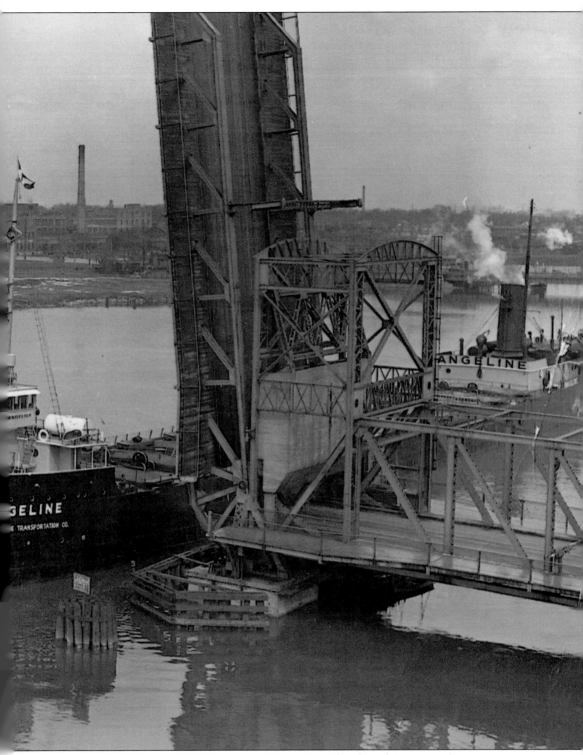

bottle on top of Fairmont dairy. (Courtesy of Green Bay Chamber of Commerce.)

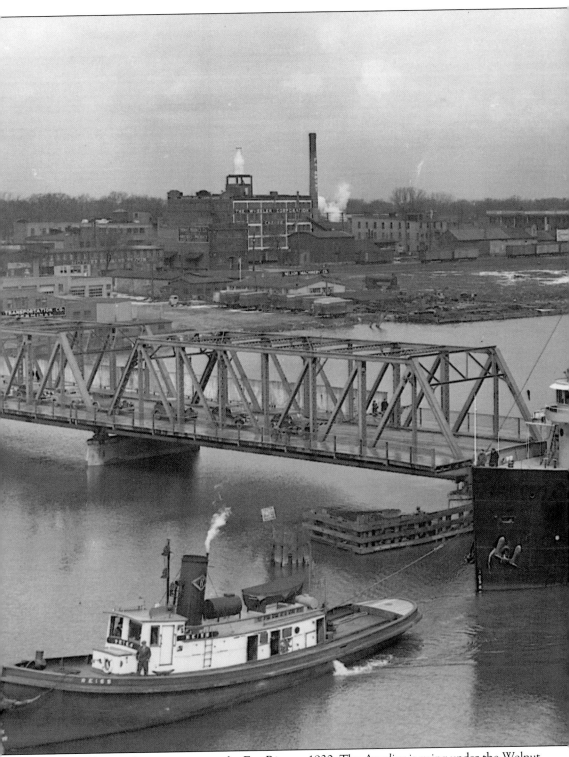

Pictured here is shipping scene on the Fox River *c.* 1930. The *Angeline* is going under the Walnut Street Bridge. Broadway is the street in the background running parallel to the river. Note the milk

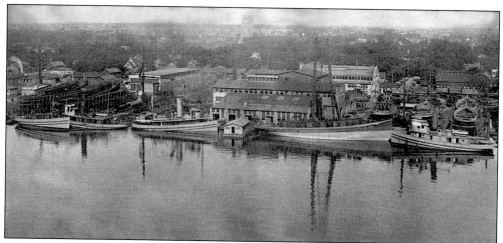

This picture shows the Johnson Shipyards. In 1867, the Andrew Johnson family moved to Fort Howard and began building their shipyard on Water Street near the Walnut Street bridge. Many other Norwegian ship builders were already settled in that area. In the second row of buildings is the former Lawson Aircraft Company, which made airplane parts during World War I. (Courtesy of Horace Lucas.)

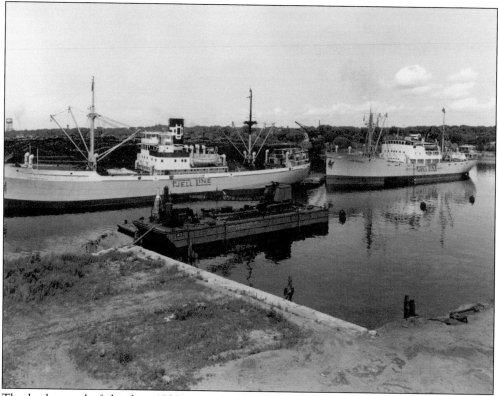

The background of this late 1930s or early 1940s picture shows the *Hemsefjell* and *Veblefjell* lined up along the Fox River. They are tied this way because of their length. The ships were used to transport powdered milk. In the foreground is a floating construction crane, specifically designed for building bridges. (Courtesy of Russ Leicht.)

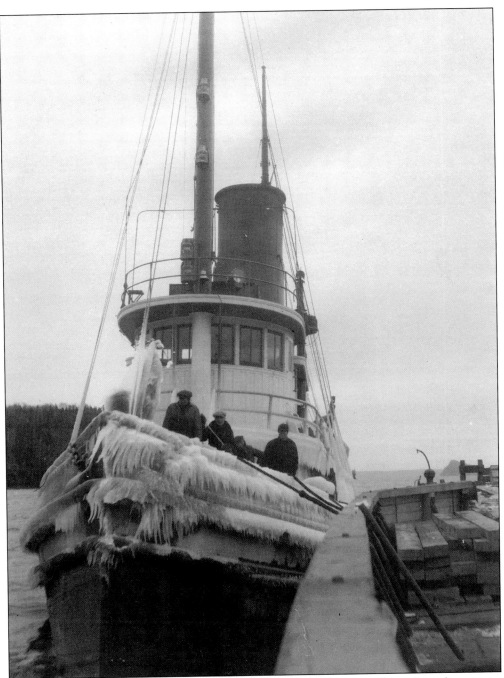

Ships were an important mode of transportation long before trains. Green Bay's location at the mouth of the Fox River, with access to the Great Lakes, makes shipping a very important industry in the area. These tugboats were used to move ships on the Fox River until they were purchased by the Army and used during World War II. Both were named "Myrtle" after Myrtle Johnson (mother of Dorothy Johnson) and Myrtle Dennison (daughter of one of the owners). In this 1910 photo, Dorothy (Renard's) grandfather, John Johnson, is the first man on the forward deck of the boat. (Courtesy of Dorothy Renard.)

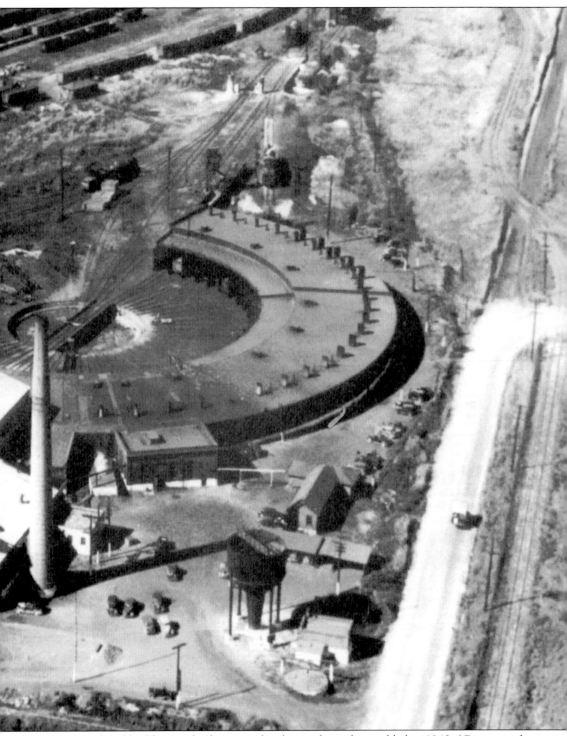

large, light colored building in the foreground is the machine shop, added in 1940. (Courtesy of Warren P. Mott Collection.)

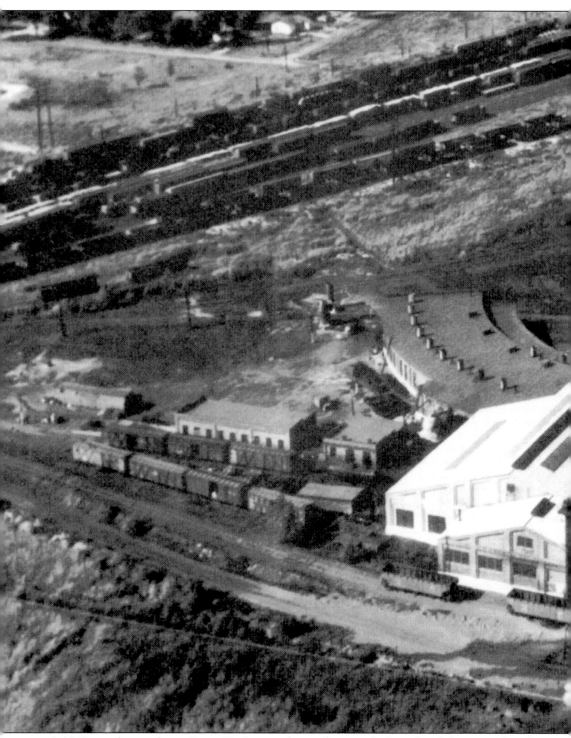

A 1948 aerial view shows Green Bay's second roundhouse, which replaced the original at the corner of Mather and MacDonald Streets, near the Green Bay passenger depot. The 40-stall roundhouse was built in 1913 and was served by a 95-foot electrically driven turn-table. The

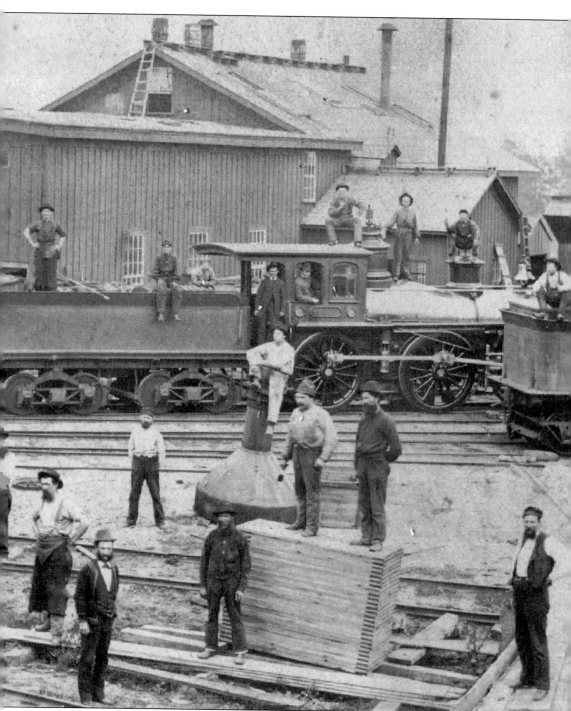

or 24), Knute Andreason, Bitters (carpenter), Lisha (?) Doty (Mr. Fisk's uncle, mason), Jim Woodward (married Libby Doty), Charles Earle (uncle of Fannie Wright), Herb Scott, Will Hanrahan (engineer), Autrine Beshine, Charlie (engineer, married Mattie Lucas), Charlie Case (son of receiver of road), John Eisman, Jim Ford, John Manning, Charlie Alling (Presbyterian), and John Bannon. (Courtesy of Oshkosh Public Museum)

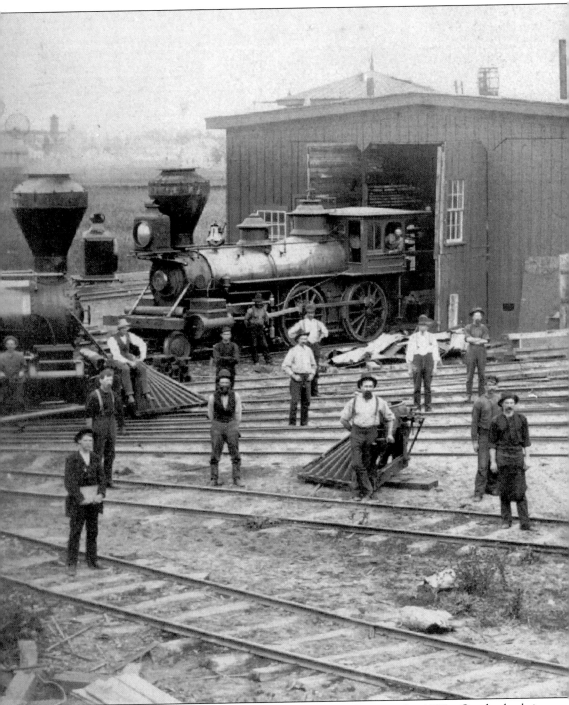

These gentlemen worked at the Green Bay & Western shops in the 1870s. On the back is listed: Preston Faville (married Louise Eisman), Ben Farlock, Gil Dunlap, Tom Farrell (boss blacksmith), John Tanner (carpenter), Charlie Bowen (boss car repair), Hi Alling, Abe Lucas (tinsmith, Nina's grandfather), Dan Conard (brother-in-law T. Farrell, blacksmith), Ed Osborn (master mechanic), Jim Allen (Jean's father, bridge carpenter), W.P. Henderson (Bill age 23

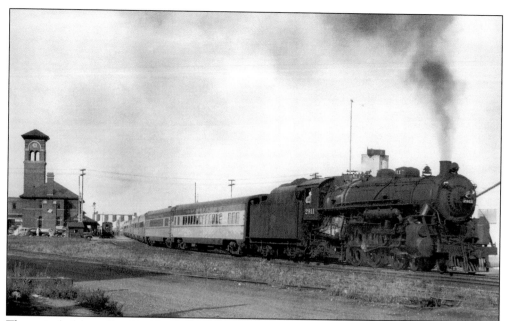

The arrival of the railroad in November of 1862 not only thrilled the residents of Fort Howard, but it also became one of the most important commercial developments in the Fox Valley, connecting Green Bay residents to other cities. In this 1940 photo, a steam engine speeds away from the depot on its way to Milwaukee. (O.P. Mullen photo; Courtesy of Ed Selinsky Collection.)

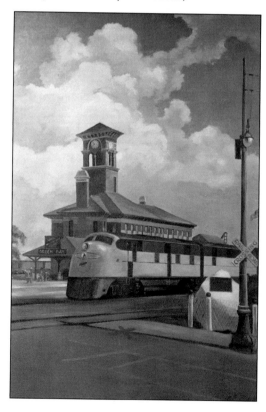

In the 1940s, steam engines gave way to locomotives. This painting depicts the famous 400, a passenger train stopping in front of the Green Bay Depot. The depot itself once used the clock as part of a "400" sign. (Courtesy of M&I Bank.)

In February 1922, Green Bay experienced one of the heaviest snowfalls in the city's history. Since vehicles of the era could not venture into the snow, traffic was at a standstill. Instead, horses and sleighs became important for a time. This picture was taken on the 1000 block of Velp Avenue as the sleigh traveled east. (Courtesy of the Otto Stiller Collection of the Neville Public Museum of Brown County.)

Clifford Bassett and Forrest G. Plott, general manager of Fairmont Creamery, are saying their good-byes to the last of the firm's horses in 1939. Joseph Olejniczak, the wagon's driver, overlooks what was a heartbreaking moment for the veteran drivers. The horses were housed at 159 North Broadway, which is now an antique shop. (Courtesy of Green Bay Press Gazette.)

he purchased in North Dakota (c. 1903). Each time he traveled there to purchase mules, he brought back a pony for his children. (Courtesy of Russ Leicht.)

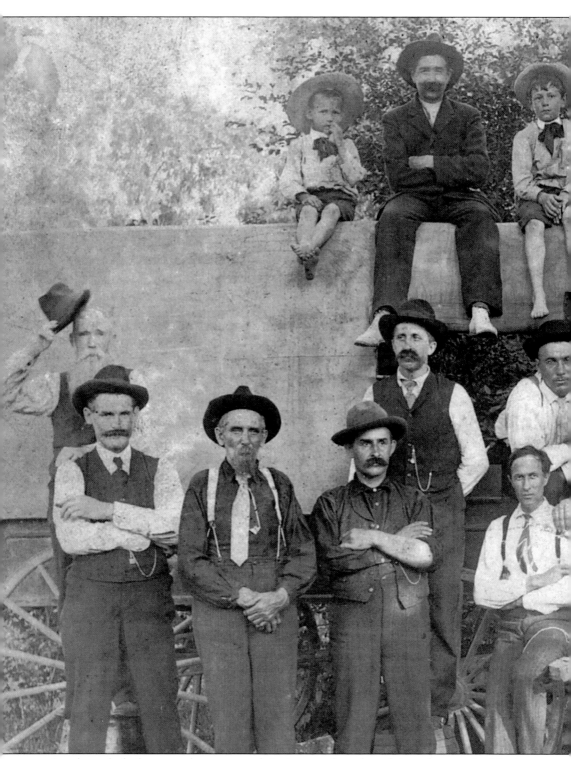

Another role for horses and wagons was bringing people and goods into the area. In this photo, Theodore Leicht, founder of Leicht's Transportation, is standing between two of the mules

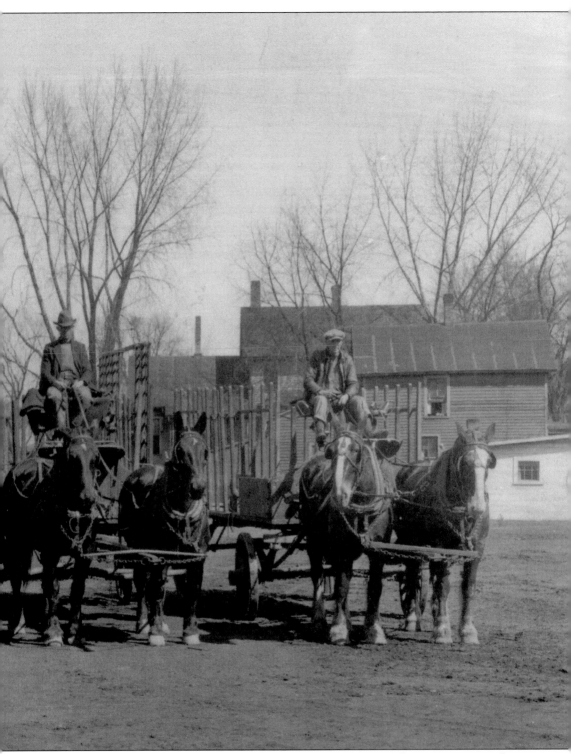

Elementary School) housed the Leicht Transfer and Storage company's first transportation fleet. This 1910 picture shows four of their teams of horses. (Courtesy of Russ Leicht.)

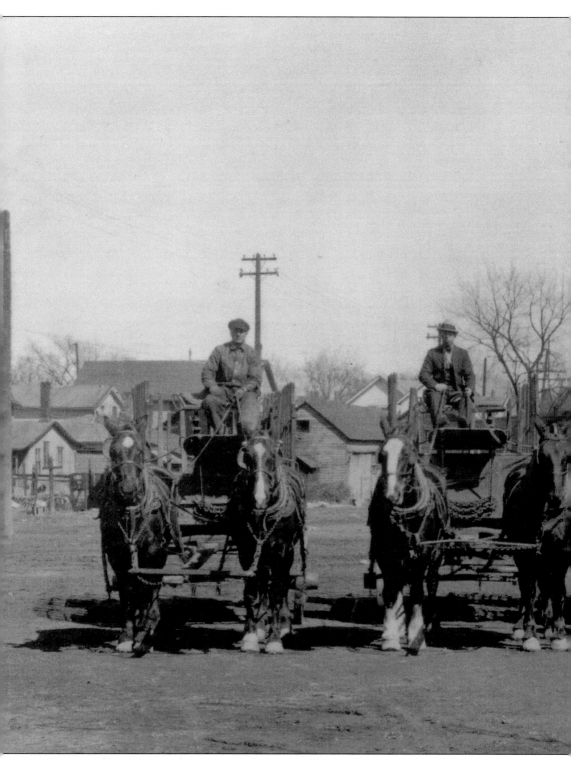

Horses and wagons served an important role in developing the area. One of their roles was transporting goods within the community. The land behind Dousman School (now Fort Howard

Two

TRANSPORTATION

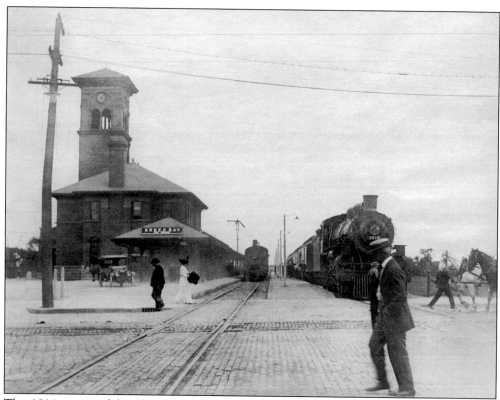

This 1914 picture of the Chicago & North Western Depot illustrates a unique time in our history. The trains in the middle separate the horses and wagons on the right from the cars parked at the depot on the left. In just 25 years, horses will be gone from the area for good, and the automobile will be the favored mode of transportation. (C.G. Stecher photo; Courtesy of Chicago & North Western Historical Society.)

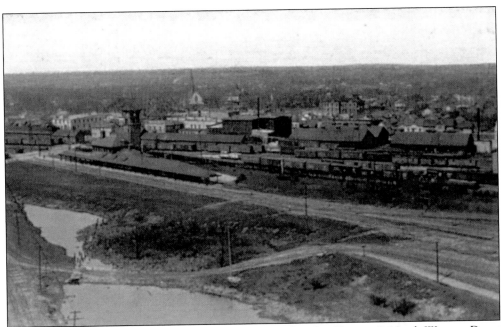

One big change in the geography of the West Side was that the Chicago & North Western Depot once stood much closer to the river. Railroad tracks were extended into the river in the late 1860s. This postcard shows how that bend of the river was cut off and isolated. The area was eventually filled in, and today is the site of Leicht Park. (Photograph from author's collection.)

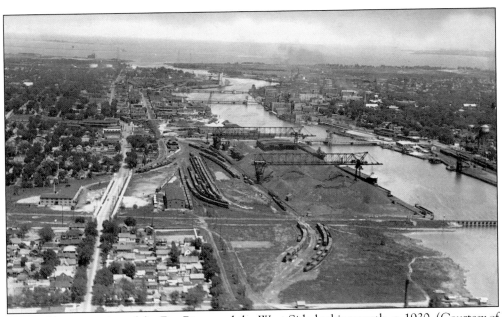

Pictured here is a view of the Fox River and the West Side looking north, c. 1930. (Courtesy of the Green Bay Area Chamber of Commerce.)

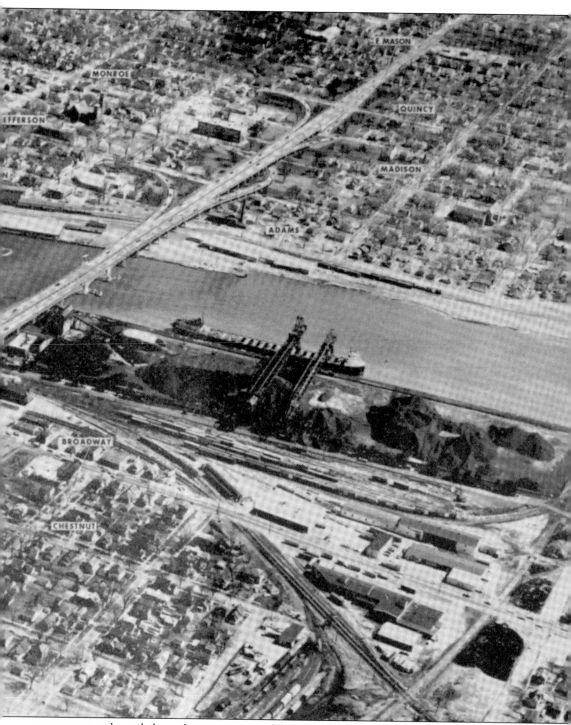

restaurants and retail shops, becoming one of the more attractive areas in the city. Residents are starting to take pride in their homes once again and are beginning to discover their history. (Courtesy of Green Bay City Planning Department.)

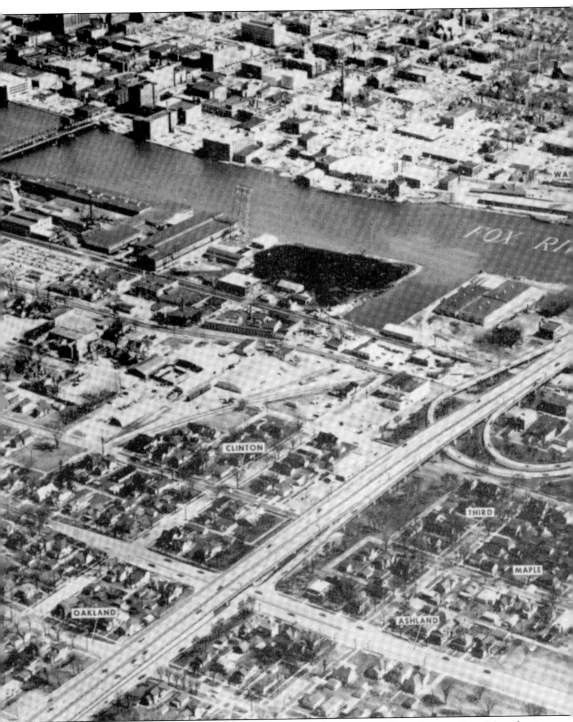

Industry is still an important part of the city today, but a new culture is emerging. More businesses and shops are opening up. Warehouses and coal piles are giving way to parks and green spaces. Fort Howard residents are seeing their city in a different light. Broadway, regarded by many as one of the worst streets in town, is slowly being redeveloped. It now houses many

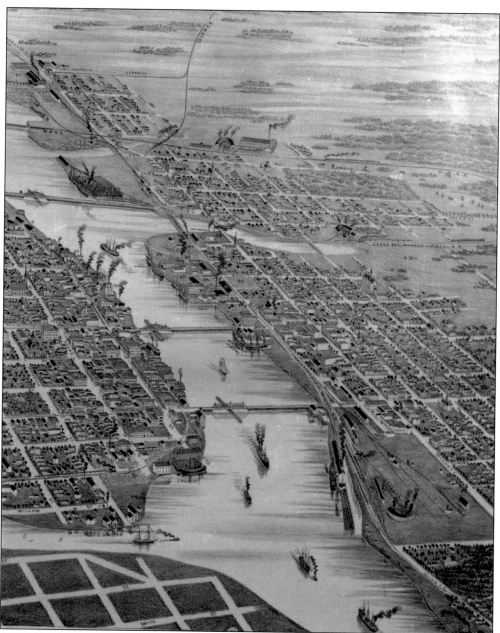

This 1893 drawing is an example of how much the Fort Howard and Green Bay areas grew in a 30-year span. In addition to two more bridges, a train trestle has now been added. Two inlets, now filled in, are shown upper right. Note that across the first inlet, all of the numbered streets are on property that belonged to the Tank family. With the incorporation of Fort Howard into Green Bay, some of the street names on the West Side had to be changed due to the same names existing on the east side, such as Main Street becoming West Walnut. Some of Fort Howard's most famous names, such as Kemnitz, Barkhausen and Hathaway, and Duncan, are starting to appear on businesses in the area. (Courtesy of Neville Public Museum of Brown County.)

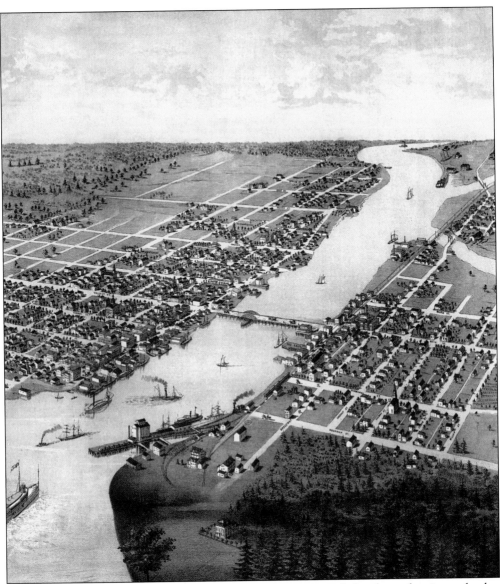

With the mission of the fort completed and the soldiers stationed elsewhere, the city evolved to industrialization. In addition to shipping, train tracks began to carve their way through the town. The first bridge, shown in this 1867 drawing, was the Walnut Street bridge, originally traveled by horse and buggy. Many of the buildings of the fort were rolled back onto the old streets of the West Side. In the lower left, Andrew Elmore's spacious home and lands overlook the bay and the mouth of the river. (Courtesy of Library of Congress Geography and Map Division.)

One

GEOGRAPHICAL
BACKGROUND

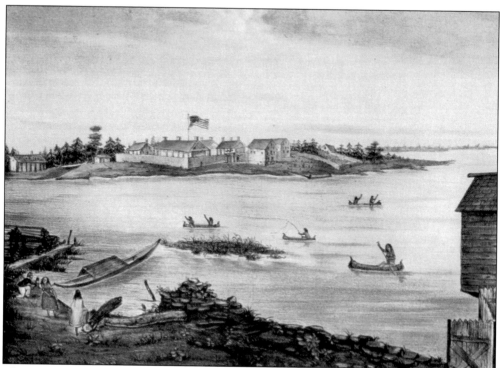

This painting depicts Native American canoes traveling along the Fox River in front of Fort Howard c. 1840. (Courtesy of State Historical Society of Wisconsin.)

Dutch, and Norwegians were some of the people to settle in the area among the descendants of the French, British, and Native Americans who were already living near the fort. This small cluster of people and their descendants would eventually become Green Bay. On February 27, 1854, Green Bay was chartered as the first city in northeast Wisconsin.

Green Bay's city boundaries, however, did not include any land west of the Fox River. One reason was because the President had declared the land around the post to be a military reservation in 1829. Soldiers were garrisoned at the fort off and on for the next 20 years. By May 22, 1852, however, the government decided there was no longer any threat to the area and ordered the fort to be abandoned. On March 19, 1863, the War Department relinquished the fort and reservation and turned it over to the General Land Office for sale. Today, all that remains of the Fort is a stone marker.

Although the Fort was gone, the surrounding neighborhood still retained the name. On October 13, 1856, the settlement officially became the Borough of Fort Howard with Robert Chappel as town president.

Green Bay and Fort Howard were growing as separate and rival communities. The Fox River had become important for shipping and industry in the area, and the west side boasted more sawmills, foundries, and boat builders. The west side also had the only brewery in Northeast Wisconsin. When the railroad came to the area in 1862, Green Bay jealously watched as the depot was built in Fort Howard. Residents of Fort Howard looked on with equal envy as Green Bay was chosen as the site for the Brown County Court House and other judicial buildings.

Fort Howard officially became a city in 1873, with James H. Elmore as the first mayor. It wasn't until 1895 that Fort Howard was incorporated into the City of Green Bay. Even though the two sides were now one, the west side still grew uniquely from the rest of Green Bay.

For this book, the boundaries of the "West Side" are from the bay of Green Bay in the north to Lombardi Ave. in the south, and from the Fox River on the east to Military Ave. on the west.

Included in these boundaries is the Broadway District. This area is recognized by the National Register of Historic Places as being historically significant. Many of the buildings in the area were built near or before the turn of the century, and survived the downtown rebuilding projects of the 1970s. On Broadway, Inc. (OBI) is a non-profit redevelopment group organized to promote the economic development and historic preservation of the Broadway area. Today Broadway is a thriving commercial district. In addition to Broadway's historic preservation, OBI is also interested in preserving the history of the west side as a whole.

Within the following pages, the west side's history will be brought to life through a unique and exclusive collection of photographs and personal stories. It will provide a glimpse into the history of the area as a way to identify, appreciate, and understand its historic significance. This is not an attempt at an in-depth history, but merely a sample of the volume thereof.

INTRODUCTION

The city of Green Bay, Wisconsin, is located at the mouth of the Fox River on the shores near Lake Michigan. The river, which has been an avenue of transportation and commerce as well as a gateway to the Great Lakes for centuries, carves its way through the middle of the city. The Historic Broadway District and Fort Howard Neighborhood are on the west side the river, near the shores of the bay.

The first people to live in this area were the Native Americans, whose ancestry can be traced back over 11,000 years, just after the ice age. The Menominee tribe has been living in this area for at least 5,000 years. The first settlers also found the Winnebago, who were descendants of the Sioux. Early texts speak of them as men of the sea. Other tribes followed in later years including the Chippewa, Huron, Potowatomi, Oneidas (who were transplanted from New York), Sauk, Fox (whose name was given to the river), Mascoutin, Stockbridge, and Munsee.

The first European to set foot in Wisconsin was French explorer Jean Nicolet in 1634. Into this new world spilled French fur-traders from Canada, followed by Jesuit missionaries ready to minister to the Native Americans and growing numbers of settlers.

Eventually, through negotiations with Native Americans, the French gained control of the waterways, referring to the area as New France. The mouth of the Fox was now to be guarded. Thus came the establishment of Fort St. Francis in 1717 on a level piece of land on the west bank of the river. The French and Native Americans lived along side each other in relative peace, and before long the fort was abandoned.

With the arrival of the British in 1761, a new fort was built on the same site as the abandoned French fort. Though founded in a dilapidated state, it was given the fine name Edward Augustus. The English only manned their fort for two years.

Soldiers of the United States came to defend the territory in 1816. They built a new log fort on the remains of the French and British site. The fort was given the name Fort Howard, after well-known soldier General Benjamin Howard, a veteran of the War of 1812.

Community growth improved through the presence of the Fort. It not only held religious and medical facilities, but served as a market for the gardens of the surrounding people. The Fort also brought a new world charm, merriment, and social dances to a hungry wilderness. Zachary Taylor, later the twelfth President of the United States, gave the area a new social status while commanding Fort Howard between 1818–1820.

The community grew physically as well. With the incorporation of Wisconsin into the United States, a large number of immigrants began coming to the area. Germans, Belgians,

ACKNOWLEDGMENTS

You are a very special group of people—you have written a book! Your pictures and memories have been strung together, creating a restoration of pride in our historic West Side. As I heard the many stories you had to tell, I grew to love each and every one of you. Thank you for your sharing and caring. This is simply a beginning!

—Gail Ives

On Broadway, Inc. would like to thank everyone who contributed to the creation of this book. From those who shared their knowledge, photographs, and time, to those who helped us write, edit, gather photos, and put it all together, we are eternally grateful. Although naming everyone would be more than could fit in these pages, we would especially like to thank the Neville Public Museum for their support.

—On Broadway, Inc.

CONTENTS

Published by Arcadia Publishing,
Charleston, South Carolina

Printed in the United States of America

Library of Congress Catalog Card Number: 2003107789.

For all general information contact Arcadia Publishing at:
Telephone 843-853-2070
Fax 843-853-0044
E-Mail sales@arcadiapublishing.com
For customer service and orders:
Toll-Free 1-888-313-2665

Visit us on the Internet at www.arcadiapublishing.com

IMAGES
of America

GREEN BAY'S
WEST SIDE

THE FORT HOWARD NEIGHBORHOOD

Gail Ives
in association with On Broadway, Inc.

ARCADIA
PUBLISHING

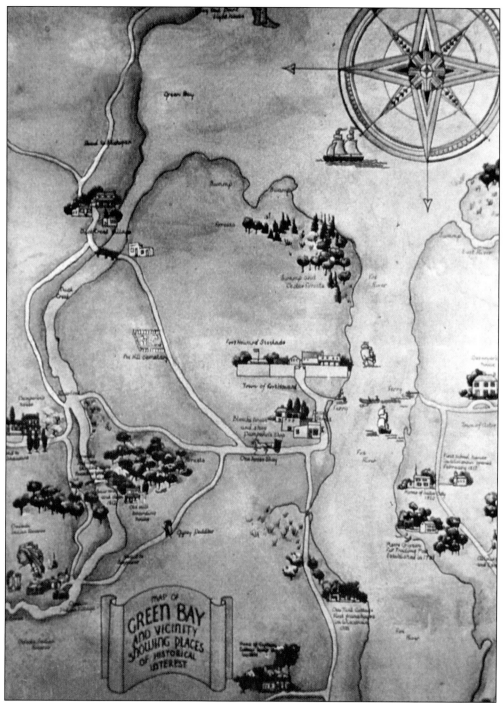

This map depicts historical locations of various places of interest. Note Fort Howard Stockade, the town of Howard, Blesch Brewery, and Pamperin Shoe Shop—the first shoe store in the area. The main thoroughfare exiting Fort Howard is Pearl Street. Following Pearl Street south along the river, Tank Cottage can be seen on the southeast corner of the map. The Oneida Indian Reserve is located on the southwest side of the map along Duck Creek. (Courtesy of William Miles.)